THE POLITICS
AND POETICS
OF CINEMATIC
REALISM

COLUMBIA THEMES

IN PHILOSOPHY,

SOCIAL CRITICISM,

AND THE ARTS

For a list of titles in the series, see page 259

THE POLITICS AND POETICS OF CINEMATIC REALISM

HERMANN KAPPELHOFF

COLUMBIA

UNIVERSITY

PRESS

NEW YORK

Columbia University Press
Publishers Since 1893
New York Chichester, West Sussex
cup.columbia.edu
Copyright © 2015 Columbia University Press

Library of Congress Cataloging-in-Publication Data
Kappelhoff, Hermann.
 The politics and poetics of cinematic realism / Hermann Kappelhoff.
 pages cm.—(Columbia themes in philosophy, social criticism,
 and the arts)
 Includes bibliographical references and index.
 ISBN 978-0-231-17072-7 (cloth: alk. paper)—ISBN 978-0-231-17073-4
(pbk.: alk. paper)—ISBN 978-0-231-53931-9 (e-book)
 1. Motion pictures—Political aspects. 2. Politics in motion pictures.
3. Motion pictures—Aesthetics. I. Title.
 PN1995.9.P6K275 2015
 791.43´6581—dc23
 2014048922

Cover images: Courtesy of Photofest
Cover and book design: Lisa Hamm

At the end of the film everyone is Blanche . . .

—Theresia Birkenhauer on *Todo sobre mi madre*

CONTENTS

PREFACE AND ACKNOWLEDGMENTS

This book is about cinema as a public space. In this space the films set up a particular relationship between politics and poetics. The book is about films and their theories and how aesthetic strategies and poetic practices emerge to reposition audiences—groups of perceiving, feeling, and thinking spectators—with respect to their reality as participants in political communities. The book is thus about films that create sensory worlds that play on the weightlessness of the individual fantasies of spectators while simultaneously weighting down or realizing the film's arrangements of bodies, feelings, and spaces through what is given to spectators. And I mean here *realized*. For cinema spectators, I argue, embody film images so that the world of the film becomes fused with a spectator's world as though the audience participated with the film in a shared *reality*. The interplay or fusion of these worlds is encapsulated in a single word that has long dominated the aesthetics of film: *realism*.

In the following chapters, I read films as attempts to make worlds fused by both film and the lived or everday reality of audiences. The made worlds comprise a perceiving, feeling, and thinking activity that is organized by the rules of the poetic, the rules of fantasy and creation. When cinematic worlds are made through film, spectators, typically restrained by natural laws or the laws of reality, become unencumbered: the worlds become light. Yet the worlds are shaped not only by the poetic but also by the political, where "the political" refers to those cultural practices that establish who within

a political community can freely articulate oneself and thus who is able and who is not able to exert a relatively free self.

I describe film as a media practice that addresses spectators in two ways with regard to their everyday living environment. Spectators are encouraged, on the one hand, to be artists, to turn the film's sounds and signs, bodily arrangments and spatial fragments, rhythms and figurations of movement into an imagined world of reality, and, on the other, to be participants in a political community. Combining the poetic and political allows spectators to imagine worlds that could be different from everyday lived reality; hence my use of the phrase *cinematic realism*. Cinematic realism is just the dynamic tension between poetics and politics that allows films and their audiences endlessly to make new worlds.

To support my argument, I draw significantly on Deleuze's writings on cinema and on several phenomenological approaches to the idea of embodied or lived experience. However, to set up my schema of politics and poetics, I draw on the very different writings of Richard Rorty and Jacques Rancière. Both of these writers offer subtle views of politics and aesthetics, yet give different stresses to how the relation between them is to be forged. Both, however, draw on the concept of "community." Rorty starts from the open spaces of moral action and individual freedom that have emerged in liberal societies. He explores the possibilities for solidarity and self-determination from a pragmatist perspective. He also endorses a shared ideal of freedom, which he refers to as the "*we*-feeling."[1] Rancière explores democratic community in terms of "dominion over equals," an idea he derives from the Greek polis. Community is a "shared sensibility" that marks out the borders of belonging and speech, what can and can't, should and shouldn't be said among equals.[2]

For both Rorty and Rancière, the history of democratic politics shows its constant aim to demarcate the appropriate restrictions for any democratic community. How do others become visible when they are not perceived as equals among equals, when they are not treated as free or able to advance their views? Rorty answers with reference to how the excluded are brought into the community by way of new descriptions, metaphors, and vocabularies—ways that testify to a community's sensibility and curiosity. Rancière views politics in terms of an aesthetic dissensus whereby "inaudible

voices" are forced through remappings and new constellations into a space of equals. For both, politics moves by the force of poetic form.

A community is thus viewed as a contingent historical reality, permanently refigured through naturalization and local reforms. However, this view relies on the interplay between poetics and politics conceived from the perspective of the utopia of art. They both adapt a romantic view of utopia. Rorty speaks of the "liberal utopia" of an utterly "poetized culture,"[3] where all disputes about truth, morality, or subjectivity become a many-voiced concert of competing new descriptions of a commonly shared reality. Rancière speaks of the utopia of the aesthetic or of an aesthetic community made up of immediate and mediated ways of thinking and feeling. What a community feels it takes up into the physical-sensory or material life of "what it thinks," and vice versa.[4] With Rorty, writing, poetry, and metaphor are the tools for the reformulation of utopia; for Rancière, film plays a far greater role.

Part 1 of my book introduces these positions in more detail, though not with an eye to entering contemporary discussions about politics and community. I focus rather on cinema as a media and mediating practice of world or reality making. I draw on Rorty's pragmatism and Rancière's poetics to extend their terms into a more Deleuzean schema that stresses the audiovisual modalities of cinematic experience. In this way I move somewhat farther apart from the language or linguistic dependence exhibited in the work of Rorty and Rancière. I offer a different account of the interplay between poetics and politics, one that takes account of the phenomenological modulations of perceptual space that lies at the core of filmmaking.

It is easy to overlook the fact that the pragmatic reduction of how we understand community is not solely due to the optimistic view of moral progress on the part of the liberal community: it is due also to believing this political thinking. Rorty's exposition of Orwell's *1984* may be read in line with the idea that political thinking itself, like the torture victims of Orwell's novel, is the result of the history of the past century. Rorty writes: "I no longer have a self to make sense of. There is no world in which I can picture myself as living, because there is no vocabulary in which I can tell a coherent story about myself."[5] At any rate, this is how Rorty's role-playing prose can be read when he writes, a few pages later, "I do not think that we

XII PREFACE AND ACKNOWLEDGMENTS

liberals can now imagine a future of 'human dignity, freedom and peace.' That is, we cannot tell ourselves a story about how to get from the actual present to such a future."[6] Rorty's skepticism is yet further justified when, as in Germany's history, the term *community* was made to smack of ethnic cleansing. If, in my book, I refer constantly to a utopian moment, my skepticism will never be absent.

For the most part, the films I treat are pessimistic, destructive, and ironic, and hence rarely utopian in any obvious sense. They neither believe in a truth of nature nor in one of morality. They are not realistic in the sense of being like life. They are films in which the reality is what is being tested by the poetic and political medium of audiovisual images. Thus the films do not share in being political in any direct or obvious sense as well. Nevertheless, they share in being responses to the Second World War, or, as Rancière writes: "We are over and done" with speaking of the "art's post-utopian present," "with aesthetic utopia, with a certain idea of artistic radicality and its capacity to perform an absolute transformation of the conditions of a collective existence. This idea fuels all those high-sounding polemics pointing to art's disaster, born of its dealings with fallacious promises of social revolution and the philosophical absolute."[7] In this view, 1945 marked a fundamental break with the collectivist idea of political communities and offered a radical new orientation of Europe's democratic societies. The films I discuss reflect that break through their different constellations of the poetic and political.

To further justify my own heuristic perspective, I look in the second part of the book at examples that show the meeting of film with avant-garde art. Here, Sergei Eisenstein's early theory of montage plays a central role. His concept of the film image, with its fourth dimension, shows the movement of a utopian gesture or commitment into a concrete form of perception, a movement that then found its way into discussions of "film as an emotion machine."[8] The fact that Eisenstein always moved between the discourse of political ideology and that of aesthetics makes his work exemplary for the art of the twentieth century.

I also examine in detail the visual idea of the New Objectivity (*Neue Sachlichkeit*). Here I attend to a visual theory emanating from the Weimar avant-garde's encounter with the cinema. After this, I turn to the "new realism" in Western postwar cinema, taking my cue, first, from Siegfried

Kracauer's *From Caligari to Hitler* and, second, from Luchino Visconti's films. The focus here is given to the more or less implicit critiques of the avant-garde model of cinema as a medium through which the modern human being of the masses can be understood as a subject of history. This utopian proposal is met with the consciousness of a catastrophic history. In Kracauer this consciousness is manifest in the figure of the reading subject of history who, in all the powerlessness of a real individual existence, regains a space of reflection in the cinema. In the cinema, viewers see themselves enclosed in a social reality that has lost sight of active social struggle. With a similar social diagnosis, Visconti's films open up the cinema as a space in which the sensibility of a past time is understood as a lost possibility of history.

Cinema, I argue, may be imagined as a medium that makes the historical basis of our sense and perception faculties visible to us, our ways of sensing and our self-experience explicit without presenting history as truth or history as making sense. The aesthetic strategies of cinema show the social on the level of the concrete placement of living individuals in the surrounding spaces of their everyday world, in their relations to work, exchange, and gender, to love, friendship, or family. This is particularly evident in Rainer Werner Fassbinder's early films, which show how European postwar film engaged Brecht's concept of theater and acting. Despite all the elaborateness of their camerawork—light, mise-en-scène, and music—the films bring attention to how actors and characters enter into ensembles in a world dominated by exchange relations, relations that undermine any distinction between fiction and reality. The relation of exchange becomes the basis of a cinematic form of representation directed at the interweaving psychic, social, and historical relations to which individuals are materially subjected.

Moving into the years associated with 1968, I look at *A Clockwork Orange* and *The Exorcist* as dissolutions of a classical Hollywood cinema that banned certain images of the social reality of persons. Within a sadistic, visual curiosity, both films make constant reference to the flow of raw images that has flooded Western cinema. What these films from around 1968 share with the films of European auteur cinema is the radical way they aim to meet the physical reality of social life through the destructive powers of a demonized sexuality.

With this in mind, I conclude with a discussion of the films of Pedro Almodóvar. His films are exemplary and singular. They stem from the ironic play of the signs of postmodern cinema, newly accentuating the physical basis of social being. At the same time, they are condensed reflections on the originary constellation of western European cinema. They work diligently on the media formations of an everyday world of feelings, a world marked as much by memories of fascism as by the entertainment of Hollywood.

• • •

I would like to express my gratitude to the participants in my colloquium for PhD students. They have accompanied my work over the course of several important years at the Freie Universität Berlin and have been infinitely inspiring through their intellectual creativity. I would also like to thank everyone involved in the editing process of the English manuscript for their expertise and support. I am most indebted to Daniel Illger, without whom this book could not have been realized.

THE POLITICS
AND POETICS
OF CINEMATIC
REALISM

1

POETICS AND POLITICS

Poetics/Politics: the title of the book published to accompany documenta X. This international art exhibition, perhaps the most significant in the world, was the source of great controversy on its tenth anniversary in 1997. In retrospect, much of what was then the target of polemical critique turns out to have been representative of important tendencies and developments in art in the first decade of the new century. At the time, the exhibition brought attention to these tendencies in a way that clarified the fundamental shift in perspective, a shift that had been carried out in art after postmodernity. In part, this had to do with the circumstance that divisions between the various media, arts, literatures, and text genres (visual arts, theater, film, video art, performance, on the one side, literature, theory, criticism, on the other) were being dissolved, their relations needing to be reconceived and reconfigured.

At any rate, rather than the anticipated exhibits of samples of current contemporary art, the exhibition presented texts, concepts, lectures, and discussions, and, above all, films—things, that is, that had not yet been associated with the term *contemporary art*. And film appeared to be the superior point of reference for this art exhibition as it shifted the focus to the relation between art and politics. The exhibition thus took up a thread that had been winding not only through the art of the twentieth century but also—at least from a European standpoint—through the history of cinema. At the end of the twentieth century, which may be called the cinematographic century with good reason, film was once again shown to be

a medium in which poetics and politics interlocked in an exemplary way. If only a few years later there was talk of the "metamorphosis of the museum into a motion picture theater,"[1] documenta X has long become one of the fixed orientation points for political art in a globalized world.

Cinema, Art, and Politics

A shift in perspective can be read in the then recent developments of contemporary art at documenta X, which pertains especially well to the situation of cinema in a rapidly changing media constellation.

This shift—whether it is seen under the heading of a second modernism or of globalization—may be characterized by four divisions, which can be illustrated quite well in the exhibition concept. For the present book, these divisions are meant to contribute to a historical and theoretical positioning of perspective, which will guide its arguments and analyses as it looks into the relation between art and politics in the history of cinema.

First and foremost, this is the relation between poetics and politics. Since Aristotle, this has designated two fundamentally different practices and discourses, defined by different logics, reference systems, and procedural rules. In the Western cultural tradition, this dichotomy has predetermined the understanding of the political well into the current discussions about democracy.[2] Even the cover design of the documenta X book makes clear—in the word *politics* the letters *li* are overwritten by a red *e*—that this separation is being called into question. Art is not to be understood as an epiphenomenon of social reality, but as an aesthetic practice that is genuinely related to the political. Put another way, poetics and politics designate two mutually referencing aspects of the political, two ways of "making," of *poiesis*.[3]

But the relation between poetics and politics does not only concern artistic production; it equally concerns—and this is the second division—the relationship between aesthetic and political thinking. (Because of the numerous lectures and discussion, the polemics against documenta X at the time spoke of a theory-laden enterprise, which deprived its visitors of the works of art.) Art is to be understood as a poeisis, a making, that contains a practice of reception, of critique, and of theory as much as it does a practice of artistic production.

The third division to be named is the strict historical perspective placed on this practice. Instead of a monumental retrospective, which could make use of history in a postmodern way as an easily accessible *Kunstkammer*, documenta X proposed—as the last great art exhibition of the outgoing century—a "retro-perspective." History had become a problem of art as a relation between "aesthetic production and political endeavors." The exhibition focused on its past, Germany in year zero, Europe after 1945, as a historical vanishing point from which to open up the present of art in a globalized world. Every reflection that questions the relation between poetics and politics must approach this question from the break in civilization meant, in Western culture, by the Holocaust, Nazism, Stalinism, and the Second World War. That is exactly why this relation cannot simply be placed into the work and described as a repoliticization of art according to the model of the avant-gardes and neo-avant-gardes of the previous century, as a retromodernity or neomodernity.

Last but not least, there is the circumstance that I mentioned in the beginning: the dissolution of the divisions between the various arts, literatures, and media cultures, which has structured twentieth-century aesthetic discourse. The claim made by documenta X is today articulated more or less explicitly by countless other curatorial undertakings. The question is not whether this or that artistic work is art, according to the standards of territorial organization, but whether the exhibition itself proves to be a workshop in which material, assembled from the whole world, can become an "instrument of productive analysis" of the interplay between "aesthetic productions and political aspirations."[4] Setting up a space as a space of art predetermines what is art, because it organizes, presents, and judges any kind of media, things, signs, materials, interactions, or events in terms of this function—the analysis of the relationship between aesthetic production and politics. This is the fourth division.

(Obviously, the four divisions can be derived in a different way as well. The close mutual relationship between poetics and politics, a poiesis that encompasses artistic production, but also reception, critique, and theory formation, the historical-cultural positioning of the perspective of this poiesis, the dissolution of the discursive boundaries between the various arts and media—these are manifestations that also can be derived in terms of the history of theory and grounded in discourse analysis, and which

have been considered fundamental to art at the beginning of the twenty-first century.)

From today's perspective, it would not make much sense to parse out and describe the field of aesthetic production according to various media, arts, and production methods. The mutual relations between aesthetic discourses and artistic practices have become too closely meshed. This concerns film in a particularly strong way. Until the beginning of the nineties, film took place above all in the context of cinema; regardless of whether it was genre films, auteur films, experimental or essay films. Even when films were explicitly advertised as film art, they still appeared in the context of cinema. Cinema was a practice that was separate from art in principle, with specific media environments, economic and cultural forms of institutionalization, and its own discourse—even if cinema and art often referred to one another and individual artists moved between the two worlds. The changes outlined, however, go well beyond this mutual referencing, the cycles of which can be traced over the twentieth century.[5] For this breaking of boundaries does not affect individual works or directors, but the territorial distribution of the various poetic and theoretical practices and discourses as such, in which the relationships of art and cinema are reconfigured. It is not necessary to make a dramatic announcement about the end of cinema in order to acknowledge that cinema, as it developed over the twentieth century, was fundamentally transformed at the end of that century. It was the cinema more than any other cultural practice that brought together entertainment and information, art and pop, fiction, theory, and document in a way that made possible the configurations of poetics and politics that today, if we follow the divisions already outlined, seem to define art as such.

In fact, this practice seems to have dissipated at the same moment that it was perceived in this way by art. The year of the documenta X, 1997, was in fact also the year the DVD was introduced, the beginning of the digitalization of the history of cinema. But even more important than the fact that this has turned film history into a generally accessible archive is the circumstance that audiovisual images were produced, reproduced, covered, exchanged, and overwritten from then on through the most diverse media practices. Soon films—old, new, short, long, fictional, documentary, epic, and lyric—could enter into media interactions in the most improbable ways, many of which had been almost unimaginable only shortly before.

Film history has become the material of a continual editing and reediting. This not only concerns the spaces of art installed by curators and performance artists; camcorders and Internet platforms such as YouTube allow for edits to be made into the user's most ordinary activities and ways of thinking.

The present book starts from this situation when it looks into the relationship between poetics and politics in the history of cinema. Not that I wish to claim that there will no longer be any cinema, museum and exhibition art, performance, and literature. But these do not confront each other in a relationship as different arts, but as the mutual interplay of the most diverse uses of media and aesthetic practices in the space of art.

The Idea of Aesthetics

Art today seems to be defined by nothing more than by these spaces, segregated from everyday life, in which the interdependencies of various poetic and political activities become visible and negotiable. They are spaces in which any aesthetic practices, expressed in any things or processes, can cause experiential realities to appear that are not those of our everyday life. It was just these spaces that were a projection of cinema from the very beginning. At least that is how it appears if we follow Jacques Rancière, whose theoretical work was one of the fundamental reference points for documenta X.

Time and again, Rancière has thematized the movement from the poetics of various arts and genres to an art that is defined solely through space, separated off from everyday life. For him, art per se designates the cultural practice that generates such separate spaces, be it in the cinema, in exhibitions, or in the theater.[6] This definition of art would point to a fundamental break in the history of art, which, two hundred years ago, produced a "discourse that came to be called aesthetics."[7] Referring to this history, Rancière situates cinema as follows:

> Cinema is not merely an art that arrived later than the others because it depends on the technical developments that took place in the nineteenth century and that, once established, would have had the same sort of history as the others: a development of its technology, its schools, and its styles, in

relation to the development of forms of commerce, politics, culture, etc. It does not only come "after" the others for objective reasons. . . . It belongs to an idea of art connected to this idea of history, thus bringing together in a specific relation a certain number of possibilities belonging to technology, art, thought, and politics.[8]

The "idea of art" means a discourse that is formulated in its most fundamental aspirations with Kant's aesthetics, shaped since Romanticism in terms of the philosophy of history and marked to this day by a long tradition of critical objections, polemical rejections, and emphatic renewals. The term *aesthetics* likewise experiences a very specific usage here and a basic generalization. For Rancière, aesthetics initially designates a historically specific way of identifying art; it does not explain the logic according to which art is to be judged and understood as art, rather it describes and reflects the forms in which something occurs as art and is experienced as art—without the possibility of establishing beforehand the criteria that something (a thing, an event, an interaction) has to fulfill in order to be art. From this perspective, art is understood as a cultural practice that is always associated with a certain idea of politics, namely democracy as it is understood in Western philosophy. In this sense, aesthetics accommodates a historical change in the texture of poetics and politics; it designates the break with the system of different poetics, which integrated art into a previously existing order of representation. An order in which what objects could be represented by what art genres in what way was established. Aesthetics means a "system of thinking about the arts that became established in lieu of another concept [of art]," a "system of thinking in which the arts are absolved from the norms of representation."[9]

This is where the generalization lies: aesthetics becomes the expression of a historical form of thinking (of modernity), which is opposed to another historical form (of premodern occidental thinking), namely representation. Aesthetics, as a way of thinking art, marks a fundamental break in the periods of Western thought:

> The fine arts were so named because the law of *mimesis* defined them as a regulated relation between a way of doing—a *poiesis*—and a way of being which is affected by it—an *aesthesis*. This threefold relation, whose

guarantee was called "human nature," defined a regime for the identification of arts that I have proposed to call the representative regime. The moment when art substitutes its singularity for the plurality of the fine arts, and produces, in order to think it, the discourse that came to be called aesthetics, is the moment when a knot came undone: this know had tied together a productive nature, a sensible nature and a legislative nature called *mimesis* or representation.[10]

The "aesthetic regime" no longer positions either the forms of thinking or the forms of art in dependency on a previously established reality (of "human nature"), which thinking would have to encompass and art would have to imitate and represent (as in the "representative regime"). Rather, the forms of thinking themselves are the generating power that produces and shapes reality as the shared sensibility of a community.[11] In the regime of aesthetics, the sensory-physical relation to the world, the bodily being-in-the-world, is determined by forms of perceptual sensation, of affects, and of speaking positions derived from the historically contingent arrangement of a commonly shared world of the senses. Rancière thus speaks of the distribution of the sensible.[12]

Aesthetics, therefore, designates the connection between an arrangement of art and an idea of thinking itself. And in this connection it is related to the historicity of a community, founded solely in the positions and relations in which we detemine how we experience our reality, how we communicate with one another about this, how we describe and process it, in short, how we can think our reality. Our truth, our morality, our sensibility is always an effusion of the "sensory fabric" in a community that we belong to. (Even Rancière's definition of aesthetics struggles with the guidelines so succinctly formulated by Nietzsche in "On Truth and Lies in an Extra-Moral Sense.")

Aesthetic thought defines art as the sphere in which a community usurps the forms of its perceiving, feeling, and thinking by taking them to be the historically contingent forms of how their commonality is expressed, while the only justification for this commonality is the mere fact of belonging to the community. At any rate, this is how I understand Rancière when he writes: "Aesthetics is the system of thinking about art in which art is always more than just art, in which it is a mode of application proper to thinking,

which produces forms of life, forms of a concrete and experienced reality of ideas. It is the thought of becoming sensually perceptible, which gives commonality to ideas, which allows a community to possess sensually perceptible forms of its idea."[13] The connection between art and history, as previously discussed, would have to be imagined as the "realization of the aesthetic discourse." Ultimately it is just an idea: the utopia of an "aesthetic community,"[14] in which a connection between poetics and politics is realized, which is projected time and again in the classic writings of aesthetics and of Romanticism as the promise of art.

The sensing mode of thought, which at the same time would be a thinking mode of the sensory material, is the utopia of aesthetics:

> No doubt this program can take on quite diverse forms, from Schiller's aesthetic education to Wagnerian mythos or to Mallarmé's "offices." Nevertheless, it is permeated with a common basic idea: Art is what gives the political community that form of visible commonality that, in contrast to the abstraction of the law, places people in living relation to one another. It weaves the magnificently visible cloth of the common world, the "chance glory" that Mallarmé called up to displace the "shadows of yesteryear," that is, of religious transcendence and communities of faith. So art tends to be life, it is thought that has become the visible stuff of life, the rhythm of the community, if not to say the mythos of community. The aesthetic mode of community is the mode of a community that thinks what it feels, and that feels what it thinks.[15]

And film can stand in for this utopia. In film, the program of modern aesthetics would seem to be fulfilled. It is the art that, in one and the same move, and in relation to everything that determines the physical-sensory life of the community, can be unmediated thought about "what it feels" and unmediated feeling about "what it thinks."[16] Film is, following this line of argument, the utopia of aesthetics that becomes reified in one medium, a connection between poetics and politics, that takes shape in the projections of the cinema as the space of an aesthetic community.

From this perspective, the factual territorial distribution of the arts seems to be an anachronism. This has consequences, not least for the question of the history of cinema. Indeed, the distribution of realms in the

cinema into different genres and poetics lands on the side of the regime of representation.[17] In fact, one has the impression that, in Rancière's view, the idea of aesthetics only plays a role for certain films—that the bulk of Western cinema, in contrast, has restituted a poetics of representation in the register of narrative genres. But in the cinema even separations that have long marked its distance from art have been introduced. Even if my argument in the following follows from Rancière's concept of aesthetics, I will neither relinquish the term *poetics* nor *genre* when looking at cinema.

If one looks for the utopia of aesthetics in the history of cinema, then what Rancière claims for art in relation to aesthetics is also valid for the cinema. Its historical appearances should not be measured and evaluated in preexisting terms; rather, they place thinking before the task of newly aligning the relationship between poetics and politics on these terms. (This is the sense in which Benjamin postulated that it was not film that needed to align itself to the benchmark of traditional art theories, but that aesthetics had to be realigned in view of the logic of the cinematographic image.)

Utopia Cinema

In fact, aesthetics and cinema were connected from the very beginning in the idea of a new visuality in which perceiving, sensing, and thinking were executed as a single unit. Seen in this way, Rancière's reflections restate an idea that was closely associated with the cinema by the film avant-gardes— from Sergei Eisenstein and Dziga Vertov to Jean Epstein and Germaine Dulac—as well as by classical film theory—from Béla Balázs and Walter Benjamin to Siegfried Kracauer and André Bazin. All of them, in their own way, thematize film as an art that realizes the unity "of a sensing mode of thought and a thinking mode of the sensory material."[18]

Vertov formulated this idea in precise cinematographic terms in his film *Čelovek S Kinoapparatom* (*Man with a Movie Camera*, USSR 1929). The film is, according to the opening title cards, the excerpt of a camera operator's diary. And then the audience is directly addressed—"Attention Viewers"—and the explanation continues in the next title cards. This film, we read, is an experiment in cinematographic communication of real events—without the help of intertitles, without the help of theater.

The film is an experimental work that aims to create a truly international language of cinema based on its strict separation from the language of theater and literature. At the beginning, during the prologue of *Čelovek S Kinoapparatom*, a space is constructed that is strictly separated from any representative framework of signs—be it that of the dramatic stage or the imaginary spaces of literature, be they the illustrations of painting. Instead, a multiperspectival spatial image is stretched between the enormous camera—which is shown from the front in the first shot, as if it were aimed at the audience, the cameraman climbing up onto it as if he were climbing a rock wall equipped with tripod and camera—and the projector—this as well an oversized machine in relation to human dimensions, operated by a professional. We see a cinema; the architecture is reminiscent of the theater. But the positions of seeing and showing, of perceiving, sensing, and speaking, are newly and differently arranged. The audience, which streams in from the side doors, is part of a mirroring, bent over the reality of a real cinema audience.

These are not scenes and impressions from social life, but the sensation of cinematographic communication itself as an aesthetic form of experience, with which the positions of seeing and perceiving and sensing, of speaking, thinking, and acting are defined and described in relations that do not correspond to existing social and cultural figurations of relating.

In the first sequence after the prologue, one might say, a young woman is shown waking up. What this means concretely, however, is the visible slackness of a hand, an arm, which limply moves on the bedcovers, the bareness of the skin of the throat, a dynamic of gazes that is built up from this slackness (we see one old and one modern painting; both show faces looking at something in fascination). In the montage of this body, its own movements become conceivable as the temporality of awakening, which in turn is coupled with images of other sleeping bodies, the empty streets and dark openings of windows flung wide open, the trees on the abandoned waterside promenades blowing in the wind. They combine into an ensemble of bodies that all push toward awakening, because the daylight washes out the guardians of their sleep, the dreams of motionless houses and moving trees, the abandoned street cafés, the boys on hard park benches, and the girls behind open windows. The awakening of the city is staged as a temporality in which the bodies, machines, equipment, and architecture of the city are woven into one another in manifold ways, like the body parts,

instruments, and movements of the musicians in a symphony orchestra, which concluded the montage construction of the prologue. In fact, the prologue still shows the silent film musicians at first as a rigid, motionless arrangement of figures, molded like sculptures from the shadowy light of the now darkened auditorium. Only when the projector lamp is turned on do they begin to intertwine with one another, an orchestra playing in the reflection from the brightly gleaming screen above them.

In the prologue's construction, the cinema itself is presented as a dream-like self-reflection of cinematographic communication: as a site where temporality from the sleep of emerging bodies is connected with the lethargic duration of houses and streets, with the wind in the trees and the leisurely cafés waiting for the hustle and bustle of the day to break into a dynamic of awakening, that even assimilates the spectators' sensations and thoughts. For their dynamic of sensation is not the experience of a viewer looking raptly at a picture; rather, it is utterly a part of the movement of the image, part of the temporal structure of the movement-image and formed by its structure as a shape of sensation—as a specific dynamic of affect.

The rows of seats in the auditorium, which fall open invitingly in Vertov's film, moved by the invisible hand of the machines, bring the spectators who are streaming into the movie theater into a position from which the social world can be viewed and described as an integral body of a multiperspectival interlocking of the forces of material, people, and machines. Described not in relations of economy or of sociology, but in the experience of the lived world of working, communicating, loving and hating, sleeping and waking, breathing, hungry, eating individuals: in affects, perceptions, and thoughts that are immediately realized as cinematographic images. The cinematographic images are always already, as we might say with Deleuze, percepts, affects, and concepts, which as such are realized as experiences by the spectators in their own bodies.[19]

The history of cinema is also the history of this utopia, the utopia that film could become the "art of an aesthetic community,"[20] in which the political community is achieved; this means a community for which, in one and the same communicative act, the shared lived world can be grasped in its material legality as political, that is, as an intended reality proposed by human beings. At the same time, it can be felt in each of its elements as a physical-sensory being-in-the-world. The history of this utopia is the topic of this book.

Cinema and Politics: A Historical Figuration

The aesthetic community is utopian because we can only imagine a collectivity, which is aware of itself in this way over long time periods, as an idea and not as a social reality–nor do we want to imagine this any more.

For the avant-gardes of the twenties, the utopia of film was associated with the idea that anonymous masses of cinema audiences were the raw form of a new political community, which the avant-gardes sought to form as a collectivity capable of action. The idea of aesthetics, the utopia of art, was recoined into a political program, which was very quickly reduced to the strategic mobilization of the mass audience, to a raw use of media technology in the service of totalizing executions of power.

After 1945, this was the occasion to subject the idea of aesthetics to a polemical critique in ever new variations, according to which the idea itself, as the bad legacy of speculative philosophy, contributed to the rise of political totalitarianism. This critique concerned the cinema in a special way, at least from a European viewpoint.

In fact, looking back at the twentieth century, it is evident how exceptional the significance of cinema became within totalitarian power politics. One can think, for instance, of Soviet montage cinema from the twenties, which explicitly put itself at the service of the communist revolution, and of the attempts—albeit with only limited success—of the fascist regimes in Germany and Italy, which subjected film production to the goal of mobilizing the masses through media. But we can also think of the propaganda battles of the Second World War in which both the Allies and the Axis powers tried to mobilize the masses through the effect of cinema. In contrast to this are the various efforts of the postwar period to redefine the relationship between poetics and politics for the cinema—efforts that were often associated with the hope that the cinema could be used as a tool in building up democratic societies. We can think of the new realisms in England and Italy, of the new waves in France, Germany, and Hollywood. As obvious as the close connection between cinema and practices of exercising power may be, it is far from identical with the relationship between poetics and politics.

But then what exactly does it mean to thematize this relationship with regard to cinema? What does politics mean here? And how can the mutual effects of both factors be conceptualized? Doesn't the question of

the "ideology production of the cinema" lie hidden in these questions, the question of that theoretical construction that the emergence of film studies really actually founded, which was continually interrogated and reconceptualized in the debates of the seventies? It was all too obvious that these effects did not correspond to particular messages or ideologies, nor to contents that were conveyed qua films to the audience. So even these debates were incited by the demands to define the structural relationship between the mass medium of cinema and its aesthetic effects in the field of politics.

In a short sketch of the historical perspective of the book, I will attempt to make clear what distinguishes the question of the relationship of poetics and politics in the cinema from a return to the cinema as a medium that produces ideology.

The fact that things have a more complicated relationship can clearly be seen, even in the schematic overview of the examples named here, in the fact that highly divergent, even opposed film-poetic concepts are addressed, which indeed likewise lay claim to defining the political dimension of the cinema in terms of aesthetics—not of contents.

In retrospect, the Second World War, at least from a European perspective, seems to be a fundamental break, which separates the idea of a cinema targeted at collective mobilization from the poetics of a new realism that marked Western cinema after 1945. On one side there are the avant-garde concepts that aim at a direct affective mobilization of the masses through film's aesthetic possibilities in order to create a form of collective subjectivity adequate to the conditions of industrial society. They are denoted by such diverse positions as the montage concepts of Eisenstein's films and the object-oriented constructivism of the New Objectivity. On the other side, there are poetics, such as those of Italian neorealism or the Free Cinema, which understand the aesthetic modeling of everyday perception in the cinematographic image as the opportunity to create new descriptions of social life.

In fact, the poetic concepts of the avant-garde correspond with ideas of social emancipation, collective identity, and community that were radically devalued with fascism, the Holocaust, Stalinism, and war. Even when, as in the British or Italian context for instance, the new cinematographic realisms were accompanied by and theoretically grounded in the political rhetoric of socialist ideals of community—the concrete film aesthetic shape

of these poetics are marked by the loss of a binding ideal of community. The films themselves, in their different cinematographic operations to describe the ordinary life of ordinary people, can make it seem entirely questionable that there could be a community to which a political appeal could then be directed. Pierre Sorlin underscores this poetic principle once again in a recently published essay when he describes neorealism as "*cinema corale*," as choral cinema. What he means by this are films in which the interaction between individuals and groups stands in the center, without these groups representing a collective subject or having a hero. Although belonging to the groups is usually established by work, and the loss of this cohesion means radical isolation, these films lack any impulse to propagate this community feeling as an ideal to be realized in the socius.[21] They are films that position individuals in a web of work, family, and love relationships and show them in their interaction without figuring in a concrete political effect of cinema.

The films of the new cinematographic realism appeal—and this is the case for the films produced in the fifties by Karel Reisz or Lindsay Anderson as well as for the earlier works of Roberto Rossellini, Vittorio De Sica, Giuseppe De Santis, and Luchino Visconti—to a community feeling, an idea of shared humanity, without having any idea of how this could be implemented sociopolitically. They did not refer to their cinema audience as knowing, but as astonished, and their everyday world became a spectacle without a dramaturgical key.

These films neither follow a political calculation—for instance those of Eisenstein—which seeks to animate a collectivity in aesthetic effects acting as a subject, nor do they form—like Leni Riefenstahl in her propaganda films—the ideal of community itself as an aesthetic attraction, in which the audience can enjoy its collectivist directedness as a spectacle.

This condition of Western postwar cinema becomes even more acute with the politicization of cinema around '68. As numerous as the attempts were to establish an agitating, left cinema—consistent film poetics arose in this time precisely from the diagnosis of the failure of political publics. Their programs grew from the conviction that the space of political articulation had got lost, the possibility of politics itself had been destroyed and replaced by the pure execution of power. On the other hand, these poetics were marked by the expectation that cinema as aesthetic production might achieve what the institutions and communication forms of political publics

hindered—namely to bring the ruptured experiences of concrete individuals into relation with one another, so that this could then support the development of a political social thinking and acting.[22] And this expectation is articulated in reaction to the experience of '68 as a "politics of form." One must, so the slogans ran—the work of Jean-Luc Godard, Pier Paolo Pasolini, or Alexander Kluge are the pertinent examples of this program—change the forms of representation themselves, the media foundations of social communication, in order to make the social reality that determines the lives of individuals visible at all and to be able to bring it to language. What was to be analyzed were the historically developed conditions of sensory horizons of experience, whether these were defined by symbolic, discursive, or media contexts; what was to be made visible was the sensory-concrete, physical positioning of individual existence in the shared space of social life; what was to be called into question were the perspectives given by this positioning, in which social life was only represented in the most fragmentary way. The cinematographic image is conceived as an opportunity to take the historical, social, and media conditions that establish the space of everyday perception, and thus the possibility of experiencing with the senses, and to make them sensually graspable, viewable, evident.

At any rate—this is the common point that links the new realisms of European postwar cinema with the new waves of the sixties and seventies, the poetics of the French Nouvelle Vague, the New German Cinema, and the New Hollywood—their cinematographic descriptions seek to make forms of everyday ways of living together visible without being able to refer these descriptions to an ideal political community or a feeling for the communal, a binding commonality. The "question of community" in these films can be grasped as an acute problem, which the European nations, reorganizing as democratic societies, were confronting after the Second World War, just as the USA was in conflicts over the Vietnam War.

Cinema and Community

Richard Rorty has thematized the sense of commonality as one of the fundamental problems of modern democracies.[23] Indeed, these democracies must require political responsibility with respect to the community, on the

one hand, without being able to call on a universally valid idea of common-ality, on the other.

The problem consists in the fact that a political community cannot do without solidarity, without a sense of commonality, but it cannot ground this requirement in anything outside of the value the community itself rep-resents. If a community does without appealing to the sense of commonal-ity, it subjects itself to merely technocratic calculations of administration and power; if, in contrast, it rests on an idea of community grounded in metaphysics, genealogy, morality, or the philosophy of history, it winds up on the front lines of fundamentalist claims to power and exclusionary maneuvers[24]—regardless of whether the grounding rests on the history of a people, the emancipation of a collective subject, human rights, or an abso-lute beyond all history.

Obviously Rorty does not only distance himself from the idea that a community could ground itself on inalienable rights and moral principles; even the attempts of communitarianism to make commonality itself, as a universal quality of the historical human being, into a standard for cri-tiquing goal-ration social processes and institutions are rejected by Rorty. He argues against an a priori foundation of politics previous to political action.[25] For him, politics can only be achieved in the appeal to solidar-ity with the convictions and values of a historically contingent community. And Rorty calls this appeal the sense of commonality, a feeling for the com-munal. The theoretical position cannot be detached—there is a "priority of democracy to philosophy"—from the political conviction that the histori-cally developed scope of moral action and individual freedom is the result of the history of liberal democracies. "Moral progress" is "a history of mak-ing rather than finding, of poetic achievement by 'radically situated' indi-viduals and communities."[26] Rorty places himself in this tradition and can therefore pragmatically define politics as a continual making, the only goal of which consists in protecting and facilitating the boundaries of solidarity, the we-feeling,[27] and the free self-determination of the individual. Its only basis is a *sensus communis*, which means both the common sense of bind-ing political ideals and the feeling of this boundedness, the sense of com-monality.[28] Neither the one nor the other can be grounded outside politics. The political community itself can appeal to nothing more than the politi-cal goal of its amalgamation and its recurring confirmation and extension

in a generally shared feeling of solidarity and belonging. This permanent reconfiguration of the community is a question, for Rorty, of continually extending the boundaries of solidarity. Viewed in this way, the history of liberal polities is above all a question of the perception of the unfamiliar and of transforming political naturalization. This "is a matter of detailed description of what unfamiliar people are like and of redescription of what we ourselves are like."[29] Indeed, it is here that Rorty situates the relationship between politics and poetics. He assumes that the sensibility with which we perceive others as "fellow sufferers" can be continually raised by inventing new vocabularies and ways of describing the community. "Novels, cinema, television" are nothing other than political or philosophical arguments, "vehicles of moral change," that directly facilitate a change in the sense of commonality through new forms of description.

From this perspective, the poetics of Western cinema that I have outlined—after the Second World War and after '68—refer quite casually to historical constellations. Indeed, the loss of an idea of community, one that needs to be emancipated, produced, or reproduced,[30] equally concerns both politics and poetics. It can be understood as a crisis of the sense of commonality in the sense I have outlined where the relationship between the poetics of cinema and politics is reconfigured. The historical incisions that are thematized in the following chapters of this book designate such crisis points in the sense of commonality. But from my point of view it is important to understand that both of the poetological formations mentioned—that of the avant-gardes in the twenties, which hoped to mobilize a new, collective subjectivity, as well as that of Western postwar cinema, which is marked by the loss, the crisis of the sense of commonality—have a common denominator in the idea of aesthetics. Which also means that this idea is in no way identical to concrete poetics and aesthetic concepts of film; rather it is realized in ever new proposals about the relationship of poetics and politics.

Poetic Experiments

To understand this point, we must once again come back to the idea of aesthetics and the utopia of art. The fact that the realization of an aesthetic community is conceived by Rancière as a historically unredeemable

promise of Romantic art, precisely as utopia, is itself still significant for the relation between poetics and politics. For it means, as I understand Rancière, that the forms of an aesthetic community, of an aesthetic democracy, do indeed exist in the space of art; in a space, that is, where any random thing or event can equally become art and can be perceived as art. This space, however, is isolated from the shared reality of perception by which a community is defined. The things of art here are neither replications nor models of social configurations nor descriptions and redescriptions of the reality of the community. Rather, art produces, according to Rancière, segregated spaces of experience, which break with the existing sense of commonality. In no way does this mean distinctions such as trivial and artistically valuable, art and entertainment, artwork and handcraft, aesthetics, décor, and design—that is, distinctions of all kinds that Dewey rightly rejects when he traces the experience of art back to a general basis of aesthetic behavior.[31]

Rather, the separated spaces of art correspond to what Rorty speaks of as the self-image of free individuals: the poetic activity of imagining a vocabulary of how to describe the world with which free persons eccentrically brings themselves to bear on the community. What is decisive for Rorty is that while these poetic imaginings of idiosyncratic languages do define the goal of liberal politics—namely, just to ensure the freedom to unfold the self—they do not motivate it. Like religion, these language games are strictly relegated to the private sphere and strictly separated from those descriptions and redescriptions that relate to a commonly shared reality in their forming and reforming. This distinction between self-image and community image is as irrelevant for Rancière as the strict separation of the spaces of art from those of everyday social reality is for Rorty.

Rorty also develops—much as Rancière—a highly peculiar way of reading the Romantic utopia of art. He speaks of the "liberal utopia" of a "poeticized culture,"[32] in which the question of what is true, good, and real has entirely become a question of pluralistically competing redescriptions of a commonly shared reality. Such a community would always be perceivable to its members as a reality that is made, which is to say, poetically produced, in such descriptions and redescriptions. It is politically defined only through the goal of creating and ensuring the freedom of each one of

its citizens. Which ultimately means nothing more than the possibility of being able bring oneself to bear in just this way: by acquiring an eccentric vocabulary, new metaphors for describing the world, with which a person can bring him or herself to bear. Freedom here is thus realized to the degree to which nothing other than one's own poetic capability and the privacy of fellow citizens limits the possibility of such descriptions.

The metaphor in which Rorty thinks these relations is that of the republic of free and talented writers. In the plurality of how they write, new realities of the community constantly arise, which are extended and altered in new writings and new associations given to old descriptions. In doing this, they emphasize themselves as an eccentric I, on the one hand, which seeks to distance itself from the we of the community; in order, on the other hand, to extend and intensify cohesive solidarity through the sensibility, raised by writing and reading, for the lives of others, of the unfamiliar, of unfamiliar communities. This metaphor describes all communal living as a matter of poetics. From Rorty's point of view, all questions of community are ultimately those that can be resolved through new descriptions. The "possibility of a liberal utopia, of a postmetaphysical culture" is based on "narratives which connect the present with the past, on the one hand, and with utopian futures, on the other."[33] Politics is solely defined by the goal of facilitating and expanding the freedom of this making.

From this perspective, the appeal to the sense of commonality is sufficient to reconfigure a liberal polity over and over again as a historically contingent, poetically experimental community. This is why Rorty can think this connection without reference to aesthetics.

For Rancière as well as for Rorty, the perception of the world, its truth, and its morality is a question of the shared horizon of a community. It can always be traced back to a certain way of describing and communicating the relationship between the I and the we of a community and their relationship to the world. These relationships are always limiting, necessarily "ethnocentric,"[34] that is, exclusionary. For Rancière, a politics that wishes to expand or alter such limitations can never articulate itself directly, because all communication is already subject to the execution of power, which determines what can be brought to language and what cannot. (A political assumption that Rorty does not share.) Every possibility of poetically redescribing this circumstance is thus restricted and regulated.

That is why art cannot at all refer in a functional way to political goals—for instance as a special way of poetically making new descriptions; rather, its goal is to create possible reference fields of experiences that politics can fall back on in order to articulate itself. The mode of this articulation is dissensus. The "commonly shared sensibility," the "sensory fabric" of a community must itself be the object of dissensus in order to be able to be newly described.

Both art and politics are related to this argument about the aesthetic regulation of a community; both are "defined by the experience of dissensus."[35] Rancière, however, conceives of these relations as a complementary referencing, not as identity. Politics is articulated as a dissensus that calls into question the arrangement of positions and relations that determine which experiences can be articulated as such by the community and which cannot. Art is defined by being able to create eccentric sensory fabrics.[36] And aesthetics is the question of how these two modes of experiencing dissensus are connected.

The Politics of Aesthetics

I would like to delve somewhat more deeply into this question in the following.

Earlier in this text, I already developed the divisions of art that Rancière's concept is based on. Art creates spaces in which positions, functions, and relations of communal life are described in a way that is radically distinct from our everyday lives. It facilitates ways of experiencing that are detached from "a particular experiencing body";[37] it opens the encounter with sensibilities and sensualities that are experienced as mute, locked witnesses of another, unfamiliar community, one that is not in existence.[38]

With this conception of the political, Rancière links up with Foucault's theories of power. For Foucault, the fundamental existential models of experience (madness, illness, transgressing the law, identity, and sexuality) are marked, on the one hand, by the knowledge and forms of creating knowledge (psychiatry, medicine, criminology, sexology, psychology) and, on the other, by the institutionalization of enforcing power (hospital, police, prison, etc.). All fundamental experiences are formed by ways of

knowing and types of power enforcement that set the scope and structure of these experiences on the levels of the economy, society, and culture. From this perspective, the field of the political is defined by the question of how experiences such as those of madness, bodily suffering, crime, or sexual desire and mortality are linked to knowledge and power. It is just this historically contingent structuring of our experiential world that Rancière grasps as a "distribution of the sensible." He understands by this an order that he describes topographically: as the positions, relations, arrangements of bodies that allow each particular political community to speak of their lived reality; while other positions and possible relations, which are already very much in existence, get no location ascribed to them, from which they could be articulated.[39] Unlike Foucault, Rancière makes a distinction between the enforcement of power and actions within such an order and the "acts of political subjectification,"[40] which "newly define what is visible, what can be said, and what subjects are capable of doing so." And these acts of subjectification are always articulated as dissensus from a given "distribution of the sensible."

It is thus precisely the given social possibilities of action from which this understanding of politics sets itself apart; Rancière understands them as enforcements of power (he defines them as "police"), which he distinguished from politics. Politics would always include the execution of dissensus; this is where the "malaise" of an experience is articulated,[41] which lays claim to being perceived: to "participation in a commonly shared sensibility."[42] From this perspective, politics is defined as the possibility of changing the "*dispositifs* of power,"[43] as a permanent refiguration of the community in the mode of dissensus.

Art and politics are related to one another in the articulation of this dissensus, joined by the idea of aesthetics. A dissensus that seeks to be articulated in opposition to the shared sensibility of a community needs the possibility of calling on a common world that is set up in an entirely different way, an entirely different idea of commonality. It is allocated to the possibility that a "polemical community" can be called upon, which is imagined as "against the consensus" of the community.[44] Producing this requirement is the politics of art within the aesthetic regime.

In no way does this mean that art itself directly articulates the disagreement, giving its voice to experiences that have no location from which to

describe them. In the separate spaces of art Rancière sees a necessary pre-
requisite to giving language to the contingency of our world of the senses,
which allows for certain positions and relations while excluding others.[45]
In the spaces of separated sensibilities, art creates the possibility of such
a dissensus without itself articulating it. It creates relations from which
possibilities can emerge to speak from positions that are not provided for
within the structure of sensuality in a given commonly shared world. Ran-
cière calls this the "politics of aesthetics."[46] But art itself cannot make good
on this articulation. Rather, it relates in a complementary way to politics as
the articulation of a dissensus that gives language to what is unspeakable
in the existing sense structures of a community. The acts of subjectification
in which the structure of a commonly shared sensibility is articulated and
set up as a relationship of *I* and *we* positions in the mode of dissensus is
what Rancière calls the "aesthetics of politics." For Rancière, art is a consti-
tutive aspect of the political, composed of two complementary aspects: an
aesthetic of politics, which determines the forms, relations, and position-
ings on which both common sense and the sense of commonality of a com-
monly shared world are based, and a politics of aesthetics that proposes
countermodels, thus creating the conditions for changing this world in
dissensus. In the experience of a sensuality that is fundamentally divorced
from our own, as the "clash of two sensory fabrics,"[47] art creates the possibil-
ities of dissensus in politics: "There is an aesthetics of politics in this sense,
when acts of political subjectification newly define what is visible, what can
be said, and what subjects are capable of doing so. There is a politics of
aesthetics in the sense that new forms of circulating words, exhibiting the
visible, and generating affects define new capabilities that break with the
old configurations."[48] This "politics of aesthetics" is the counterpart to the
politics of dissensus and is in no way identical to it.[49] It creates the condi-
tions to experience the sense world given to us in its historical character as
a "sensory fabric" that is set up, made—to return to Rorty's terminology—a
poetic, experimental configuration of community that stands in the open
temporal horizon of history.

 The politics of aesthetics is thus is no way fulfilled in the politics of
individual artists; rather, as the historical constellation of the relation-
ship between art and politics, it is antecedent to these politics; in no way
can it be placed into the work as a political intention, but consists in the

(incalculable because historical) effect of a certain historical shape of the mutual relationship between poetics/art and politics.

The forms of aesthetic experience do indeed create a "new landscape of the visible, new forms of individualities and of connections, different rhythms of perception. . . . They do not do this, [however], in the specific manner of political action that produces a *we*, the forms of collective declaration." In the separated spaces of new sensualities, the "ways of experiencing without a particular experiencing body," historical conditions of a politics arise that can relate in dissensus to shared sensibility as contingent, politically established reality. "But there is no principle of a particular cohesion between these micropolitics and new descriptions of experience [of the politics of aesthetics] and the formation of collectives for political statements."[50]

The Politics of Cinematographic Realism

The politics of aesthetics is thus in no way a rhetorical formula aimed at politicizing art or determining the sociopolitical function of artistic practice. Rather, it designates a specific relation of art and politics, which Rancière considers fundamental for the aesthetic thinking of modernity.

From this perspective, art itself designates a specific historical formation of the political, which can be divided into two mutually related fields of activity: an aesthetics of politics and a politics of aesthetics.[51] Situated in the tradition of Western thought, these are historical formations of a specific correlation between poetics and politics that has accompanied the idea of democracy from the very beginning.

Poetics designates the logics and methods of such activities, artistic practices, texts, and works, which confront the relation between each historico-culturally determined configuration of community and the possibility of quite different configurations.[52]

The history of the cinema is the history of such poetics. It has allowed for spaces to arise in which these confrontations can be effected time and again. Spaces from which our reality can become visible and describable in ever new perspectives in its contingent relations between perceiving and speaking, sensing and expressing, desiring and acting. It is the history of

the utopia of aesthetics as Vertov regarded it: the history of a seeing, split a thousand mutually penetrating ways, comprised of series of crossing viewpoints and perspectives: series that in turn penetrate and reflect one another, spanned out in the triangle between camera, spectator, and projector. Within this seeing, the position of an *I* in its relation to the *we* of a community can be described; the community's shared world of the senses can be grasped and described from any point as relations of this one particular world. They can always be imagined and described quite differently in any given case.

This is why cinematographic communication—as Vertov formulated it—is always an experiment. It is achieved in images in which aesthetic sensation must be shared in order to be conveyed at all. For its object cannot be detached from the aesthetic experience in the form of arguments and information. What is introduced as a result is merely a sense of communality—a *sensus communis* in the sense already described. Kant defined the term *common sense* as a feeling and associated this feeling with the possibility of aesthetic judgment. Here, however, what is conveyed through common sense is not, as in the Kantian beautiful, the universality of the human community, but the experience of particularity of any community, the experience of politics.

The history of the cinema has produced spaces in which our world is visible as the world of completely different communities. They are proposals for a communal life that is absolutely not our own, but that is represented in forms of expression that arise directly from the reality of our own lifeworld. Stanley Cavell has attempted to grasp this paradox with the term "automatic world projections":[53] images that are indeed presented as perceptions of the world corresponding to what we are used to, but that propose arrangements of bodies and spaces that are radically separate from the world of our everyday experience. In the history of cinema, it is "realism" that stands for this paradox. However convoluted the term *realism* might be, it forms the hinge that makes it possible to relate the various figurations of how politics and poetics interact with one another. In this sense, the present book represents the attempt to sketch out the main features of the politics of cinematographic realism by comparing and analyzing a handful of case studies.

In the following chapters, then, I will refer to a cinema that, much like the political community the films belong to, represents a historical form

of appearance. I understand this cinema as a particular media practice, let's say of Western culture, that developed in the twentieth century as the dominant aesthetic practice, in order to appear, at the end of the century, in a process of transformation, the end point of which can really not yet be seen today.

Vertov's experiment on film communication can be found today on You-Tube. The hundred thousand clicks for *Čelovek S Kinoapparatom* may be taken as evidence that the cinematographic image—much like the medium of writing—designates more a modality of thinking that, while discovered by the technical medium, is not defined and limited by it. And the history of cinema would then be only the beginning of a second alphabetization, in which we will learn to produce and to communicate new links between perceiving, sensing, thinking, and speaking in moving images. From this perspective, what appears in cinematographic realism is a change in the modes of thinking and communication that has only been achieved to a very small degree in contemporary thought. My questions are then aimed at a cinema that we can indeed get an overview of as the history of a cultural practice, but whose future as a form of communication is still unpredictable.

As I have already stressed, the films discussed are certainly chosen quite at random, and their representative value could be contested. The arrangement I have chosen therefore does not claim to represent the entire field of the politics of aesthetics in Western postwar cinema. Rather, I would like to use the individual cases to outline a perspective that spotlights how the possibility of politics has virulently remained an insistent problem in this cinema. That question generates a conspicuous diversity of answers, theorems about a kind of thinking, represented by the films themselves.

2

BEFORE THE WAR

The Avant-garde, Film, and the Utopia of Art

Eisenstein's Theory of the Moving Image

There is a misunderstanding that marks the reception of Eisenstein to this day, namely, the idea that dialectical montage, with its principles of opposition and conflict, is essentially a matter of what the images concretely represent. What is commonly called "intellectual" or "abstract" montage often means nothing more than interlinking different visual contents according to their symbolic meaning.[1] Eisenstein's concept of montage then appears to be a kind of visual language that serves to convey various kinds of worldviews (*Weltanschauungen*). This idea has little to do with the aesthetic project, but a great deal to do with the ideological project that Eisenstein explicitly linked to his work. In light of this ideological project—the mobilization of masses of spectators in the service of the socialist revolution—Eisenstein seems in fact to have proposed film as the instrumental language of propaganda and political agitation.

On the other hand, there is hardly another filmmaker who so radically understood every problem as an aesthetic problem of form and who developed them in analogy to the other arts (music, painting, drawing, theater). If we take our cue from these wide-ranging reflections, what opens up is an aesthetic program that takes neither its goal nor its justification from any ideological function. Eisenstein developed a concept of cinematic visuality in which the specific "way of thinking in art" seems, in fact, to be realized. He proposes the cinema itself as a place where the utopia of art can be

fulfilled as political practice; he proposes film as the "thinking of images,"[2] which "realizes the identity of a sensing mode of thought and a thinking mode of the sensory material."[3] Central to this mode for Eisenstein is a concept of the moving image that joins the affective and the cognitive, the energetic and the material processes of exchange in society.[4]

The idea that cinema is primarily about movement has been a platitude since the early years of the avant-garde. The insight that this movement refers in a particular way to the affects of the spectator has also always become part of the common understanding of cinema. And even the connection between the two, between motion and emotion, is implicit in the idea of the cinema as a feeling machine, which found its first theoretical configuration in just this discursive formation. It is the minimal consensus in the avant-garde's understanding of the new art, which Eisenstein could draw on without much trouble.[5] And still, within every single one of these obvious elements—movement, emotion, and the connection of the two in the cinematographic image—lies an intricate theoretical problem, which itself affected and still does affect the understanding of movement.

The Space of Narrative Action and the Space of the Image

When we speak about movement in film, what we initially mean is movement in a given space: people going from one position in space to another, crossing landscapes and cities in trains, cars, and airplanes or on horseback; what we mean is the movement of trees in the wind, the raging sea, the rain, and the drifting of snow. These almost naturally objective movements—like smoke, steam, or fog, flowing sheer curtains, and abrupt or gradual shifts in lighting—play a significant role in the range of forms by which images are presented in the cinema.

But let's leave aside for the moment all artistic differentiation in terms of form and keep to the specific sensual persuasive evidence of film. These movements then describe the levels in which the film image signifies a representation of objects, things, and people in a space that corresponds exactly to our everyday world of perception. Movement here means the displacement of the positions of moving subjects and movable objects within a given space.

Most concepts of film analysis—be they semiotic, text theoretical, or cognitive—implicitly assume the condition of a previously established space and the movements carried out within it. Under this assumption, the cinematographic image is strictly limited to the realm of our everyday perception. Both necessarily take for granted a space antecedent to any movement that can be grasped by the senses.

This a priori given space can be understood as a first dimension of cinematographic visual space. But this fact should not be equated—as it often is—with the idea of illustration and realistic reproduction. Perhaps we could speak instead, along with Stanley Cavell, of "automatic world projections": of images that may indeed be presented as habitual perceptions of the world, but that represent something that in no way signifies any particular place in our everyday world?[6]

Movement here means the displacement of objects and of the actions of subjects within an a priori, given space. This movement takes on an intentional direction, a sense in the logic of the fictional activity of the protagonists (who are often compelled, inhibited, or hunted in cinema). Therefore, in light of this first dimension of film, I will speak of the "space of narrative action."

For Eisenstein, this level of the cinematic movement image merely forms the starting point, the material of the art of montage, but by no means its goal. From his perspective the space of narrative action signifies the given framing, the boundaries of the consciousness of everyday perception. This framing is an expression of a specific historical constellation, specific relations of power and domination. But film art begins by going beyond this preestablished framing of our sensory world, organizing "the collision between different cinematic measures of movement and vibration."[7] The film image as a space of narrative action would itself not yet be a movement image; instead it includes within itself the movement that is dissolved, that is to be gained in the spectrum of its different dimensions.

In fact there is a movement that does not at all take place on the level of the space of narrative action, but lies in the form of representation itself. This is the movement of editing in a somewhat broader sense: on the one hand, choosing and setting a cut, the framing, on the other, the change made by this cut, be it discontinuous editing and montage, be it

the continual motion of the camera, of the flow of reframing. In both—in framing, in montage—one and the same movement is realized, which beforehand had no counterpart on the level of the space of narrative action. It appears to lie at the level of the act of representing and of the form of the media. In framing and reframing, in the sequence shot, editing, and montage, a rhythmic pattern of movement is formed, and this signifies a dimension that is specific to representation. For Eisenstein, *this* constitutes the first dimension of the cinematographic image.

Space here is thus no longer the a priori given space of ordinary perception. Instead, the very spatial coordinates of our perception represent one element of the composition of movement and are drawn into the cinematographic movement image. We can understand Erwin Panofsky's famous citation in this sense when he speaks of the "dynamization of space" and the "spatialization of time."[8]

With regard to the camera and montage, space itself is a function of composition, a spatial construct, an effect of the figuration of movement. As such, it seeks to be perceived in its compositionality as something represented, that is, to be referred back to intention, meaningful structure, and expression.

For Eisenstein, this is where the art of montage comes in. It detaches the different aspects of movement from their given conditions and arranges them in a new movement image that follows its own law of motion, its own rhythm. Thinking of his colleagues in the Russian school, Eisenstein speaks of "orthodox montage," oriented in its construction to a logic of the dominant. This can be a montage that shows the visual subject as the dominant dimension (corresponding therefore to the conventional understanding of intellectual montage), or one directed at the changing rhythms and the tempo of the movements of objects, a montage oriented to the direction of the movements of visual objects or to the length of the shot.

Based on this concept of the dominant, Eisenstein developed—as one specific element of his montage theory—three fundamental dimensions of movement. Furthermore, it is the categorical differentiation between these three dimensions of movement that forms the basis for the idea of the dialectical construction of opposites. Eisenstein defines montage as a system of conflict formations between the different dimensions of movement

whose spectrum is delineated in the construction of the cinematographic image. It is no coincidence that, in doing so, he continually takes his cue from the model of musical composition; for him, the different dimensions of the movement image are materials for composing a visual experience in time, in the same sense that musical composition structures an acoustic experience in time.

Three Dimensions of the Movement Image

The first dimension of the movement image is characterized by *metric montage*, referring to shot length and frequency of editing. Movement here behaves in much the same way as do beats and the length of notes in musical structures; it is responsible for producing the cinematographic image as a spatial figuration in the first place. It articulates a spatiality that no longer accounts for what is represented, but comes into being as a figuration of this movement. Meter here does not refer to any cognitively discloseable dimension of the image. Rather it joins the pulse-beat of the visual object "with the 'pulse-beat' of the audience 'in unison.'"[9] In the meter the artificial pulse-beat of the cinematographic image is conveyed to the spectator's perceptual apparatus. Precisely here, it forms the basis for a visual space that incorporates both the image on the screen and the perception of the spectator.

The second dimension is characterized by *rhythmic montage*. This is based on arranging different object movements in the image and organizing them rhythmically. This can occur in the individual shots in terms of the proportions of the temporal length of various movements or in terms of the movements as oppositions between various units of shots. These oppositions, in turn, can refer to opposing directions, to various lengths, or to the alternation of different rhythms. Rhythmic montage therefore contains the entire spectrum of what Eisenstein calls orthodox montage. Only that montage whose dominant is oriented toward iconographic motifs is not covered by it. This is for systematic reasons, which I will come back to.

What is crucial for understanding the Eisensteinian model is the formation of oppositions between each of the different dimensions of movement. In this case, this is the opposition between metric and rhythmic montage.

Eisenstein explains this arrangement of oppositions using a passage from his film *Bronenosec Potjomkin* (*The Battleship Potemkin*, USSR, 1925).

> The "Odessa Steps" may serve as a classic example. There the "drumbeat" of the soldiers' feet descending the steps destroys all metrical conventions. It occurs outside the intervals prescribed by the metre and each time it appears in a different shot resolution. The final build-up of tension is produced by switching from the rhythm of the soldiers' tread as they descend the steps to another, new form of movement—the next stage in the intensification of the same action—the pram rolling down the steps. Here the pram works in relation to the feet as a direct staged accelerator. The "descent" of the feet becomes the "rolling down" of the pram.
>
> (117)

Eisenstein emphasizes the dialectical contrast between two different dimensions of movement as the specificity of his model of montage, distinguishing it from the orthodox school of montage.

The third dimension of the cinematographic movement image that Eisenstein names is *tonal montage*. This refers to the timbre and atmosphere, the quality of the light, the rhythm of the graphic patterns, and the intensities of the pictorial construction. Tonal montage sketches out the compositional modulations of the image on the level of light and photographic qualities (image composition, focal distance, degrees of sharpness) as an independent dimension of the movement. There are, as Eisenstein writes, vibrations, "spatially incommensurable transpositions [that] are combined according to their emotional resonances" (118). The change in the value of light, the rhythm of the graphic design, the intensities of the painterly qualities in the visual composition therefore determine a dimension that is specific to the movement image, which we could call "melodically emotional" (120).

The Fourth Dimension: The Time of Cinematographic Perception

Tonal montage organizes constructions of oppositions between units of sound, atmospheres, and intensities. The synthesis, however, in which these formations of conflict are resolved opens up a further dimension of movement. The conflict of intensities (light versus dark, soft contours versus

hard contrasts, calm versus turbulent graphic patterns, etc.) provides for an area of perception that Eisenstein refers to as *overtonal montage.*

In this context he speaks of a primary and secondary dominant. While the primary dominant marks the tonality of the film in its entirety—its major or minor key—the units of the secondary dominant intervene as contrary emotional states, classifying, sharpening, mitigating, leveling, contrasting.

Here, as well, Eisenstein gives an example from *Potemkin:*

> This secondary dominant is realized in the scarcely perceptible ripple on the water, the light bobbing of vessels at anchor, the slowly swirling mist, the seagulls landing slowly on the water. . . . The movements are transpositions of material edited according to their tonal, rather than their spatial-rhythmic, sign. For here the spatially incommensurable transpositions are combined according to their emotional resonances. But the principal indicator for the assembly of the shots remains entirely in the sphere of the combination of shots according to their basic optical light variations (degrees of "obscurity" and "illumination"). And it is in the structure of these variations that the identity with a minor harmony in music is revealed.
>
> (118)

Overtonal montage forms chains of intensities that only become realized as modulations of the process of arousal in the spectator's affective resonances. They achieve this as a specific tonality of perception and sensation, as the spectator's perception and sensation.

Therefore this last dimension of movement cannot be grasped either on the level of the contents of representation or on the level of the form/technique of representation. It appears to us neither in the formal units of the film—however we define them—nor in the represented events as a tangible object. For at no point can this movement be dissociated as an image from the process by which the film takes shape for the spectator as an image in the first place. It is not the screen but the spectator's perception that designates the place where the fourth dimension of movement is realized, where it becomes reality.

Overtonal montage allows the cinematographic image to be grasped as a temporal structure, which, like a piece of music, can only be realized as a whole, always only in the concrete duration of a real act of perception.

It designates that dimension of movement in which the compositional structure is detached from all iconographic, technically material, and symbolic conditions as something utterly new and distinct, as the duration of the spectator's sensation.

This is in no way some confusing formalistic positivism, but an attempt to describe this last dimension of movement, when finally all elements of the film image, whether they belong to the illustrative, symbolic-iconographic, or technical-structural levels (rhythm, dominants, meter), are related to each other in an all-encompassing interconnection. Eisenstein's goal is to make it possible to understand the fourth dimension as the collaborative effect of all levels of opposition in montage and in view of the entirety of the film.

Speaking of *Generalnaja Linija/Staroje I Nowoje* (*The General Line/The Old and the New*, USSR, 1929) he writes:

Thus the thematic *minor* of the harvest is resolved by the thematic *major* of the storm, the rain. (And even the harvest—a traditionally major theme of fertility under the sun's blazing rays—is used to resolve the minor theme and is in addition soaked by the rain.) Here the increase in tension proceeds by internal reinforcement of the resonance of that same dominant chord. The growing *pre-storm* "*oppressiveness*" of the shot. As in the previous example, the tonal dominant—movement as light variation—is here accompanied by a second dominant, a rhythmic one, i.e. movement as transposition. Here it is realized in the growing force of the wind, condensed from air "streams" into the watery "torrents" of rain. (A complete analogy with the soldiers' feet passing to the pram.) In this general structure the role of the rain and wind in quite identical to the link between the rhythmic rocking and the haziness of the lens in the first example. In fact, the *character* of the relationships is the direct opposite. In opposition to the consonance of the first example we have here the reverse. The heavens gathering into a black stillness are contrasted with the strengthening dynamic force of the wind, that grows and condenses from air "streams" to watery "torrents"—the next stage of intensity of the dynamic attack on women's skills and the delayed rye. Here this collision between two tendencies—the intensification of the static and the intensification of the dynamic—provides us with a clear instance of *dissonance* in tonal montage

construction. From the point of view of emotional perception the "harvest" sequence is an example of the *tragic* (active) minor key, as distinct from the *lyrical* (passive) minor like the "port of Odessa" sequence.

(119)

What is brought to light by the overlapping compositional structure of the movement image is a dimension of the film image that cannot be accounted for either as movement in space nor as spatial figurations of movement. It is the time in which the film is revealed to the spectator as a world whose logic, whose sensibility, and whose modes of sensation follow specific laws, categorically different from those of everyday perception; the time in which this logic is revealed and altered in each moment of cinematographic perception as a specific manner of seeing, hearing, sensing the world. The cinematographic image can always only be understood as an image in the time in which it is realized as the perception of a living and present spectator.

The Bond Between the Screen and the Spectator's Body

For Eisenstein, it is highly significant that the transition from the image on the screen to the audience's perception represents nothing more than a further step in the unfolding of a single movement, which is carried out in the cinematographic image in dialectical jumps. "Thus, the transition from the metric to the rhythmic method arose from the emergence of conflict between the rhythmic and tonal principles of the shot. The transition to tonal montage resulted from the conflict between the tonal principle of the shot (the dominant) and the overtonal [the secondary dominant]" (120). In the montage of opposites a continuum of dialectical transformation takes place between the various dimensions of movement, in which the movement *in* the image becomes the internal movement of the audience via the movement *of* the image. For Eisenstein, this continuum is founded in a double equivalency between the psychophysical processes of the spectator-subjects and the movements of the film image. On the one hand, a physiological stimulus reaction is attributed to the spectator-subject in which the rhythmic shaping of the movement image is directly realized as a conflict between impulse and resistance. On the other hand—drawing on a physiology from the art of acting—the spectator is accorded a kind of mimetic

faculty that allows him to perceive the unit of montage in its entirety as an expressive movement and to reproduce it in each case as a specific emotion, as a movement of sensation.

So, on the one hand, Eisenstein imagines the spectator's psychic and cognitive activity as a higher form of neural activity, which ultimately can be positioned at the same level of matter where motor activity is located. In this sense, Eisenstein defines both film and theater as "arts that deliver, because of their formal characteristics, a series of blows to the consciousness and emotions of the audience."[10] From this perspective, montage means the complex interconnecting of various elements of arousal that form a "sum total of its effect" on the spectator.[11] Film composition is a matter of *"influencing this audience in the desired direction* through a series of calculated pressures on its psyche."[12]

But, as much as Eisenstein's concept of montage cannot be reduced to any dialectic of an intellectual chain of associations that serves to convey the given *Weltanschauung*, this concept also cannot be based on a purely physiological schema of impulse reaction. On the other hand, Eisenstein refers to contemporary theories of expression and highlights the affectively organized, mimetic recoding of movement as a movement of expression in the cinematographic process of perception. The spectator detects a figure of expression in the perceived movement figure, which he transforms into an emotion, a movement of sensation, literally realizing it in his own corporality.

Even the "sum total" of the effect of montage as a whole is ultimately realized as expression.[13] This means "the particular 'feeling' of the shot that the shot as a whole produces."[14] From this perspective, the spectator's emotional response itself is a component of the edited aggregate of movement and the montage a coupling of oppositional movements of expression, which incorporates the spectator's specific affective responses.[15] So, on the one hand, the edited movement image sets up a course of physiological arousals and effects that the spectator runs through. On the other hand, this image is the matrix of a process of permanent doubling back in which these effects are recoded as figures of expression and realized as spectator emotion.

In the end, montage refers to the "juxtaposition and accumulation, in the audience's psyche, of associations that the film's purpose requires."[16] It provokes and connects the spectator's reactions and associations on

the level of the cinematographic image; in fact it is not appearances but chains of associations that are joined together, linked up to each spectator with a concrete appearance. Ultimately it is the body, the corporal ego-consciousness of the spectator that is the object of montage construction. As Eisenstein maintains, the basic material of the cinema is the audience.[17]

It is only on the basis of this thinking that the relation of montage to the level of film representation—the concreteness of everyday perception as well as the symbolic register of iconography and pathos—can be grasped more precisely. Cinematic representation bears on the reality, already given outside the film, of the old order of consciousness: the structure of everyday perception, the order of the symbolic, and the old pathos of religion and art. Montage is the (re)arrangement of existing connections between representations, forms of expression, and the spectator's affective judgments. The film image is exercised as a dialectical transformation between three levels: that of tangible, illustrative, objective representation; that of the technical-material reality of the cinematographic image; and, inextricably intertwined with it, that of psychophysical sensation and the spectator's emotions and thinking.

This is indeed something quite different from a montage of abstract visual ideas, which the spectator would then be left to decipher. Instead, in his concept of montage, Eisenstein proposes a type of movement image that is always already conceived in its structure and form as a kind of perceiving and sensing to be carried out, almost like a storyboard of a concretely occurring seeing and hearing. It understands the cinematographic image as a temporal structure that becomes spatial by becoming a specific world of perception within the living, present seeing and hearing of the spectator.

Inasmuch as it encompasses film as an image, seen and heard, thought and sensed in its entirety, the cinematographic visual space includes the spectator's own perceptual sensations as an immanent structure. Referring to this immanence, Eisenstein spoke of the fourth and the fifth dimension of the film image: that of time and of thinking.[18]

The Thinking of Cinema

The bond, however, that connects the image with the bodies, the symbolic structure with the spectator's affects, is movement in its various dimensions.

Between the physiological schema of impulse reactions and the mimetic acts of the perception of expression, montage unfolds the spectrum of these dimensions as a transformation of movement carried out step by step. Ultimately the various dimensions of the movement image describe nothing more than their different aggregate steps: from the prefilm movement, already existent in our everyday perception, through the artificial constructs of metrical units of the frequency or length of the cuts, up to the rhythmic arrangement that becomes sound: a vibration in the spectator's perceptual sensation (sound is only one stage of rhythm, writes Eisenstein [121]); from overtonal montage through the perception of the temporality of the film composition up to a form of thinking that could negotiate contradictory sensations (121). "The gradation [between the crude physiological overtonal sounds and intellectual processes] is here determined by the fact that there is no difference in principle between the motive force of a man rocking to and fro under the influence of primitive metric montage . . . and the intellectual process within it, for the intellectual process is the same oscillation—but in the centers of higher nervous activity" (123). Thinking begins where the "sum total of its effects" is answered by "the ability to reduce . . . perceptions to a new denominator," that is, "to develop within yourself a new *sense*" (115). The spectator's achievement of synthesis, dialectical sublation, consists of developing a new form of thinking that might correspond to the seeing, hearing, and sensing of the film. By the same token, just as the spectator realizes a way of perceiving specific to each film world in his own seeing, he realizes the spatial figurations as a specific way of sensing, as a kind of perceiving that is not his own. Over the course of the film he realizes its sense arrangement as a feeling arising, growing, and capturing him. He realizes it as the figure of a sensation of the world, as a specific physical-sensory being-in-the-world.[19]

The spectators literally produce the ego-form of sensation on their own bodies, which appears on the plane of aesthetic perception as a radical not-I; namely as the profile of emotional change, of alternating levels of intensity, of the conflicting agglomerations of opposites, and of their explosive dissolution. Out of their process of perceptual sensation, the spectators must form a figure of this sensation, the image of a self, which lies beyond their existing self-image.

Ultimately the various dimensions of movement designate steps in the transformation process of the form of consciousness itself. The oppositions of movement in the image are implemented as conflicting impulses on the level of the spectator's economy of affect, entering the level of thinking as an awareness of this emotional conflict: from the stereotyping of everyday perception, the automatized patterns of affect, the symbolic orders of the "old pathos" of religion and art; through the meter of the editing, the montage of rhythms, the modulations of tonal atmospheres, and the alternation of qualities of sensation; up to the figures of expression of a new pathos—from the peripeteia of opposing pitches of emotional processes to the reliefs of a new kind of thinking.

The new pathos in no way refers to new iconographic formulas (the milk machine instead of religious prayer rituals), but instead to the sum total of the montage effects, which the spectator has to convert into the figure of an I-see, I-sense.[20] This "I" certainly does not correspond to the individual spectator. It signifies a kind of sensing and thinking that the mass of cinema audiences shares, a literally communal feeling and thinking: a feeling shared in mass, which in one and the same moment is a thinking of the social and a thinking that is a shared sensation of the self, a view of the social. For Eisenstein, the cinematographic movement image in its various stages and steps of transformation has become a direct component of the affective and intellectual life of the society. For him the cinematographic visual space incorporates both the film and the spectator: an impulse of movement that meets the inert physicality of a mass whose self-consciousness virtually arises like a dialectical jump out of the collision between the surging film impulse and insistent affective reactions.

From this perspective, films are to be understood neither as texts nor as narrative structures, nor as representations of plots, stories, or pictures. Instead, they are aggregates that install, prestructure, and make possible a certain way of perceiving, sensing, and understanding as the spectator's experience. They are to be understood as a priori structures that constitute a specific mode of seeing and hearing, of sensing and thinking. And they stage this perceiving, feeling, and thinking as an aesthetic experience in the space of the cinema. Eisenstein proposed the cinema as a visual space in which the linking of the symbolic registers of cultural interpretations of

the world with the affectivity tied to individual corporality becomes the object of this process in the most direct way.

This is why Eisenstein sought to distinguish his theory of montage from the formalist models of the "orthodox" school. These remained at the level of the form of film, the represented movement, the icono- graphic motifs, and the mechanical-technical movement of the appara- tus. Dialectical montage, however, differentiates the various dimensions of movement in their opposing constructions in order finally to liberate a movement that is a direct innervation in the life of society, a direct social metabolic process.

A New Iconicity: New Objectivity and Film

He had a photographer's attitude, asserted Siegfried Kracauer looking back at director G. W. Pabst. His film *Die Freudlose Gasse* (Joyless Street, D 1925) is generally considered the prototype of a realistic style associated with the term *New Objectivity* (*Neue Sachlichkeit*). In film history this term is used to distinguish a period of Weimar cinema coinciding with the economic stabilization of the years 1924 to 1929, in contrast to the expressionist direc- tion of the first years of the republic. Rather than "symbolically meaningful compositions," the "arrangement of real raw material" now defined the aes- thetic process; rather than being about expression, it was about the reality of social circumstances.[21]

The *objective fact*, the *veristic facticity*, the *image of the thing itself*—using such formulas, New Objectivity was initially presented as an aesthetic program dedicated to reportage and documenting the neutral observa- tion of social reality. Therefore, although it applies to every area of art, it is an artistic direction with an aesthetic process that reveals a deep affin- ity with the medium of film. This affinity found its most succinct expres- sion in the concept of the so-called cross-section film (*Querschnittfilm*). The travels of a banknote, hurrying from hand to hand (*Die Abenteur Eines Zehnmarkscheins*, 1926), or the rhythmic arrangement of human gestures, mechanical processes, of cars, buses, and trains along with crowds of peo- ple into a visual symphony (*Berlin. Die Symphonie der Großstadt*, 1927) are

considered the paradigms of the poetics of the New Objectivity. Film theo-
rist Béla Balázs called them "reality films" and writes concerning Wilfried
Basse's *Markt am Wittenbergplatz* (1929):

> Here we see nothing but trivial objects: markets stalls in the process of
> construction, baskets filled with fruit, people buying, people selling, and
> flowers and animals, and goods and rubbish, all of this. And yet the won-
> derment of the joyous recognition that this is exactly how things are can-
> not be reproduced by even the most miraculous of magic tricks! None of
> this has meaning. It offers neither a particular novel insight nor anything of
> topical interest nor a specific lyrical mood. We simply enjoy our fill of what
> our eye encompasses. The objects are simply there and the sensuous plea-
> sure we take in sheer existence is intensified to the point of intoxication. . . .
> This marketplace, then, is "a purely optical experience."[22]

The attempt to represent the reality of everyday life in a flowing cross-
section image brought forth a kind of cinematographic iconicity that is a
prime example of how New Objectivity understood art. This image seems
to be able to expand, without any subjective element, into "the thing itself":
"The things are simply there . . . ": Ultimately, however, the formula may
not be able to live up to the phenomenon.

New Objectivity was a catchword used on all sides during the twen-
ties and can signify an aesthetic program as much as a political stance, an
existential attitude or merely a fashionable label. It indicates the emphatic
affirmation of urban modernity as much as it does the sober calculation
of pragmatic rationality, the socially critical positions of leftist intellectu-
als as much as the heroic disillusionment of right-wing cultural pessimists.
Research on the Weimar period today therefore uses the term *New Objec-
tivity* to refer to a disposition in the history of mentalities in Weimar cul-
ture; its sees its art-theoretical, philosophical, and literary credentials as
documents of a "cool conduct" or as the sign of an intellectualism of crisis,
marked by the philosophy of life.[23]

The term *New Objectivity* only seems to gain consistency in the history
of styles when it takes on the critical distanciation exemplified in Kracauer's
position cited previously. Kracauer sums up the assessment that the left-
ist intelligentsia had of the New Objectivity toward the end of the Weimar

Republic in light of the ensuing political catastrophe: a fatal political-ideological neutrality underlying the aesthetic interest in the "casual configurations of real life,"[24] the "attitude of the photographer" reproducing social reality and thereby falling short of the historical truth contained within it. The motifs in terms of content, as well as the aesthetic processes and the poetic program, are all equally read as the expression of ideological consciousness. Particularly in literary studies, this assessment has continued into the present day.[25]

In film history, New Objectivity has been classified in various ways depending on which perspective has been taken. If the subject is foregrounded, it is the films in which the hustle and bustle of big cities, the streets, the mechanized world is thematized; if one starts from narrative style, it is then pseudo-documentary modes of narration with an emphatically antisentimental attitude—from *Geheimnisse Einer Seele* (1926) to *Menschen Am Sonntag* (1930). If one emphasizes the formal composition, then the curve stretches to include Walter Ruttmann's montage films, the architectural phantasmagorias of someone like Fritz Lang, and even G. W. Pabst's "invisible cut." What all of these have in common is that they oppose the construction of movement, space, or photographic objectivity to the expressive atmosphere of early Weimar cinema.

If we assume this very formal commonality, we can speak of a consistent poetics of New Objectivity; this is at odds, at any rate, with current political trends and ideological categorizations. Namely, if we observe these films in the context of the aesthetic avant-garde of the first third of the twentieth century, a certain understanding of art becomes clear, one that seems much closer to the formalist tendencies of modernity than would appear at first glance.[26]

Construction Instead of Illustration

This context is quite clear in the visual arts. Here it is evident that the "new realism" is in no way a return to any nineteenth-century ideal of representational illustration; rather it presumes a new understanding of the image, to be placed at the same level as the cubist or expressionist formal world. Gustav Friedrich Hartlaub, whose 1925 exhibition, "New Objectivity: German Painting Since Expressionism," coined the term, already emphasized

this connection in his commentary on the exhibition, where we read: "We shall soon see that the germ of the new art was already contained in the old, and that a great deal of the visionary fantasticism of the older art has been retained to the present day in 'verism' itself."[27] At the height of classical modernity, New Objectivity developed the idea of the objective as a specific form of aesthetic abstraction, which it opposed to expression: instead of subjectively distorting it, it takes the objectivity of perception as a strict formal standard, which can be extended and made absolute.[28]

If we understand objectivity in this sense as a formalist construction, then it becomes clear that completely different aesthetic as well as ideological intentions can be included in this understanding of "New Objectivity." The spectrum has in turn been characterized by Hartlaub in political terms:

> I can distinguish a right and a left wing here. The former, conservative to the point of classicism in its emphasis on timeless values, seeks now, after the experience of so much extremity and chaos, to sanctify everything sound and healthy, the bodily-sculptural reality that is faithfully drawn from nature, perhaps enhancing the earthier and more ample dimension. . . . The left wing on the other hand, stridently contemporary, evincing far less faith in art, spawned rather by the very denial of art, seeks with primitivist exactitude and obsessive self-exposure to unveil the reality of chaos as the true countenance of our time.[29]

So on the one side there is verism. It produces objectivity by disassembling manifestations of the everyday world into innumerable isolated details in order to achieve an anatomical description of the social; classicism, on the other hand, carries out its aesthetic reduction of everyday forms of perception in order to relate the social to an original world of forms, which is vouched for by the history of art. The former understands the image as an instrument with which "the objectivity from the world of actual facts" can be seized and can position it against ordinary consciousness "in its tempo, its degree of heat";[30] the other sees it as an artistic aggregate that strips everyday objectivity of its seemingly natural evidence in order to reveal a form that could qualify as timeless.

This merely designates the poles between which the new objective representation can move in various amalgamations; even the aggressive

verism of an Otto Dix "academically" falls back on the iconography and pathos from art history, for instance that of medieval painting.[31] What all the variations have in common, however, is an analytical view of everyday reality, which allows social life to congeal in its superficial appearances. In effect, the aesthetic operations that take the everyday out of context and transport it into another system of relations all produce the impression of hyperreality.

The word of visionary fantasticism is directed to this effect; this is what Franz Roh is referring to when he speaks of magical realism in his book on postexpressionist art (1925), which appeared in the same year as the exhibition.[32] He also sees in "new objective verism," in the "ideal realism," as well as in "new classicism" only one part of the movement whose common thread is a new understanding of visual objectivity, which Roh associates with the term *magical*.[33] Taking off from this idea, the art historian Alfred Neumeyer finally makes the connection to surrealism.

"Forms of Seeing Outside the Real"

Already in 1927, Neumeyer had succinctly analyzed the compositional technical foundations of the New Objectivity.[34] He describes them as a multistage process of abstraction. On the one hand, things are isolated in their individuality, that is, they are disconnected from the context of their everyday perception and their atmospheric factors; on the other, they are sealed off from the artist's interpretations, intentions, and assessments; finally, they are deprived of precisely that element in representation that modern painting was so proficient at, namely the illusion of movement. Neumeyer compares this threefold abstraction with the effect of photography: painting simulates the mechanical accident of a failed snapshot, which releases the objective details from the atmospheric context and—due to the lack of composition that would compensate for this—makes them appear as if congealed.

Above all, he sees a decisive effectivity based in the breakup of the illusion of temporal continuity, one that then makes it possible to compare the new objective realism with surrealism:

> While every good photograph may reproduce the transitory, the transition of movement into a momentary position of rest, or of this position of

rest into movement, the bad photograph, as we see in peripheral photographers with a mixture of horror and amusement, feigns an immobility in time and therefore timelessness itself. Bodies and faces coagulate as if under the hypnotic effect of the objective. . . . It is a similar matter in the manner of representation of the most recent painting. Coming from an impulse for isolation, the wish to encircle the object as tightly as possible, it seeks to eliminate the moment of the temporal. What we generally experience as "surrealist" in such pictures, as frozen reality, is the conservation of the moment in time in the faces of those represented or in the grouping of still lives.[35]

Countless other similar descriptions of representational technique could be mentioned here, from all areas of art: the artist "crystallizes the object, pulled microscopically close out of the vague flow," he "breaks it apart like a compound from the natural sciences," "freezes it" and assembles the elements gained from this into a newly constructed unit.[36] This construct is the image itself—or more precisely, it is the unit of visual space.

This process can be seen quite clearly in the portraits of New Objectivity. The visual principle erases every semblance of (e)motion and therefore the foundation of the ideal of classical portraiture, the illusion of a living, personal expression. Think of the flat surface of Christian Schad's faces, which seal the type like an anatomical specimen in a kind of mechanical perfection, or think of Otto Dix's portraits, which amplify physiognomic details in their disparate multiplicity and, rather than relating them in the expression of their inner sensation, amasses them in an aggressive visibility of the corporal, which seeks to attract the observing gaze. What remains are physiognomic data, related in the most various ways to a constructivist unity: the face then becoming a dead thing.[37] Instead of the image of an inner sensation, what appears is the construction of a visual space that refers the visible to a quasi-technical perceptual mechanics.

In terms of the techniques of construction, the process of objective abstraction assumes that art is no longer oriented to an illustrative spatial model, but that it considers space itself as an object to be constructed; a variable dimension of what is represented, only established with each concrete spatial configuration. In order to characterize such processes of spatial construction in the painting of the New Objectivity, Neumeyer once

again makes a comparison to optical tools. He explains the "distant view" as the reverse view through a pair of opera glasses: a "dream-like form of seeing outside the real" in which the "reach of the depths goes far beyond the real," while the "sharpness of the visual image" remains constant. Here we find—looking more carefully—the depth of focus described as a painterly visual form.

In order to explain the second building block, he refers to the well-known comparison to the microscope, the "close view" of details that is no less outside the real: "Seen from the immediate vicinity, the discolorations of the object by light and air retreat in favor of its plastic qualities and the inherent local color, its relationality to other objects disappears, as does its integration in the world of the transitory, and finally even the domination of reigning formal centers disappears in favor of a uniform, homogenous coexistence."[38] The construction of space in the painting of New Objectivity breaks the homogeneous space of ordinary perception into a certain number of divergent close and distant views in order to interconnect them or to insert them into an overlapping distant view. The space thus created does not represent any standardized way of viewing, nor any "pure category of space"; neither does it imitate any "natural space" or follow any obligatory "rule of the art of spatial construction."[39] The perception of space itself has become a "new object," a thing that is broken up into pseudotechnical installations of views (microscopic views, snapshots, and reversed opera glasses) in order to provide the elements of a pure construct. The result of this is an artificial space that only exists through the picture and as a picture: a combinatorics of spatial perspectives, stances, and gestures, which can borrow from the visuality of technical apparatuses as well as from the rhetoric of the history of painting, an aggregate of perception assembled from heterogeneous views.

It can be justly claimed that the concrete form of appearance of this visual space is what constitutes the content of the image. It has literally become a "new objectivity." Nowhere more clearly than in the logic of spatial construction, the representational ideal of the New Objectivity turns out to be an aesthetic formalism, shunning the mimetic model. The image, in its factual reality as an aesthetic object, has become the medium of non-human perception. Only on the basis of this understanding of the image can we then ask what realism might mean for the New Objectivity.

A Nonhuman Eye of Art

With regard to the political left one might speak of an alienating process of representation, whereas in view of the right it would be a romanticizing one. Ultimately, however, the effect sought by the images themselves is marked by a deeper ambivalence. The representational ideal of the New Objectivity is not only infinitely ambiguous in political terms but also in its aesthetic effect.[40] Indeed, because of this ambiguity, the registering gaze of the camera lens and the visuality of the film have become the paradigm for the "new objectivity."

In the classicist as well as the veristic variant, in the fantastic as well as the analytical one, we can recognize an extended objectivity that has long become familiar through the technical aspects of the forms of perception in film and photography. (Neumeyer's comparisons are only one example among many, of which Benjamin's oft-cited thesis on the optical unconscious is the best known.) But shouldn't this new visual concept have had a reciprocal effect on the aesthetics of Weimar cinema? And shouldn't this be the case not only for the cross-section film, the formal experiments of Ruttmann, Viking Eggeling, and Hans Richter, but also for the so-called Weimar auteur film? As is well known, film criticism at the time spoke of "studio constructivism."[41] Fritz Lang's architectural visual designs can be linked to this as much as can Murnau's image construction, which is more indebted to painting. And G. W. Pabst's melodramas show a formal constructivism in the formation of space and the arrangement of movement that is thoroughly comparable in its abstraction with the "light-dark" phantasms of "expressionist cinema."

Siegfried Kracauer's critique of the "photographer's attitude" refers to this constructivism. He argues against the idea that one could encounter social reality through any mechanized manner of seeing. "Hidden within its enthusiasm for the immediate reality" is Weimar culture's notorious inclination to the fantastic and the irrational.[42]

Kracauer worked out these thoughts in a 1927—that is, the highpoint of the New Objectivity—essay on photography.[43] He thematizes the aesthetic functions of the photograph and sounds out the character of its objectivity: journalistic mass photography dissolves the relation of the tangible world into an endless sequence of random images; the "barren self-presentation

of spatial and temporal elements" destroys the consciousness of a world of sense.[44] Ultimately, the photographic image is accused of ideological ambiguity. As such, photography becomes an index of a world in which the possibility of historical truth and identity gets lost. In making this diagnosis, Kracauer precisely describes how the art of the New Objectivity calculated its aesthetic effect; while at the same time—and this becomes clear once he starts looking back at the film of the New Objectivity—he skips over a significant factor: "his [Pabst's] insistence upon cutting results from his keen concern with given reality. He utilizes *tiny pictorial particles* to capture the slightest impressions, and he fuses these particles into a finespun texture to mirror reality as a *continuity*" (my emphasis).[45] Montage in Pabst, however, is in no way attempting to mirror reality. Rather, it represents a construction of moving images that has nothing in common with the principle of spatial continuity, which would later so mark classical narrative cinema.[46] It follows an aesthetic program that Neumeyer, at the end of his analysis as the logic of the New Objectivity, summarizes as follows: with these artists it is obvious that the "belief in the reality of the world of objects has been shattered. . . . The paradoxical situation has arisen where painting gives itself over to a cult of the object without possessing any reality or any consciousness of reality."[47]

The fragmenting function of the cut and the empty fixation on detail of the photographic gaze are responsible for a mechanized form of perception that is taken as the model for a nonhuman eye of art. Seen in this way, the "barren self-presentation of spatial and temporal elements" of the photographic image would describe the ideal of a kind of aesthetic positivism of the senses,[48] which can initially only be represented as destructive and negating.

To that degree, the New Objectivity refers less to a period of the history of style in Weimar cinema than to its aesthetic disposition—in the understanding of the image sketched out here. In its aesthetically advanced parts, the new medium's reflexive exploration of visuality stands in the foreground as a new objectivity—regardless of whether one is using this style or the other. Indeed, precisely because of this, Weimar cinema, all in all, partook in the fundamental change of aesthetic consciousness, such as was articulated in the aesthetic avant-gardes from Futurism to the "New Objectivity." In order to clarify this thesis, we must take a look at the phantasmatic dimension of verism; for this was the dimension where the ideological descriptions of function were directed at the new visuality.

"The Image Must Be Barbarism"

When, a few years before Hartlaub's exhibition, those around the Dadaists and Futurists were speaking of a "return to objectivity,"[49] of a "new naturalism,"[50] the destructive function clearly takes the foreground. "Dada: this is consummately effective malice, alongside exact photography the only justifiably visual form of communication," reads a manifesto from April 12, 1918.[51]

The comprehensive ideological suspicion is no longer only directed against the traditional self-conception of the bourgeois individual, but against "natural" perception itself. Correspondingly, there was a demand for an art that could manage to reduce the world to the photographable. It should refuse any subjective excess, any deepening into the spiritual and metaphysical, and instead should develop cinematic processes:

> Dada is the reaction to all these attempts at disavowing the factual, which has been the driving force of impressionists, expressionists, cubists and even futurists (in that they refused to capitulate to film); however, the Dadaist doesn't try to compete with the camera, or to breathe soul into it (as did the impressionists) by giving the worst lens—the human eye—priority, or (like the expressionists) turn the apparatus round and simply depict the world inside their own bosom. . . . Whereas once inordinate amounts of time, love and exertion were expended on the depiction of a body, a flower, a hat, the shadow cast by a figure, etc., today all we have to do is take a pair of scissors and cut whatever we need out of the paintings, the photographic reproductions of these things.[52]

Photography became a metaphor for a form of perception in which the patterns for interpreting the image of the world as humane, established in psychology, aesthetics, and the everyday world, were shattered.

"The image must be barbarism, insecurity, and pessimism—a view offering delight only to a few": Alfred Döblin, from whom this sentence originates,[53] had already sketched out a poetics of the new novel in 1913, which, in its futuristic emphasis, can already be recognized as the program of the "new naturalism": "We don't narrate, we build. . . . The façade of the novel can be made of nothing other than stone or steel, electrically flashing or dark, it is silent. The composition pulsates in the progression, just as music

does between the notes that are formed. . . . 'I am not I,' but instead the street, the lamp, this and that event, nothing more."[54] Psychologism, eroticism must be swept away; doing away with the self, divesting the author, depersonaliza-tion . . . away with human beings! Power to kinetic fantasy and to the aware-ness of unbelievable, real contours! Fantasies of facts.[55]

Döblin also attempts, in order to bring consciousness to the level of the technologized world, to commit art to a positivism of the perceptual senses, which have their model in the photographic objective. "One can find certain things about cities weak or dangerous, one can take sides in the clash of the drives at work in cities. But one cannot reject or even evaluate the cities themselves, the combustion points of social drives. Natural forces of this type and their expressions can only be observed."[56] Art should repro-duce reality in its condition as "dehumanized reality" instead of interpret-ing it psychologically or ideologically; it should represent it to the reader in its mere facticity. For the independent reader, what is represented may produce a sense that does not get its meaning from the author's intentions.

Döblin is guided by the idea of a fundamental nonsimultaneity of spiri-tual and technological intelligence. The scope of experience and the self-image of bourgeois individuality solidified into anachronism in the face of the technologized life of the big city, and they blocked the development of an appropriate consciousness, a new spirituality. The first goal of aesthetic strategies is therefore to come to a sober assessment of the factual reality of life: "In the new epoch, other systems and other parts of the brain will be physiologically active. The exhausted old parts will recuperate. Muscles, eyes, ears, and their nervous-psychic projection now take the foreground. We want to move on, to see and to hear."[57] The politics of aesthetic destruc-tion can only be understood once we establish its philosophical underpin-nings: for it is in no way exhausted in the celebration of modernity. No matter which gesture is used to affirm the mechanized lifeworld, whether in a cynical or celebratory attitude, an ironic or heroic one, the affirmation of the alienated human being follows the calculations of a negative uto-pianism, which has its roots in the disposition of contemporary thought associated with the philosophy of life. "The barbarism of this period has a double origin: it comes from the incongruity of spirituality and practice, then from the anti-spirituality of the recent technological drive itself."[58] There is an attempt to reach the zero point of a world that has fallen into

crisis, with the idea that this crisis has to be nurtured by all means neces-sary,[59] guided from the hope of finding the beginning of a new civilization at this zero point of spiritless and cultureless modernity.

In Döblin's essays from the tens and twenties, we can trace how the emphasis on modernity in the New Objectivity developed from the (expressionist) pathos of the alienated man. It is the very same rising con-sciousness that sees the dawn of a new epoch in human history, only then to see this expectation take off in the opposite direction. The oppressive consciousness of estrangement of the "era of the natural sciences" would indeed like to turn out to be the mute sign of a still unrecognized new spiri-tuality, of one not yet brought to life.

> There are spiritually important consequences to be drawn from the natu-ralistic period. The natural sciences of today have not yet drawn them and cannot draw them, since everything is still quite at the beginning. There is still a lot of battling with the past to be done. The world cannot be newly experienced on the spur of the moment. . . . We will increasingly encroach on nature in a completely new way, as nature's time has just begun. And this period, which recognizes no god ruling from beyond, will see that the entity that this world is, and which is expressed in it, to a much greater degree than was previously believed when we were still humanists, is glori-ously social and amicable.[60]

The "new spirituality" then—this took the foremost position among the keywords of the New Objectivity—was in no way identical with scientific rationality. It is the utopian formula by which the dehumanized human and his modern barbarism is proclaimed to be a messenger of a new, still unknown life, which cannot be understood according to the old models.

If Döblin calls for an image of barbarism, thereby challenging the com-mitment to the spiritlessness of the contemporary lifeworld, he is follow-ing the calculation of utopian rationalism, which can be traced from Adolf Loos's writings up to the functionalism of the Bauhaus architects, from Bruno Taut's Glass Pavilion letters up to Walter Benjamin's understanding of technology. The turn against the decorative image and ornamental deco-ration is sustained by the expectation that we could get hold of the icons

of a future culture in the facts of current social life (of functional architec-
ture, of technological machines, of the design of consumer products). It is
directed at an objectivity that becomes an index of a new spirituality, but
one that only appears strange in the present. So Döblin's words are thor-
oughly marked by the religious zeal of the atheist:

> The current epoch must be characterized by the feeling of smallness that
> comes from the insight of losing the central position in the world, and from
> the insight into the irrelevance of the individual animal-human being.
> Alongside this, the feeling of freedom and independence that comes from
> the certainty of not living for the beyond, and of having to manage every-
> thing on our own. The impulse toward the most vigorous activity is associ-
> ated with the feeling of freedom growing immediately out of it. After belief
> in the beyond has dwindled, no despair arises at all. It is like this: the starry
> sky above me and the railway tracks below.[61]

This means that art, in its destructive function, should lay open the location
of the origin of this new spirituality.

The Feeling of Beginning

"The image must be barbarism": The formula can also be taken quite lit-
erally. One might think of the amputees that people Otto Dix's first post-
war pictures. These pictures show the opposite of a commiserating, human
gaze. An intermediary text in Brecht's *A Man's a Man* puts this nonhuman
gaze literally into words:

> But Mr. Bertolt Brecht goes on to show
> That you can change a man from head to toe.
> You'll see a man remodeled like a car
> Without incurring the slightest loss or scar.
> You'll see this man by the friendly treatment bested
> Gently but firmly he will be requested
> To run with wolves, however devilish
> And forget about his private fish.

"Brecht is the first German playwright who neither celebrates nor attacks the mechanics of the mechanical age, but takes it as a matter of course, thereby getting beyond it," was Herbert Ihering's commentary on one staging of this play.[62] He called this attitude a "feeling of beginning" in a sense no less effusive than that emphasized by expressionism.

Döblin set the pitch that was then enthusiastically taken up by Joseph Roth and others in the twenties when they sang about modernity in the big city as a poem made of architecture, mechanical movement, and crowds of people.[63] Only a handful, however, brought the dialectic between the affirmation of a dehumanized lifeworld and the utopia of a new spirituality to the point that Herbert Ihering did in his theatrical critiques of the early twenties. Speaking of a performance of Brecht's *In the Jungle of Cities*, he wrote:

> The beauty, the poetry of the "jungle" lies in its poetic conquest of a distant, barbaric, modern fairy tale city. An incomparable colorfulness, a lushly overgrown lasciviousness flourishes among musty, filthy city walls. A tropical heat, an arctic cold alternates over a gigantic, technologically barbaric city. . . . When we later look back at the play by Bert Brecht, we recognize how precisely the feeling of beginning is articulated in it. The feeling for a time poor in experience but rich in culture, for an emotionally slack time fraught with technology. War and revolution meet a kind of humanity so mechanized by civilization that elementary events can no longer be experienced as elementary. The drama could not start up where it left off. It could not deny or wipe out Americanism. But it was necessary to see it not as a refinement, not as stage of development, that is, not to refer it back to the past once again, but to experience it as a new, primitive beginning. The last technical precision of the period could only be artistically potent if one managed to experience it as barbaric. As a primitive time, which would be productive for an emotional beginning.[64]

Ihering would criticize another staging of *In the Jungle of Cities* for having attempted to control the fantastic elements with interpreting references and for having clarified them too much in the direction of emphasizing the "loneliness of human beings." His objection reads: "The technical, the industrial, the mechanical world must first be experienced as fantasy before it can become emotionally potent."[65] Ihering recognizes the feeling of beginning

again in Brecht's early plays, where he discovers modernity as the barbaric primitive period of a coming civilization that does not yet know anything about itself. Ihering unfolds the logic of this aesthetic reduction in his reflections on a new type of actor. He understands the actor's physical capacity for transformation in much the same way he does the stage world that he describes: in his transformational game a fantasy comes into play that does not refer to any psychological expression but to the thing itself, to the actor's body. Admittedly, what he means here is not his real existence, but the phantasmatic potential of his visuality. Particularly by using the example of Werner Krauss, Ihering describes a way of acting whose attraction no longer lies in the representation of a figure, but in physical transformations, in the phantasm of a hyperreal, polymorphous body. This way of acting—one might call it expressionist—functions in Ihering's understanding like the portrait in New Objectivity: the living "expression becomes a mask" in order to become "living and horrifying beyond all naturalness" in this congealed form, allowing a strange, artificial "liveliness" to come into view.[66]

With these reflections, Ihering circles around a commonality between expressionist acting technique and the phantasmic qualities of the New Objectivity, and indeed, this commonality for him is the basis for understanding the cinematographic image. In the liveliness of an artificial body beyond the natural, Ihering sees the originary objectivity of films as given: not only because film—as he writes—"leads [the actor] back to the beginning of his art, to the body"; rather, quite the opposite is also possible, that the acting method described by him makes the specific visuality of the film image apparent. He summarizes the development of cinema in 1920 as follows:

When naturalism reigned, stage and screen could not come together. An art that was measured by probability, by similarity, by proximity to life is doomed to fail before the composed image. The race with reality ended with the victory of the material. Since we did not know the specificity of the motion picture, but had to protect naturalness from getting boring, we invented the crass plot. We wanted to make everyday events sensational and psychologically interesting. But this is exactly what was wrong. Film remained focused on the word (that was left out). The motion picture was mute speech. The fact that film today stands before a new, revolving development is thanks not only to advances in its technology, not only to the

awareness of its conditions. The development only became possible when an art of acting took hold on the stage that was formed out of a renewed feeling of the body, and art of acting that concentrated, organized, and was rhythmically obsessed with itself. . . . Film therefore does not have a future because it advances technologically, but because its claims touch on the painterly, architectural, actorly claims of time. Film exists because the new actor exists.[67]

The transforming body of the actor designates an "objectivity" that for Ihering is the essence of the cinematic. This idea connects him—despite all to the contrary—with the peculiar physiognomy that Béla Balázs asserts for the cinema.

The Utopia of Art: Film

Balázs understood the visuality of the cinematographic image from the side of the perception of the living face, emphatically welcoming the return of a physiognomic way of thinking.

For the man of visual culture is not like a deaf-mute who replaces words with sign language. He does not think in words whose syllables he inscribes in the air with the dots and dashes of the Morse code. His gestures do not signify concepts at all, but are the direct expression of his own nonrational self, and whatever is expressed in his face and his movements arises from a stratum of the soul that can never be brought to the light of day by words. Here the body becomes unmediated spirit—spirit rendered visible, wordless.[68]

At first glance, Balázs seems to be seeking to renew the promise of bourgeois aesthetics with these words, heralding in the cinema a people that would rediscover the lost unity of body and soul. Seen in the way, *Visible Man* is a programmatic title and seamlessly follows on the old idea of the visibility of the soul in physical appearance. Balázs once again sums up the idea of the gestural body and the logic of quiet sensitivity: a silence of the soul that can only be expressed without mediation, that can be shown, but not spoken.

The soul that became body without mediation could be painted and sculpted in its primary manifestation. But since the advent of printing the word has become the principal bridge joining human beings to one another.

The soul has migrated into the word and become crystallized there. The body, however, has been stripped of soul and emptied. . . . The back of a headless Greek torso always reveals whether the lost face was laughing or weeping—we can still see this clearly. Venus's hips smile as expressively as her face. . . . In a culture dominated by words, however, now that the soul has become audible, it has grown almost invisible. This is what the printing press has done.

(10)

In this way, Balázs speaks of human alienation through the abstraction of language, as if wanting to transfer idealistic art philosophy directly to the cinematic image. But even if he mixes conventional ideas of art and a romantic pathos of origin into his reflections, Balázs always remains conscious of the mechanical principle of the cinema and recognizes in the film image an animated, artificial liveliness. In fact, he understands the "visible man" not simply as a precultural existence, not as an originary nature of man, but as a social reality to be conveyed and produced in aesthetics, technology, and media. Balázs also means a future spirituality, which is revealed in the visuality of the cinema:

Now another device is at work, giving culture a new turn towards the visual and the human being a new face. . . . The whole of mankind is now busy relearning the long-forgotten language of gestures and facial expressions. This language is not the substitute for words characteristic of the sign language of the deaf and dumb, but the visual corollary of the human souls immediately made flesh. . . . It is film that will have the ability to raise up and make visible once more human beings who are now buried under mountains of words and concepts. . . . Culture means the penetration of the ordinary material of life by the human spirit, and a visual culture must surely provide us with new and different expressive forms for our daily intercourse with one another. . . . Conscious knowledge turns into instinctive sensibility: it is materialized as culture in the body. The body's expressiveness is always the latest product of a cultural process. This means that [film] . . . represents the future development of culture because it involves the direct transformation of spirit into body.

(9ff)

The "visible man" means the ordinary man, filmed, seen from a photographer's position: a barbarian about whose prospects no one knows.

Balázs clearly perceived the affinity between the realism of the New Objectivity and the cinematographic image. Even if he positions himself as starkly rejecting the destructive impulse in the New Objectivity, he comes very close to its poetics in his attempt to understand the visuality of the cinema as a new form of iconicity. He opposes the imaginary of the cinema, the "inner facts" and the pure expression of the image to the "reality films" of the New Objectivity and the external objectivity of the things represented, but he nonetheless presents this opposition as two poles of the cinematographic image.

Speaking of Basse's *Markt Am Wittenbergplatz*, continuing the passage cited earlier, he writes: "The marketplace, then, is a 'purely optical experience.' Yet it still appears also as an event in a particular time and place. This sense of spatial and temporal specificity invests the objects represented with a reality beyond the image. The effect is of facts that are merely communicated to us in the form of images. Their objective existence is not exhausted by the image, they are not reduced to a pictorial impression" (160). I—n order then to follow up with another example describing the opposite in a flowing transition:

> The wonderful reality films of the Dutchman Joris Ivens, in contrast, no longer set out to communicate realities. They do not point to objects that we might also see for ourselves. What matters in his films is merely the optical impression, not the reality represented. Objects lose their substance here because what the films value is appearance. The image itself is the reality that is experienced. And a reality that is only experienced visually is the substance of the absolute film. The Rain that Ivens shows us is no particular rain, rain that has fallen somewhere or other. No sense of time or space holds these impressions together.
>
> (160)

Released from all "sense of time or space" the image itself is "the reality that we experience and there is nothing behind it, no concrete objective reality beyond the image" (161).

Balázs's reflections on the cross-section film spin a web of observations that make it possible to imagine the oppositions of external and internal facts, of thing and impression, as two sides of one and the same thing. They present the visuality of the cinematic image as a form of abstract objectivity in which the very coordinates of inner and outer have become variable: an image that grasps its object in the modulations of its perceptibility; out of these modulations, subjective impression and outer tangibility only produce the basic forms of a series that is in principle infinite. It is the reality of the cinematographic image itself as a fact that would produce consciousness.

The perspective on the New Objectivity changes then, if we do not immediately take its program as an ideological pronouncement, but as a politics of the aesthetic. The art of the New Objectivity seeks to install an independent view of the world, a way of seeing that the interpretational patterns of human perception are taken from. Neutrality and objectivity, fact and document are quite perplexing designations for a poetic concept that seeks to represent reality in an image where consciousness is still missing. The fact that this art is infinitely ambiguous, not only in its aesthetic effect but also politically, is made clear by a final citation from Balázs's book, *Early Film Theory: Visible Man and the Spirit of Film*: "It [cinematic visuality] contains the first living seeds of the standard white man who will one day emerge as the synthesis of the mix of different races and peoples. The cinematograph is a machine that in its own way will create a living, concrete internationalism: the unique, shared psyche of the white man. . . . And, when man finally becomes visible, he will always be able to recognize himself, despite the gulf between widely differing languages" (14f).

It is the utopia of the aesthetic that Balázs formulates once again as the utopia of film: a kind of perception that is a way of thinking and a way of thinking that is a way of feeling, that is the life of a community without mediation. The Second World War and the experience of fascism and the Holocaust would radically call this utopia into question.

3

AFTER THE WAR

Cinema as the Site of Historical Consciousness

nitially, however, the utopia of art and the utopia of aesthetic thought would seem to be the connecting link that could unify the postwar debate over realism and the program of the aesthetic avant-garde. Both discourses are characterized by a sharp critique of the traditional concept of artistic autonomy. But this critique takes a decisive turn after the Second World War by continuing to incorporate avant-garde poetics, but now turning against the idea of art itself.

The film poetics of the avant-garde combined the idea of a new subjectivity of mass society, beyond bourgeois individuality, with the "cinema" as an aesthetic form of experience. Indeed, with the arrival of cinema, a form of mass culture appeared that diverged sharply from the traditional understanding of artistic autonomy. This constellation—a new mass medium that devalues the foundation of an individualistic understanding of art—seemed to indicate the specific potential of the medium. Cinema could then become a paradigm for a new mass culture, directed at new forms of subjectivity, at the possibility of radically restructuring the physical-sensory horizon of society.

It is precisely this definition of function that was called into question by the film-poetic projects after the Second World War. The experience of National Socialist domination as the unification of a new form of media culture, entertainment industry, and state terror, as well as the use of film during the propaganda battles of the Second World War, discredited the idea of the mass medium.[1] On the

other hand, popular educational programs in the early postwar years relied on the documentary value of film images and photographs of Holocaust victims, corpses, and survivors, which circulated as historical evidence of genocide and war crimes.

Against this backdrop, it is understandable that the primary film aesthetic projects in the postwar period focus on radically reevaluating the history of the still young medium. The two most influential postwar film theory concepts lie completely within this framework: André Bazin's plea for a cinema of transparence, in which the spectator provides the basis for a view of reality that is not predetermined by ideological judgments, and Siegfried Kracauer's ethics of redeeming physical reality. The one approach disparagingly refers to the montage concepts of the avant-garde, which until then had represented the ideal of artistically outstanding film, asserting instead a tradition of cinematic realism; the other denies the validity of any concept of art, whether based on expression, construction, or alienation, in order to oppose it with a—as it was called in theoretical works— media-ontologically positioned telos of film: the affinity of the film image to physical reality.

In terms of this discussion, however, it would be valuable to call attention to a certain circumstance, one that marks something like a blind spot in the debates about the new realism of Western cinema. The renewal of western European cinema was not only articulated through a critique of autonomy in art. Rather, the form of the aesthetic experience in cinema was more or less explicitly tied to Hollywood genre films. Both Bazin and Kracauer developed a concept of realism aimed at a form of subjectless discourse, founded not on any intentionality on the part of an auteur, but on a modality of aesthetic experience proper to the cinematographic image itself. Both see these narrative methods realized in American genre cinema rather than in European art cinema.[2] Bazin's analyses of William Wyler and Orson Welles are widely known, but even Kracauer was oriented, if rather implicitly, on a "realistic narrative method" that he most likely saw realized in Hollywood genre cinema.[3] Even the term *classical Hollywood cinema* stems from this context and is marked by Bazin's reflections on the genre of the Western.

While the critique applied equally to the traditional understanding of art as well as to the avant-garde models of cinema and film, it articulated, at the

same time, an understanding of culture that, in reaction to the experience of the Second World War, saw Hollywood cinema as part of the renewal of Western culture. Popular genre cinema could become emblematic of the idea of a new society founded on egalitarian democracy.

Unlike the avant-garde concepts of montage, which sought to mobilize collective existence, the form of aesthetic experience in the cinema is understood here as the potential of an adequate experience of the world within the modern lifeworld. The cinema audience no longer functions as the representative of a new collective way of existing, but is addressed as what it was from the very beginning: a gathering of anonymous individuals faced, without understanding or being understood, with the complex modes of appearance in modern mass society.[4]

In film history this change in perspective is closely connected with neorealist poetics. In Visconti's *La terra trema* (*The Earth Trembles*, 1948), one of the films that would be taken to spell out the program of neorealism, social forces also appear as overpowering forces of nature. The camera's view, gliding over the sea and the mountains surrounding the port, creates an image of a rising storm that appears more mystifying than realistic.

Visconti's nonprofessional actors in turn present melodramatic miniatures, songs, and little tragic scenes in the streets and squares of their village, as if it had been transformed into the open-air stage of a literally popular spectacle. The camera opposed this untrained amateur spectacle with its own reality, its own staging of the gaze. To the degree that the (social and economic) conflicts come to a head, the landscape becomes the expression of a numinous, incomprehensible violence that the human forms helplessly confront as they scurry over the quay, lost under the gray sky. In the disproportion of the small everyday melodramas and the overpowering shadows of nature, we can see the relation of the characters to social forces, which they confront blindly and incomprehendingly, like tragic heroes meeting their fate—as if the village dwellers were singing and playing their life for the entertainment of the gods, sitting invisibly and unapproachably on their thrones over the mountains.

For the characters, a power is realized in the concrete economic conflict, a power under which they suffer helplessly; for the spectator, the world of the fishers is presented as a universe in which everything becomes a sign of a suffering that is itself incomprehensible: the touching dilettantism of the

acting gestures, the view through doors and windows, the gray on gray of the moving surfaces of water, the camera's gaze gliding over the mountain ridges, the dark threatening clouds. Things, people, nature—all take on an emblematic quality, the meaning of which remains undisclosed.

With regard to this technique of mise-en-scène, Deleuze speaks of a "cinema of the seer" (*cinéma de voyant*), of pure optical and acoustic sensations;[5] it shows a reality lacking the acting subject, therefore also lacking this subject's preexisting sense of a pragmatic interpretation of the world.[6] The visual space of the cinema becomes a place where the "objects and milieus" of social life appear as an "autonomous material reality." Both the spectators and the protagonists must "invest" the material reality of the social, things and people "with their gaze," transforming them into a world of signs "in order for action or passion to be born, erupting in a pre-existing daily life."[7]

The films of neorealism behave—this is also a thesis that Deleuze formulates in light of Visconti—like "'inventories' of a setting," taking stock of the "objects, furniture, tools" that constitute it.[8] The visual space of the cinema is no longer the place where a new subjectivity is formed, no longer the utopia of a historical subject; instead it is the place where real individuals seek to get their bearings in a world where contexts and rules, logic and power relations are uncertain. The cinema is the real place where our everyday world is presented to any random moviegoer as potentially legible, decipherable, and nonetheless unread.

I would next like to discuss this reworking of the utopia of film in more detail by means of two examples: first through some short reflections on Siegfried Kracauer's analysis of the politics of cinema under the sign of fascism. His book *From Caligari to Hitler* represents one of the most influntial examples of a process of writing history that does not pretend to reconstruct, but proposes the genealogy of the present starting from the necessities and needs of that present.[9]

Second, I would like to take up the example of Visconti's historical films in somewhat more detail, examining how much the new realism after the Second World War is bound up with an understanding of historicity that finds its most decisive point of reference in film. Visconti's histories stand in a highly fraught relationship to the canon of neorealist film. Indeed, they are often considered a manneristic or aestheticist reverberation, having little or nothing in common with a politics of the cinema aimed at everyday

social reality. On the contrary, I would like to show how it is precisely in these films that an understanding of the visuality of film as a poetic concept can unfold, an understanding that is paradigmatic of the politics of aesthetics in Western postwar cinema.

Kracauer: The Viewability of the Social

Kracauer's *From Caligari to Hitler: A Psychological History of the German Film* was published in Princeton in 1947. Kracauer wrote the book in English; in fact, after emigrating, the German intellectual only worked in his adopted foreign language.

There is hardly another book that has so fundamentally influenced the discourse of modern film studies. Ever new waves of reception and critical examination of his theses can be read in retrospect as stages in the formation of the discourse of film and media theory. Each station—be it the theories of a genuine film realism or of auteur cinema, be it the turn in cultural studies to text and sign theory or to discourse analysis—always involved a critical rereading of this text. Now it is perhaps not so surprising that a book, written during the war on the question of what social forces led to fascist society, would open up a wide-ranging field of thought. It is also not necessarily surprising that it covers areas well beyond its intended theses and assertions. Not surprising because the book arose equally as part of the social examination of fascism and as part of the cinematographic discourse it analyzes.

Kracauer worked on the *Caligari* book during the entire period of the war. Already during his exile in Paris he had sketched out the project of a psychological history of Weimar cinema. After the German army invaded France in 1940, this project was the justification used by those members of the Institut für Sozialforschung who had immigrated to the U.S. to help him to acquire a visa. Finally, as a fellow at the Rockefeller Foundation, Kracauer began his work on the—as he called it—"Social Biography of Weimar Film." In the famous film department of the Museum of Modern Art in New York he systematically viewed the films, most of which he already knew from his time working as a correspondent and film critic at the *Frankfurter Zeitung*.

The book was thus an act of intervention in those social processes that are its themes—the emigrant seeking to objectify the question of which social forces had determined his fate. And this question is posed right in the center of the visual space of the cinema: Where are these forces visible? In what form are they shown? In what disguises do they come into view?

One can vividly imagine the scene: the reviewer of countless films from Weimar cinema watches every one of them over again in the museum— all the films he had discussed throughout the twenties. And he wonders what he had overlooked back then. He looks for manifestations of the social forces that had banished him, excluded and exiled in this place— the place that itself is like a cavern in time, a bunker in the cultural space of the propaganda battles and entertainment offensives of the cinema of the world war. A place where it was possible to look again a second time: tracing the gestures, stances, and forms of appearance in those collective ambitions that make up the basis of the National Socialists' power. A power millions had to suffer through their bodies, with no chance to see the very social forces that were annihilating them or at the least causing them such distress.[10]

The idea that these forces were already visible in the visual space of the cinema, even before they had manifested themselves in social reality, is the fundamental hypothesis of the whole project. Kracauer writes: "I analyze German films from 1918 to 1933, which provide me with precise information about the dominant psychological dispositions of Germans during that period. The whole project is an attempt to get hold of the decisive psychological processes that were playing out at the time deep below the surfaces of divergent ideologies in Germany."[11] In contrast to the other arts, film more directly reflects—as Kracauer argues in what follows—the mentality of a society. This is for two reasons: on the one hand, film is a collective product and therefore unsuitable as the medium of any single artist's aspirations to individual expression. On the other hand, it appeals to the anonymous crowds and therefore has to address the needs of the masses in order to be received *en masse*.

Kracauer's hypothesis of the mirroring of psychological disposition in film has led to all kinds of discussions, critical repudiations, and reevaluations. In many cases, in fact, it got early film studies on the wrong track and led to certain impasses. In the specific constellation of Western postwar

cinema it paved the way for a highly reductive understanding of realism in film, a realism that in the end dissociated film from its aesthetic relations and its connections to the other arts, reducing it to its ideological subtext as a product of the culture industry.

We can forgo a detailed analysis of these conflicts. For the surface reading of the thesis, that films mirror the psychological dispositions of a society in their representation, misses the theoretical point of Kracauer's work. And this point is the question of social conditions and forces, invisible per se, and their visibility in the cinema. How does physical-sensory suffering, which is, however, necessarily individual, wind up within the spectrum of a socially shared perception of reality?

The Inner Life of Society

Even if today we would no longer share certain of Kracauer's positions, his text marks a fundamental shift in perspective: if we understand the film image here not as a depiction of social reality, but as a medium with which this reality is disclosed as a physical-sensory being-in-the-world. As Kracauer writes: "In the course of their spatial conquests, films of fiction and films of fact alike capture innumerable components of the world they mirror: huge mass displays, casual configurations of human bodies and inanimate objects, and an endless succession of unobtrusive phenomena. . . . Films seem to fulfill an innate mission in ferreting out minutiae."[12] Film grasps a reality—external, physical—that should be clearly distinguished from the everyday recognition and understanding of the social world. Indeed, the theoretical tension of the *Caligari* book is grounded precisely in this distinction. For Kracauer it is never a matter of the mere reproduction of social reality, the way it is represented to our ordinary knowledge and perception, but instead of a reality that continually eludes our everyday consciousness—an external, physical reality that is excluded from the realm of what is visible in the everyday world. The psychic disposition, the "inner life" of the society, also "manifests itself in various elements and conglomerations of external life, especially in those almost imperceptible surface data which form an essential part of screen treatment."[13] These are the configurations of the external reality in which film discloses the specific visibility of the "unseen dynamics of human relations."[14]

Gertrud Koch pointedly summarizes Kracauer's train of thought when she writes: "Because the movement of films can capture space, they also always include—quite independently of whether they are fictional or documentary—'random configurations of human bodies and inanimate objects and an endless series of inconspicuous phenomena.' Only through these 'barely perceptible superficial appearances,' do films become 'keys' to hidden mental processes."[15] What Kracauer brings to light by asking about the "psychological disposition," the "inner life" of society, is the stances and gestures that the characters use to carry out their actions; it is the spaces that these characters occupy, spaces where they come into relation with and separate from each other; it is the architecture that has always marked and determined their stances and gestures.[16]

"Mentality," the fundamental approach of a collective consciousness, as Kracauer sees it, is manifest as an individual corporal being-interwoven-in-the-world, as a specific sensibility of the corporal-physical being-in-society.

Still during the Weimar period, Kracauer wrote about visiting an employment agency.

I visited several employment agencies in Berlin. Not to indulge in the common reporter's pleasure of using a bucket full of holes to scoop things out of life, but to assess what position the unemployed actually have in our society's system. Neither the various commentaries on unemployment statistics nor the corresponding parliamentary debates provide any information on this subject. They are ideologically tinged and adjust reality in one sense or another; while the room of the unemployment agency is itself provided by reality. Every typical room is brought about by typical social conditions that are expressed in it, without the disturbing interference of consciousness. Everything disavowed by consciousness, everything that is otherwise deliberately overlooked, is involved in its construction. The images of the room are the dreams of the society. Wherever the hieroglyph of some image of space is deciphered, there the foundation of social reality is revealed.[17]

Tracing such images of space, dreams of society, and using them to lift social reality into the realm of the visible denotes the aesthetic potential of the cinema. The visual spaces of the cinema open up external reality as a field of the possible experience of social reality. A reality of society,

represented in the stances and gestures of the body, in the spatial configurations of surfaces as well as in the emotional atmospheres, in the modes of perception and modulations of the gaze carried out by the camera's position. It is presented as the experience of reality in the mode of possibility.

A further example of Kracauer's specific way of thinking can be found in the *Caligari* book. There he writes about a scene in *Kameradschaft* (*Comradeship*, G. W. Pabst, 1931):

> With *Comradeship*, Pabst again came into his own. His innate sense of reality strikingly reasserts itself in the washroom episode. An all-pervading spray envelops the naked miners as well as the rows of clothes which hang down from a distant ceiling; it is as if a weird mass of animal carcasses loomed high above the faintly gleaming group of lathered human bodies. Nothing seems staged in this episode; rather, the audience is let into one of the arcana of everyday life. The studio-built mine gives a complete illusion of subterranean rock. Ernö Metzner, who made the settings, remarked that candid shots of a real mining disaster would scarcely have produced a convincing impression of it. "In this instance nature could not be used as a model for the studio." Dreadful reality is inseparable from the halo with which our imagination surrounds it.[18]

When Kracauer says that what is created, the aesthetic semblance, is a necessary prerequisite, it once again becomes perfectly clear that his concept of film images is neither geared toward illustrating nor toward reflecting the needs of the mass audience. Only the aesthetic transformation of external reality can bring out a specific phantasmatics, an unsuspected visuality in the everyday forms of appearance. It provides for an image that does not refer back to something that was there already. Instead this image shifts the sensory-physical reality into the visible, which is the historical basis of our subjectivity, the social form in which our subjective ways of perceiving and sensing can be recognized in the first place. The aesthetic transformation exposes the social as something like the "inner life" of external reality, as the self of the visible, physical reality of things, of gestures, of spaces. A self that only becomes viewable in the visuality of the cinema, that becomes a spatial image in which the dream of a society is represented to the dreamers.

The Historical Foundation of Our World of Sense Perception

What is still formulated as a methodological premise in Kracauer's *Caligari* book later solidifies, in his main book of film theory, into a formula that pointedly defines the specific aesthetic potential of film: the "redemption of physical reality." This "redemption" pertains to nothing other than the historical dimension of our reality, the temporal character of how the life of a society materially appears.

When, at the end of his life, Kracauer turned to the philosophy of history as a question of "the last things before the last," he ascertained to his surprise that he had always been concerned with this question: namely when he reflected on the specific form of experience in the "photographic media."

In the introduction to *History: The Last Things Before the Last*, he writes: "Recently I suddenly discovered that my interest in history—which began to assert itself about a year ago and which I had hitherto believed to be kindled by the impact of our contemporary situation on my mind—actually grew out of the ideas I tried to implement in my *Theory of Film*. . . . I realized in a flash the many existing parallels between history and the photographic media, historical reality and camera-reality."[19] In his final work a (misunderstood) thought obtrudes on him, one that had always been the impulse for the work: the thought that the photographic media—in their specific visual quality, in their specific aesthetic mode of experience—make it possible to grasp a historicity that is of great significance for modernity. In fact, Kracauer had already formulated these thoughts in the twenties in an essay on photography.[20]

> I have pointed out in *Theory of Film* that the photographic media help us to overcome our abstractness by familiarizing us, for the first time as it were, with "this Earth which is our habitat" (Gabriel Marcel); they help us to think *through* things, not above them. Otherwise expressed, the photographic media make it much easier for us to incorporate the transient phenomena of the outer world, thereby redeeming them from oblivion. Something of this kind will also have to be said of history.[21]

Even if "redeeming them from oblivion" sounds a lot like the ubiquitous metaphor of salvation, there are explicitly no conditions of ownership

under discussion. The "incorporation" applies to the "inner life of society" or, as Benjamin formulated it, to the "furnished man."[22]

The subject of this sensibility, the "I" of this "inner life," is the film audience, as real as it is heterogeneous. For this reason, Kracauer does not place the aesthetic potential of the cinema on the side of the artist, but as the possibility of experience for the spectator. The cinematographic mode of experience applies first and foremost to the film spectator's effects of subjectivity. It discloses a sensual, physical reality that cannot be part of our ordinary perceiving consciousness precisely because our perceiving consciousness itself is, on the contrary, still a part of this physical reality. Our self, our subjectivity, our ways of sensing and perceiving are always already "nature,"[23] grounded through and through in the social world. They are always already a form of participating in "a shared sensibility." In the "various elements and conglomerates of external life, especially in those barely perceptible superficial appearances," the historical foundation of our everyday world of perceptions becomes visible.

The Reader in the Cinema

If Kracauer sees the aesthetic potential of the cinema endangered by both the artistic demands of authorship and the constructivism of the avant-garde, then this is due to his positioning of the aesthetic subject on the side of the audience. Not the auteur, not the artist—the anonymous individual in the mass of moviegoers is the subject of this experience. At any rate, Kracauer, throughout all aporiae and speaking in the name of the experiential possibilities that the cinema can be for its audience—and not, as is often asserted, in the name of a (regulating) poetics of film grounded in the ontology of the medium—explicitly inveighs against artistry in the cinema, against the avant-garde, and against auteur cinema. "It is a matter of redeeming receptivity, without which all art is dead. In opposition to the genius of the artist, which in classical aesthetics provides the work its rules, Kracauer defends the mass's desire for distraction, which has been created by modern working conditions."[24] From this perspective, Heide Schlüpmann's work on Kracauer can also be read as a continuation of the process of reinterpreting the utopia of film,[25] how it is formed with the avant-garde into the idea of the cinema as a visual space in which the

reality of individual existence becomes the unavoidable point of reference for this utopia.

> In the social interspace of the cinema, intellectuals, weary from abstractions, meet workers and employees in search of distraction. Artists are also gathered here, the literati, whose existence is called into question by the technical reproducibility. In the "homogenous cosmopolitan audience," the categories determined by the division of labor are suspended. Film is something that momentarily produces outlines of the complete human being, nature and spirit. What is significant is not the object itself, on which both the last gasps of reason and of deformed will find relief, but the fact that any hope for a new condition lies in this commonality, in this connection.[26]

In the "social interspace of cinema," the utopia of art—the possibility of viewing the social, "in which, at one and the same time, all thought is sensed and all sensation is thought"—becomes the form of experience of real individuals in an abstract mass audience. Kracauer's interpretation of the utopia of film can be summed up in this way. Indeed, he focuses on the mode of experience that Walter Benjamin sought to sketch out in his essay on surrealism, using the term *image space*.[27] He focuses on a kind of seeing, or perceiving, in which the external appearances of the everyday lifeworld are represented as their own physical foundation, as the historical becoming of the most personal modes of sensing. The physical reality to be redeemed concerns the historicity of our faculties of perception and sensation.

What Kracauer was considering in the film archive at New York's MoMA, what he was rethinking once again in a language different from his native tongue, is the cinema as image space, in which social conditions become visible as the possibilities of living-in-society. His theses, despite their propensity to be misunderstood, reveal a discursive plateau that could only be marked off little by little in the scholarly engagement with the cinema—and that, indeed, still has to be marked off. Kracauer's book gives us a view of cinema as part of the politics of aesthetics. It is not only radically contemporary—and as such a document of the historical constellation that Kracauer is seeking to analyze—it is furthermore itself part of the discussion within cinema about its possibilities: a discussion that is articulated equally in films and in criticism and theoretical concepts. His book is

a manifestation of this discussion, which festers like an old wound in the thinking about cinema.

When Kracauer attempts to recognize, in Weimar cinema, the conditions that confront him as reality becomes historical, he puts himself on par with the cinema spectator whose experiential potential he is seeking to examine theoretically. His work about the history of Weimar cinema makes emphatically concrete the figure of the reader, as Benjamin had proposed it.[28] There is, as we read in the essay mentioned earlier, a "hundred percent image space" to be discovered in the "space of political action." In this formula, which encapsulates the encounter between the historical avant-garde and the cinema, the decline of aesthetic consciousness is brought together with the decline of the political consciousness in a highly particular way. With polemical verve, Benjamin formulates in 1928 what for Kracauer in 1944 had become the unavoidable historical experience: that any art, separated from the political dimension of aesthetic thought, corresponds to a politics that only *seemingly* relates to the existential conditions of actual individuals.

> For what is the program of the bourgeois parties? A bad poem on springtime, filled to bursting with metaphors. The socialist sees that "finer future of our children and grandchildren" in a society in which all act "as if they were angels" and everyone has as much "as if he were rich" and everyone lives "as if he were free." Of angels, wealth, freedom, not a trace—these are mere images. And the stock imagery of these poets of the social-democratic associations? Their *gradus ad parnassum*? Optimism. . . . Nowhere do these two—metaphor and image—collide so drastically and so irreconcilably as in politics. For to organize pessimism means nothing other than to expel moral metaphor from politics and to discover in the space of political action the one hundred percent image space. This image space, however, can no longer be measured out by contemplation. . . . In all cases where an action puts forth its own image and exists, absorbing and consuming it, where the nearness looks with its own eyes, the long-sought image space is opened, the world of universal and integral actualities, where the "best room" is missing—the space, in a word, in which political materialism and physical creatureliness share the inner man, the psyche, the individual, or whatever else we wish to throw to them, with dialectical justice, so that no limb remains untorn.[29]

The "hundred percent image space": Benjamin's metaphor of revolution defines an aesthetic program that became a social reality in Kracauer's work. The emigrant, rewatching old films to find out how the forces that have determined his existential situation are constituted, is the reader to whom the space of social action is revealed as an image space, an image space in which the ways that physical reality appears can be grasped as the social forces that he no longer has to suffer through with his own body, that he can study instead as a history of how our everyday sensibility is shaped.

What is heralded as the utopia of a new subjectivity of the masses in the emphatic metaphor of revolution gains a quite contemporary shape in the figure of the reader in the cinema.[30] In this figure, the utopia of art, whose avant-garde character is concisely formulated in Benjamin's dialectic of political and aesthetic thinking, is realized as a social reality by articulating a radical disenchantment in this thinking. It means the random, everyday spectator, the numerous individuals of the mass audience, who have become the subject of film art: "This implies that he resembles not so much the expressive artist as the imaginative reader bent on studying and deciphering an elusive text."[31] What corresponds to this reader in the cinema are films that newly mark out the system created by the sensual evidence of a world taken for granted by ordinary consciousness; films that do not take up any political position, but instead project a social space that questions the possible positions of articulating the singular.

Visconti: The Sensibility of Another Time

Referring to these films, Deleuze spoke of neorealism as one of the "cinemas of the seer" in the early postwar years. For him, this term meant films in which the transparent self-evidence of things in the everyday world of appearances was transformed into a puzzlingly opaque world of signs; at the same time, however, the belief in a subject capable of acting within history had been shattered. As much as this poetic concept may be tangible and evident in Visconti's early films, it seems to be very scant in those films where the relation to the historical past is expressly thematized: that is, in the history films. And yet it is precisely these films that testify—in

their attempts to create an image of a time in history before the catastrophes of the twentieth century—to an understanding of cinema as the space of historical consciousness, an understanding very close to that of Kracauer.

Visconti's later history films—*Il gattopardo* (*The Leopard*) from 1963, *La caduta degli dei* (*The Damned*) from 1969, and *Ludwig* (*Ludwig II*) from 1972—are considered the high art of cinema. Nonetheless, they have a thoroughly dubious reputation in contemporary discussion. The reason for both these facts lies in one and the same factor, which we can now see in a single glance: the virtuosity of the mise-en-scène, the art direction, and the acting style. In contemporary discussions this virtuosity has been seen as a renunciation of the political program of neorealism and as the symptom of a traditional understanding of art and a lack of sociopolitical involvement. Beyond these debates about the relation of art and politics, a certain aesthetic dignity is grounded in virtuosity, which today seems more evident than ever before.

But the question still presses: whether so pure an aesthetic evaluation does not simply further a critical perspective on Visconti's films that was already prevalent at the time—even if the context for such assessments has changed. Now, as then, the films are generally not seen in terms of their political aspirations, as if their view of the historical world of Europe were based on a purely aestheticized interest in a past, decaying beauty, which remained outside the author's political intentions. As outstanding classics of European film art, Visconti's historical dramas appear themselves to be merely of historical interest.

In the contemporary discussion, a series of attributes has been attached to the director's virtuosity that seem highly ambivalent in relation to any cinematic concept of realism with sociopolitical intentions. On the one hand, they have been labeled pessimistic, on the other, mannerist. Finally, there has been some critique directed at the dramaturgical principle of mythologically overglorifying the social worlds being represented. The first of these attributes concerned the elegiac tone, the fact that these films all deal with a world just at the moment of its disappearance. They are seen as pervaded with a sense of mourning that applies to the refined culture of a past time—without the optimism of tomorrow, of youth, of what is to

come. Their elegiac worldview is thought to lack any clearly defined political analysis. Interwoven tightly together with this was the second attribute. This focused on the dominant position that was granted to the decor, the set design, and the mise-en-scène in Visconti's direction. Here the attention is directed to a tendency toward mannerism manifest in the decorativeness of his films, a tendency that would combine with the filmmaker's pessimistic worldview to create a decadent aestheticism. The beauty of the films would then be the opulent splendor of decay. The third attribute finally concerned the idiosyncratic dramaturgy, Visconti's preference for the cosmos of familial relations, which, located in the high nobility or among the very rich, was seen as overglorifying and mythologizing the social relations represented. In this view his films followed the strategies of melodramatic oversimplification by reflecting social and political conflicts in family constellations. The historical world finds its allegory in the fate of the utterly unequal, the old and new nobilities.

A pessimistic worldview, aesthetic mannerism, and mythical glorification: these attributes can be traced—granted, not in their negative senses— in even the most recent literature on Visconti.[32] For the discussion at the time, however, they represented a kind of imposition. For, unlike the films of younger directors—Antonioni, Pasolini, and Fellini—Visconti's later works were perceived in relation to the neorealist project. Visconti was the aging neorealist who in his later work paid homage to a morbid aestheticism, a nihilistic negation of the world that one could indulgingly forgive the great artist. Now his young contemporaries in Italy, France, Germany, or the New Hollywood were hardly less obsessed with form. But in their cases the form of cinematic representation was understood and discussed as an aesthetic concept, while in Visconti it was simply read as the filmmaker's worldview, as his elegiac address about the world and the course of history. But Visconti's history films reveal cinematographic visual spaces that are no less conceptions of a specific visuality than are the visual spaces of Antonioni or Pasolini.

Looked at carefully, all three of the attributes I have mentioned point especially to a cinematic kind of staging, which gets its specific imprint from the dominance of acting direction and spatial design. The attributes therefore apply to all of Visconti's spectacle films, whether they

constitute—like *Senso* (Italy 1954)—the middle or—like *Il gattopardo*—the height of the oeuvre or—like *Ludwig*—actually the later work. The fact that these attributes are associated foremost with the history film suggests that there is a connection between the question of how the present relates to history and the possibility that cinema could produce an image of memory that would be collectively valid. At any rate, the following reflections start from the thesis that Visconti is exploring this connection in his films. In their poetic conception, his history films imply a specific understanding of the aesthetic potential of the cinema to engage with history—and therefore a specific understanding of political film art.

So the first question that arises is about the specific cinematographic forms of representation that are developed in these films. What is the poetic conception of cinema they are based on? The analytical reconstruction of the poetic conception of the cinematographic visual space implied in the films can form the foundation through which we might newly inquire into the films' relation to history, society, and politics.

In light of contemporary ideas of film realism, this question seems always already to have been answered. The films represent a (highly particular and individual) view of the historical world, to which cinematic strategies were added as an extra, inessential ingredient, individual style, historical precision of detail, and mannerist decoration.

In the following I would like to attempt to reverse this perspective. Namely, if we do not assume any previous representational mode of the film image, but instead understand the cinematic strategies themselves as inventing a specific modality of aesthetic experience, that is, as proposing a specific visual form, then the ways that film and history relate at all—how films discuss, reflect, and represent it—would initially remain open. Keeping in mind the provisos that I have mentioned, I would like to sketch out a film-analytical perspective in which this reversal could be carried out. To do so, I will, on the one hand, concentrate on the first film of the so-called Germany trilogy: *La caduta degli dei* from 1969. As fits its story, this film represents the high point in Visconti's work on the possibility of imagining cinema as a medium of historical memory. On the other hand, I would like to look more carefully at *Senso* from 1954. In relation to this film, a certain broad conception of perception can already be described that essentially remains in place for all the later history films.

Pessimism, Mannerism, and Mythical Excess

"Pessimism, no. For my pessimism is merely one of the intellect, never one of the will. The more intellect makes use of pessimism to get to the bottom of the truth of life, the more the will gears itself up, I think, with revolutionary optimism." Visconti formulated this sentence in 1960 in an interview about his film *Rocco e i suoi fratelli* (*Rocco and His Brothers*, 1960). He continues: "This is why I think that with *Rocco* I have not just given a partial image, but an image on which everyone can agree, provided they are of good will: in condemning that which deserves to be condemned, and in taking up those hopes and aspirations that no free man can really refuse."[33] If there is anything in Visconti's work that is incompatible, it would be this sentence and the film *La caduta degli dei*. In this film, about the downfall of a German industrial dynasty, one would be hard-pressed to find any moment where the hopes of free human beings are represented. On the contrary, the only character that could embody this at all is led away in the end, as the high-end product of the great meltdown of all the bonds of love, friendship, and family: Gunther, the grandson of the industrial patriarch, an educated, artistic young man. Looking back from the end (we see—in a reference to the film's beginning—the blazing fire of a furnace), all the crimes in this family saga seem to have no other aim than to melt down the figure of bourgeois philanthropy into a figure of burning hatred and the purest nihilism. And yet this figure, in its arrangement, differs in no way from that of Rocco, the subject of Visconti's remarks on pessimism.

As with Rocco, the pessimism here does not mean the filmmaker's worldview, but refers to an aesthetic strategy. It is directed at a character type who does not articulate the moral attitude of the filmmaker or of any other possible real person, nor does it represent such an attitude as allegory. The discussion of pessimism refers to the principle of construction itself, to the character as "an image," which is not comparable to replicating real human beings. "An image on which everyone can agree, provided they are of goodwill: in condemning that which deserves to be condemned, and in taking up those hopes and aspirations that no free man can really refuse." The character confronts the spectator as an image that demands moral consciousness as a response. It is not the expression of moral consciousness, but a medium for forming it. Pessimism here

refers to a strategy of staging with which the characters become sealed off from the filmmaker's intentionality and become a subject for thought on the side of the spectator.

In this respect the character in Visconti is never separable from how the cinematic visual space is shaped. In *La caduta degli dei* this is a house, the ancestral home of the von Essenbecks. The villa is presented as the interior of devastated interpersonal relations, where all the efforts of free human beings seem to be losing their ground. But the same question comes up once again on the level of interior design. What dimension of experience is targeted by the film's aesthetic procedures—can we not simply understand the staging of the house as a dark allegory of a nation's downfall, adorned with countless embellishments taken from European cultural heritage? This question points to the second attribute, mythological glorification.

Among these embellishments are references to Wagner's opera, *The Ring of the Nibelung*, to Shakespeare's royal dramas, and to the epic work of Thomas Mann, all of them references that the contemporary discussion cited as symptoms of an outmoded understanding of art. And, in fact, these do seem to be the forerunners. *La caduta degli dei* really does seem to be parading the poetic logic that Thomas Mann had explained in the case of Wagner: the interweaving of mythological and psychological visual material in a hermetic, artistic world in which people and their conflicts appear larger than life. "Exacerbating the conflicts? But this is the task of art. What matters is that the conflicts are real."[34] With this remark, Visconti turns against the standards of an understanding of realism that he does not share.

But all this is not automatically associated with monumentality and mass scenes, as critics suggested at the time. Viewed more carefully, large stretches of *La caduta degli dei* prove to be more of a chamber play of individual passions, a family drama that would fit just as well under the title of a later film: *Gruppo di famiglia in un interno* (*Conversation Piece*, 1974). For all the monumentality of the subject, the film is often lacking in widescreen effect, to speak metaphorically. There is no evidence of bacchanal landscapes or monumental battle scenes, the great iconographic themes of *Senso* and *The Leopard*; neither is there any open horizon of time, the epic expanse of these films, nor the spatial trajectories that open up time and

again in Countess Serpieri's (Alida Valli) villas and in the palaces of the prince of Salinas (Burt Lancaster). The sequence showing the massacre of the SA, with its monumental staging, forms a kind of film within a film and represents a significant exception. Time and space in *La caduta degli dei* have the effect of being peculiarly compressed and constricted. The Essenbecks' villa appears as a hermetically sealed cosmos whose inner construction follows a highly abstract logic.

The unreality of the temporal structure and the spatial construction can, in fact, be viewed as a mythologizing process; at any rate it is clear that the film is proposing the family drama as a mythological figuration in which history and politics are interpreted psychologically. But this is in no way equivalent to amplifying a psychological family drama into an allegorical image of history. Instead, the film aims to make politics graspable, not directly (inasmuch as that might be possible at all), but in its psychic effects, its individualized powers and impacts.

In an interview about *Rocco e i suoi fratelli*, Visconti says: "As can be seen, I have arrived at social conclusions, perhaps even political ones, having only taken the path of psychological examination and the faithful reconstruction of a human drama throughout the entire film."[35] *La caduta degli dei* achieves this "reconstruction of a human drama" through its construction of visual space. The strictly limited, seemingly abstract-allegorical interior establishes the inner perspective, even as it represents a detailed reconstruction of the villa of a German industrial baron in the thirties. It contrasts the inner world of the industrial family with an absolute exteriority of politics, history, and society.

The reality of history can only be grasped in its destructive effect, the changes in this highly artificial interior space. It is characterized by an exterior that disturbs the family scene, whose agents—the Gestapo commando, Aschenbach—intrudes into this interior like a virus into an organism. In the world of this film, history is something that changes the scene without this change ever becoming quite comprehensible. A shift in the lighting, a disharmonic zoom, an abrupt change in color—at first these are hardly noticeable, but in the end they represent a creeping devastation. History is the duration of this change; a time quite detached from the course of the plot, which can only be grasped in the gradually diminishing light, the changing of colors, the ever more vacant table.

In fact, the few exterior shots in the film (a steelworks, a street in Ober-
hausen, a tenement house) mark historical reality, the political, as a force
working from outside. The presentation of this outside culminates in the
monumentally staged annihilation of the SA troops. Inserted like an inter-
lude, this sequence divides the film into two halves that mirror one another.
Such monadic mirrorings are what Deleuze is referring to when he speaks
of "crystals of time" in Visconti's histories.[36] The crystal image should not be
understood on the level of the plot, as a film text, nor as a plane of action.
It is realized solely in the act of being perceived by the spectator. The third
attribute refers to the interweaving of historical and aesthetic reality in the
spectator's space of perception, found time and again in Visconti's later
films: that of mannerism.

This attribute explicitly turns up for the first time in the discussion of
Senso. The film, from 1954, which contains numerous references to opera,
both in the subject matter and in the mise-en-scène, makes it perfectly
clear that Visconti is at least as comfortable on the theater stage as on
the film set. The question arose as to whether his way of staging did not
indeed follow an aestheticized mannerism, one that would clash with the
program of neorealism. And if so, in this positive view of mannerism,
understanding it in the sense of the refinement of decoration, whether
this label might be considered justified to some degree. This is a ques-
tion that Visconti answers firmly in the negative: "*Senso* is in every way
a realist film. . . . I tried to make it with maximum realism, at the same
time giving it this element of Italian melodrama."[37] He explains further
that the demands of neorealism have to do with content in essence or, if
you will, with politics, which can be realized by means of quite different
staging strategies, genres, and categories of film. Visconti understands
the demands of realism as a political requirement, not as an aesthetic cat-
egory. He means nothing more than the demand for social truth in art.
For him, as an opera, theater, and film director, it must matter that every
art, every type, every genre can fulfill the demands of contemporary real-
ism in the manner appropriate to it. Realism—from this perspective—is
always and only positioned as mediated by the logic of each specific set
of rules within a given form, and the demand for social truth is in turn
mediated by each aesthetic concept. This ideal of realism is available to

art in all its modes. The composer Hans Werner Henze has described Visconti's ideal of realism as follows:

> The black on the screen seems blacker, deadlier, the white more garish and severe, the shadows speak. Every detail is necessarily arranged in the action. Herein lie the first two essential characteristics of a style that can only be identified with Neorealism to a (nearly unessential) degree. From the beginning it is the clear language of an artist whose hard, Latin, piercing eyes don't lose sight of anything in the environment, the light, and the landscape that surround the human being, the object of its effect, that might form him, beautify and displace him; it is the talent to beautify the truth in every case, even in the most disagreeable, through that love for the truth that in his profession is called precision, of giving the truth a wild, destructive beauty.[38]

"That love for the truth that in his profession is called precision"—at first this would seem to contradict the ideas of mythological glorification and mannerist formalism. But this precision in Visconti refers above all to the staging of a world of things that articulates the desire, the sensibility, the way its inhabitants wish and feel in every detail. Henze continues, naming the second characteristic of Visconti's art: "a certain melodramatic attitude: an operatic procedure, a stylistic maneuver that is undoubtedly derived from the techniques of the lyric nineteenth century. We find this in the dialogues, which almost always, despite any realism, have something of the sung concertati of opera in them, and also in the graphic, choreographic mass scenes; they breathe in the atmosphere at the Teatro alla Scalla."[39] From this perspective, a formational principle becomes clear, one that may already be found in La terra trema (1948)—the film, with its nonprofessional actors, speaking in dialect and playing themselves as the inhabitants of a Sicilian village, became one of the primary examples of neorealism. The film is characterized by an acting style that, with its choreographic rigor and its dialogue formation, theatrically translates, exceeds, transcends the language of the fishermen and their everyday gestures. Every encounter, every action, every song is rigorously staged so that the inhabitants of the fishing village themselves are effectively inserted into the scene like dramatis personae at various locations in their village, as if they were moving

through sets in the acts of a drama. The camera in no way functions as neutral and demonstrative, simply showing what is there. Rather, it articulates a willful, sensual experience of the locations and landscapes, these people's particular experience of the world, their wounded pride, their euphoria, their infatuations, their despondency, and their unending fear. The streets, the ports, the mountains, the sea, all appear as the strophes of a song of joyful and tearful days and of the anxious hours of greatest despair. One could see here an opposition to neorealist poetics, to the emphasis on dialect, the nonprofessional acting, and the reality of the Sicilian locality—but it is completely justified to say that Visconti has grasped reality fundamentally like the backdrop of an opera stage.[40]

This is precisely not the objective world of things and people as it is known to general understanding, to the common sense of sensibility. It is the physical-sensory world of the experience of an always individual person, the sensibility and the individual human ways of sensing that take shape in the visual spaces of these films. It then stands to reason to view Visconti's films in relation to the theory of film melodrama, to the mode of excess and hyperbolic expression.[41] But we should not be too quick to jump from the Italian *melodramma* to the theory of film melodrama. In Visconti, at least, set and art design are in no way unmediated expressions of the characters' feelings. The arrangement of the objects, the staging of the visual space have a descriptive, intellectually opening relation to the characters—and not an atmospherically expressive one. The sensibility that unfolds in these visual spaces always has a sociohistorical basis. For the spectator, this sensibility is at first glance represented as the "beauty of the objects and people" of a world that is completely foreign to them; a beauty that is gradually revealed to be the fixed law of the world, in which the characters of the film are enclosed and even trapped.[42]

This poetic logic is most clearly seen where the melodramatic qualities of opera themselves are the theme, in the film *Senso*.

The "Faithful Reconstruction of a Human Drama": Politics from the Inner Perspective of Individual Feeling

It would be difficult to imagine an opposition greater than that between *La terra trema* and *Senso*. And yet these films share a close bond, precisely in

their political intentions. Both the title of the film, *Senso*, as well as its ending, the execution of Lieutenant Mahler (Farley Granger), were, by Visconti's own account, imposed on him. He had not wanted to make a love melodrama, but a film named *Custozza*, which was supposed to use the resounding defeat during the Italian War of Independence to open up a means of relating to the missed opportunities in European history. In Visconti's version, the film's final tears, the film's pathos of lost chances are directed at this other history.

Senso begins with a well-known scene from Verdi's *Il Trovatore*. For the first two minutes we see the singers on stage in such a way that the space of the stage actually constitutes the film's space of action. When the names of Alida Valli and Farley Granger appear imposed over the opera stage in the opening credits, we initially associate them with the opera characters and in fact expect a "melodrama" in Verdian style, with all the lavish decor and high pathos that goes along with such an utterly artificial form of representation. And yet, in the famous opening scene of *Senso*, we can grasp a spatial figuration, a way of constructing the cinematographic visual space, by which we can pinpoint the poetic logic of Visconti's history films. Hans Werner Henze describes this beginning in his essay on Visconti: "*Senso*":

> *Senso* . . . where the melodramatic tone is most consciously maintained throughout, begins with a scene at the Teatro la Fenice during a performance of *Il Trovatore*. The camera, which has been focused directly on the distant stage for quite some time, pans into the gallery where the Venetian populace is crowded into the standing room section, and travels from there to the main floor where the Austrian occupying officers sit in their white uniforms, and then into the loge where the Serpieri family is sitting, along with their guests, the Stadtkommandant and his adjutant. Here begins the hateful, impossible love affair, in this cordial atmosphere, amid polite bows that smell of betrayal, which form a sharp contrast to the grim walls of the opera set, visibly reflected in the Murano mirror, and the revolutionary sounds of the Verdian liberation music dedicated to a new Italy that force their way into the conversation.[43]

Henze describes the mirroring interweaving of the performance on the stage and the plot of the film as a spatial construction whose opposing sides are joined by the singing of the Verdi opera. How is this presented in detail?

In the first shot, the stage is shown in the classical form, as a space of representation: a space that lifts everything within it to symbolic reality. The closed composition of the frontal framing of the stage means that this space is identical with the film shot. Only when the camera pans into the audience does this space become identifiable as a stage. While the perspectival depth is emphasized here by architecture, the space of the audience, the attentive crowd embedded in the decor, appears as a rather flat image. The panning camera blurs the geometrical perspective and the depth of the architectural space. The flowing impression is of a viewing, listening audience, enclosed and structured by the ornamental framings and partitionings of the historical decor.

On the one hand, we have an image that represents the populace as a gathering of listening and viewing people; on the other, this image becomes associated through its visual axis with its off space, the space of the stage, to such a degree that a third thing arises, a clearly defined space of action; the impression of the assembled crowd and the image of the action on stage prove to be part of the diegetic world of the film: a historical performance of the Verdi opera *Il Trovatore* at La Fenice, Venice's famous opera house, in 1866. Until the camera pans, opening its view over the packed loges full of attentive faces, this space of action had not yet existed.

Henze describes how the scene continues as follows: "The feeling of turmoil, of threat, erupts at the end of the act during the tenor's famous cabaletta 'Di quella pira l'orrendo fuoco,' amid resounding calls of 'viva l'Italia, viva Verdi' and green, white, and red broadsheets streaming down from the highest gallery, like rain forcing its lightness and freshness into the languorous and stuffy air of the oppressors."[44] By more precisely analyzing the prologue, which lasts nearly fifteen minutes, we can see that the special mirroring construction between the action of the opera and that of the film represents a highly complex structure that is inextricably entangled at the level of music and singing.

The starting point is formed by dividing the cinematographic visual space into two different dimensions, each of which has a fundamentally different status in terms of reality. From this first division of the image—the impression of the spectators and the events represented on the stage—Visconti develops the fundamental principle of how space is constructed in the film. Essentially it consists of mirrorings, multiply entangled at

the level of individual details, in such a way that they continually unfold within new refractions.

When, during Manrico's cabaletta, the camera shows the film spectator the "other side" of the stage for the first time, that of the opera's audience, this happens from the perspective of the proscenium. It is as if the singer were directly addressing the audience, calling on them to "quench the fire within with the blood of the Austrians." When, at the moment of his high C, the camera responds with a shot from the viewpoint of the highest galleries, that is, from Olympus, Manrico's men rush on stage and raise the battle cry. In a countermove, we see the freedom fighters preparing their revolutionary coup. The division between the space of the stage/image on the screen, opera singer/opera spectator is staged as a mirroring between Verdi's opera and a fictional political event during Verdi's time. This mirroring itself, the mirroring of art and social reality, is the theme of the movie. At any rate, the visual space of the film describes much more than simply the site of a fictional historical plot.

During the first minutes of the credits we hear the duet "L'onda de' suoni mistici" ("The Wave of Holy Sounds"). Leonora and Manrico sing of their love. The appearance of one of Manrico's men abruptly interrupts the harmony. The enemy has set up a stake to burn a gypsy woman. Through a window in the rear stage a red, flickering light can be seen. With an exaltedly theatrical exclamation, Manrico proclaims that the gypsy is his mother. A text is superimposed over the scene providing information about the political situation at the time of the film's action. Manrico walks downstage, draws his sword, holds it up, and belts out the cabaletta: "Before I loved you, I was yet her son; your suffering cannot restrain me . . . Unhappy mother, I hasten to save you, or at least hasten to die with you!"

While colored handbills fall from the upper balconies, the "feeling of unrest and threats" literally jumps over to the other side. The affect changes form, the singing changes into political action. What had previously the impression of a society, collecting and assembling, presented on the flat image of the screen, now emphatically becomes the space of action. The singing indeed turns into a political action executed in the space of the audience. In place of a passive audience, we see the action of a people's self-expression: "Viva l'Italia, viva Verdi." This action cuts through the crude entanglements on stage, illuminating them in one blow through an

Un film

LUX

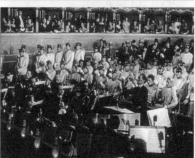

interpretation that could not be clearer: "Viva l'Italia, unhappy mother, I hasten to save you, or at least hasten to die with you!"

In the film's mirroring construction a figuration arises that can no longer be grasped on the level of plot, can no longer be seen as the space of action. For the audience's response is not simply a fictional historical event that finds itself mirrored in the action of the opera; in the mirroring, it itself becomes a symbolic form, a *coup de théâtre*, a highly artificial image of the pursuit of freedom. Conversely, Verdi's opera emerges in this mirroring as a real object: as an artifact in which the "aspirations of free people" that the fictional scene is narrating become historically reified. In the reciprocal mirroring, the spatial figuration as a whole has become the cinematographic image of the feeling of freedom, which is embodied in Verdi's opera as an artifact, as historical object, a tangible historical thing.

The possibility of a cinematic "recollection-image" in Visconti is in no way based on the illusion of the (imitating, costuming) decor,[45] whether it be the pompously striking stage decorations or the highly detailed art design, by which a historical opera performance from 1866 in La Fenice is described. Rather, the staging of the film presents the opera itself as a past feeling, embodied and made material in the art object. This staging of the aesthetic qualities of material things as a transformation of the historical reality of a past social life denotes the fundamental axiom of Visconti's poetics of the historical film.

The cabaletta is staged for the contemporary cinema spectator as a present "feeling" of a past time in the form of music. The passionate affair of Countess Livia Serpieri for the Austrian lieutenant Mahler then is a matter of betraying this feeling. Even this mirroring comes directly from the

spatial figuration we have described. The second part of the sequence plays out in the loges of the Venetian nobility and the Austrian generals.

The countess, Livia Serpieri, asks to be introduced to Lieutenant Mahler. She wishes to protect her cousin Ussoni (Massimo Girotti), who had accosted the Austrian officer during the tumult. Livia stands in front of a mirror (two of the three walls of the loge contain mirrors), takes off her shawl, touches up her hair, and opens her neckline slightly. In the mirror the curtain can be seen rising behind her. Stage and loge join in a single spatial figuration. Her commentary, in which she expresses her lack of interest in the fourth act, which has just begun, exposes the film melodrama as a feminine intrigue to save the Italian freedom fighter. "This isn't the first time I've seen *Il Trovatore*. Besides, Austrians love music. We Italians, on the other hand, come to the theater for very different reasons."

A cut, a long shot, shows the set of the fourth act. Leonora is standing on a landing in front of a gloomy fortress. Ruiz enters, announces that Manrico is being held prisoner in the fortress's dungeon. Leonora's song narrates her resolution to free Manrico. Another cut joins this song with Franz Mahler's entrance into the loge. A close-up shows him in the doorjamb: the image of a pretty young man. The camera follows him for a short moment, pausing at the framed mirror, which Mahler passes quickly, only to be immediately shown next to Livia in the mirrored image. Both can now be seen from behind in the mirror. Between them we see Leonora on stage, as if her song and her appearance were in turn a reflection of the faces turned away from the film spectator.

From the outset, the camera dissolves the space into a series of framed and mirrored images, in which the events on stage and in the loge are interwoven into multifaceted refractions and reflexes. The film cuts to the couple shot from the front in the loge, Leonora's singing providing commentary on their conversation. A third perspective shifts both of them into the image in such a way that we simultaneously see their faces and the singer in the background, as if the loge had now become part of the stage.

When Livia finally understands that the Austrian officer has no interest in dueling with her cousin and would much rather see him arrested, we once again get a long shot of the stage: Leonora, shot from below, evokes memories. And, while the singer reproves the messenger, ("But, pray, don't imprudently tell him the pangs, the pangs that rack my heart!"), we see

Livia becoming anxious, covering her opened neckline with her shawl and preparing to leave. It is as if Leonora were singing about the coming pangs of the Countess Serpieri, torn back and forth between her love for the Austrian lieutenant and loyalty to her cousin, the Italian freedom fighter. She wants to save him, she must—just as Leonora must save her beloved Manrico, Manrico must save his outcast mother, and the opera audience must save oppressed Italy: "Either at the cost of my life I shall save your life, or, forever united to you, I shall descend into the grave!"

The last shot of La Fenice shows the loge, which in its reframing has now completely become like a stage. Standing in the door in the background is Livia, framed by the doorjamb; she stands with her back to the camera, hesitates, leaves the frame. In the melodrama that follows, a depiction of Venice responds to the theme of the opera, one that looks like a visual staging of certain passages from the seventh symphony by the Austrian composer Bruckner.

A Monadic Mirroring of History

In the mirroring of stage and audience, of Verdi's music drama and the political action of the audience members, the prologue in *Senso* mirrors two different dimensions of reality—that of art and that of politics—in order to expand this mirroring in the next act into a further mirroring: the drama of individual feelings and passions, the encounter between Countess Serpieri and the Austrian officer Mahler.

Within this mirroring construction, a single element can belong to a fictional, past, or present real occurrence, depending on which refraction of

the mirroring it appears in: an aria as an emotional eruption in an operatic plot, as an artistic performance within a fictional film plot, as a real artistic artifact, as the aesthetic experience of a real film audience.

The mannerism of the decor and the lavish precision in detail are neither aiming for historical reconstruction, for visualizing a past time, nor for expressing the characters' emotional states and moods. Rather, the design and music, the costumes and architecture point to art itself as the sphere in which things exceed the time of their everyday purpose. They indicate art as a transitional zone between the sensibility of concrete individuals and the societal common sense of good taste and conventions of perception. They point to the possibility of communicating between the sensibility of a past world and that of a present one. This is why everything visible in Visconti's film takes on the form of the decorative—the women with their crinolines, the men in their uniforms, the kitchenware, the artworks, the furniture, the technical equipment.

The beauty is the form, in which the objects of a past world of sensation, the things belonging to a strange, faraway world of senses creep into our physical-sensory experience. The fact that we can experience them as beauty, that we perceive them aesthetically—and exclusively aesthetically—constitutes the central axiom of the poetic logic of Visconti's historical films. It constitutes the cinema's facility to bring contemporary spectators into a relation to the past, the possibility of a cinematographic memory image.

Seen from the standpoint of this poetic logic, art constitutes a sphere in which we can experience the physical-sensory reality of a world that is not ours, that is not the present one. This does not mean that this reality already exists outside the film image, that we could reconstruct, illustrate, or reenact it to the last detail. This past sensibility reaches into our world precisely to the degree that it has become beautiful appearance, singing, music, choreography; it exists to the degree that it has entered the visual space, which is disclosed to the spectator in an aesthetic experience as the sensibility of another time, another present. All the attributions associated with Visconti's history films, from morbid aestheticism and a pessimistic worldview to mannered decorativeness, refer back to this poetic logic.

Visconti's films unfold their visual spaces as the experiential worlds of a sensibility that is not that of the spectator. They unfold a world from which she is radically excluded. And yet, the spectator shares in this sensibility

through an aesthetic experience of perception, through his experience of the beauty of the things and the people in the film.

In this aesthetic experience the spectator enters into a close relationship with the protagonists of the films. He sympathizes with the Countess Serpieri, with the prince of Salina, with Gustav von Aschenbach (Dirk Bogarde) from *Morte a Venezia* (*Death in Venice*, 1971), and with Ludwig (Helmut Berger) in their lugubrious sense of beauty. The fact that there is no such sympathy in *La caduta degli dei*, the fact that it is only applied to the talented grandson Gunther (Renaud Verley), then to be negated in the end, indicates the special place of this film within Visconti's work.

And yet, even *La caduta degli dei* revisits the fundamental principles of the aesthetic concept that had been developed in *Senso*. This film also proposes a cinematographic visual space in which the architecture is determined by mirroring different realities: the reality of art and that of society, that of individual passions and the collective eruption, the reality of a past sensibility and that of the physical-sensory experience of the contemporary film spectator.

In *La caduta degli dei* we can distinguish three different levels of such mirrorings. The first level is the staging of the villa; it is shown as a kind of topographic arrangement of the characteristics, relationships, and passions of its inhabitants; the fundamental axis of the mirroring consists in the relations of things to characters. The second level is the dramatic constellation of the characters, which is presented as a mosaic of scenes and figures from European literature. The third level is the mirroring between the interior and the exterior of the villa as two parallel worlds: here the birthday party and the death of Joachim (Albrecht Schoenhals), there the SA party and the massacre; here the upper-class villa, there an apartment in the tenement house, the site of Martin's (Helmut Berger) disgraceful act.

The Absolute Interior

With all the circuitousness associated with the place, the staging follows a peculiarly abstract principle of construction. The suites and bedrooms are strictly allocated to the characters and appear more as part of their exposition than as any description of location. We never get any kind of wandering shots that might familiarize us with the house. Instead we see ever new

perspectives on parts of salons, the library, the reception hall, the stairs, the gallery, the dining hall, which create spatial relations with a logic of their own without ever disclosing the concrete spatial dimensions of the house.

In the film's first shot we read the names of its inhabitants, written on silver-framed place cards: one is highlighted, Joachim von Essenbeck. We see a table, lavishly set, surrounded by numerous servants who never stop adding new things to the overabundance on the dining table. Then we see Konstantin. Sitting naked in a bathtub in the middle of the room, he may as well be taking a bath on stage. From the first moment on he is established as the character whose massive corporality forms the greatest contrast to these rooms, in which everything that points to physical needs—sleeping, eating, washing, dressing—is represented and cloaked in costly objects, fine tools, and decorative items.

This is the world of Joachim von Essenbeck: his every movement, every gesture, every fold in his clothing embeds him in the dark wood tones of the furniture and the muted red tones of the carpets and rugs like in a velvet sheath. There could be no greater contrast than that between the tiny gesture with which he rejects the touch of his servant, who wants to go over his jacket once again with the clothes brush, and Konstantin's (Reinhard Kolldehoff) first words, with which he commands the youthful butler to scrub his back rigorously.

In Joachim's case, the dignified setting—silver-framed photographs, vases, golden mirrors and chandeliers, crystal bowls and red glass carafes—tells of the Wilhelmian past (the first shot shows him kissing a photograph of his son, who had died in the First World War, another shows the Kaiser). In the case of Elisabeth (Charlotte Rampling) and Herbert Thallman (Umberto Orsini), the interior is presented in bright modernity. The couple, no less than the patriarch, conforms harmoniously to the decor dominated by pale brown and pink tones, cream-colored and white furniture. Only that here the objects seem to orchestrate the elegance and beauty of their movements. They are—or rather they would be—the perfect example of the sophisticated, proper bourgeois couple. In fact, they are the ones met with the first wave of annihilation.

We only see the chamber of Sophie (Ingrid Thulin), the baroness of Essenbeck, after an evening of festivities—little performances in honor of Joachim's birthday, the festive dinner, Joachim's speech. While Frederick

(Dirk Bogarde) speaks of the Reichstag fire and forges the assassination plot—alternating between discretion and bluntness—the flickering shadows from the hearth dance over the furniture and the faces. The dramatic light, accentuated by various lamps, stands in contrast to the atmosphere of lethargic sleepiness that comes from the opulent abundance of coverings, curtains, and all kinds of recliners, armchairs, and sofas. Gradually the flickering shadows in the half-lit room combine with the actor's gestures and facial expressions to form an expressive entity in which Sophie's calculating coldness and Frederick's obsessive ambition fuse into one another.

Already in the first minutes, a visual space is created that forges a relationship between the opposing aspirations and affective types of the characters within the concrete spatial circumstances. The spaces are like mirrors of the characters, folding into themselves, which in turn are aligned with the central ensemble of salon, dining hall, reception hall, and gallery. Two different levels of reality are intermirrored in these spaces, as in the stage and audience at the beginning of *Senso*: the physical reality of the characters and the world of beautiful objects. What emerges is a world seen as if under glass, which the film only rarely moves past. And, when it does, it is, in turn, these other places themselves that appear to be a monadic mirroring of this absolute interior, the Essenbeck villa.

Even if this family, detached from all sociality, refers to a social constellation, it still first and foremost signifies a representational practice, a kind of staging. The family gathered around the table, surrounded by their minions, is itself a theatrical scene, a kind of court theater in which the nobility stages its everyday life as a representative spectacle for the common people. We might be able to grasp something of the "aspirations of free men" in this spectacle, although its fundamental rule is that of not-being-common and never-making-common. When Joachim speaks of Hitler as the one with whom he is never allied, he is not speaking from any political conviction, but from the aristocratic disposition that also animates the prince of Salina. In fact, in *Il gattopardo* there is a clear utopian dimension, while in *La caduta degli dei* there is only a slight trace of it left lingering. The nobility pertains to a world in which all the necessities of life find their happiest expression in beautiful objects, a world that is completely artificial, all culture, all peaceful order. This is what accounts for the odd, luxurious delight in the decor; it is actually a wealth of individual sensibility. It makes it possible to understand a kind of being-individual that does not exist as a social

relation. It is a sensibility that is not and cannot be shared. This is also its only flaw, but it is a significant one: that it does not seek to be general, that it necessarily must remove itself from common social life.

There is yet another level at which the characters have something of the actorly. They move in the decor as if on a stage because they are always already playing roles. The assassination plot and the conspiracy of Lady Macbeth, the family meeting and the myth of the Nibelungs, the slaughter of the SA and the massacre at Etzel's court. Martin as Dostoevsky's Stavrogin and at the same time as the hesitant Hamlet, with Sophie as the queen mother and Frederick as Claudius. Aschenbach (Helmut Griem) as Mephisto and the molested child as Gretchen. These relations are not meant as overburdened references, but they do set up another level of mirroring. It causes the characters themselves to appear as revenants from the world of art. In fact they are reflections of the great character types and dramatic scenes that signify evil in European literature. Instead of general knowledge about psychology, the film bases its characters on the individual markings with which art has explored the psychic possibilities of humanity—in order then to relate them to the question of the general catastrophe of history.

On all these levels of mirroring, the film reveals the Essenbecks' villa to be an utterly interior world—but not in the sense of the conventional melodrama. It proposes a cosmos of passions that, like Verdi's opera on stage at La Fenice, belongs to a quite differnt reality than that of the spectator: the reality of art. The beauty of the decor, the beauty of the people and the objects, practically forms the zone of transition in which the world of the characters communicates with the world of the spectator, joins in with his senses, only in order to break apart before his eyes. In Visconti it is constantly proven, writes Hans Werner Henze,

> that in the landslides of our civilization, everyone remains shut up in his own area of egocentric inadequacy. . . . Spectacles of the negative that seek truth and precision in an unheard of manner; nothing is forbidden there, nothing is unhealthful. Then come the great moments of silence, holding one's breath, where a person steps out from the décor, where he "achieves his smallest dimension," in which only he seems accessible to the truth, in the intimacy in which the coldness of the century surrounds him like an eerie reverberation.[46]

Nearly every character has such a moment of his or her "smallest dimension": Joachim, Sophie, Konstantin, Frederick—even Martin; only Aschenbach does not. In relation to the spectator, these moments articulate the film as the time in which the beauty of objects has become blurred and degenerate.

The Duration of Decay

In relation to the film, to the interior of this world under glass, social, historical reality is manifest as an absolute exterior in this decay. It is the exterior of the deep dark night, through which Aschenbach and Frederick's car approaches the family celebration, while Joachim is listening to the poem being recited by his grandchildren. It is the night through which the Gestapo task force will very soon roll in. It is the black of night in which Herbert looks out the window while talking to his nephew about the state of things in Germany, only to flee into this night immediately thereafter. It is the darkness from which the soldiers in their black uniforms will show up at the end of the SA gang's revelry. It is the darkness from which Herbert will return toward the end of the film to tell of death, betrayal, and the concentration camps, and of the victory of the National Socialist state. It is such that, in the end, it is by no means clear whether what we have seen is an image of the birth of the Third Reich or of its demise.

While Frederick takes up Joachim's place and rooms soon after the patriarch's murder, Martin—the principal successor and Sophie's frail son—is everywhere in the villa, but without any particular space assigned to him. Instead the exterior weighs on him like the literal process of the decay of the interior. He is even introduced with a stage entrance. The celebration has just begun, Joachim has watched his grandchildren's performance in appreciation, first Frederick and Aschenbach enter the room, then Martin turns on the stage lights, and finally the news of the burning of the Reichstag is delivered.

With Martin's appearance, the transparent light that had so far settled over the objects is literally refracted into its component parts: the muted green of the upholstery, the red-orange of the flowers, the blue of the servants in livery. It is as if the colors had in the same moment been released from the objects and set free from the safe order of things, in which just this

order begins to fall apart. In what follows then, the colorful mix of light—first a cold green, then a blue, and in the end a faded purple—is always present whenever death, betrayal, and desecration occur. And just as the blue of darkness refers to the exterior from which Frederick and Aschenbach make their way into the interior, the red on red, with which Sophie's face is presented and which introduces her character, seems to play with thoughts of the innermost interior. It simultaneously presents Sophie as mother, wife, and daughter in Joachim's realm, as the mistress of desire.

The film is a chamber play of individual passions and intertwined relationships transported into the format of History. What is presented in the Essenbecks' villa is a hermetic cosmos whose interior construction follows an abstract logic. For the relations of the visual space do not follow any geometrical logic of everyday understanding, but instead outline the specific laws of the world presented in the film. The visual space here is identical with a space of perception whose immanent logic of relation is revealed to the spectator as an idea of the entire film.

In relation to this "interno," politics, history is an exterior that becomes comprehensible through the effects that it produces in the interior: the disintegration of the individual psyche and of social relationships, the deformation of desires and passions, the meltdown of the bonding forces of love and sexuality. It is presented as a deformation of all the desires of life and love, a meltdown of all impulses aimed at communality, whether of gender, family, or friendship. But the film is not preaching to the spectators about the relationships between psychic and historical-political reality. Instead it opens up a visual space for them, in the time of their perception, that makes it possible for them to think of these relationships as their own actual relationship to history.

The film presents an image of these processes, an image of the time in which they are completed. It returns time and again to the first scene, the image of the celebratory dining table. And, as if this were marking out the time of the changes, the inhabitants of the house continue to disappear, one after another.

Seen from the spectator's perspective, it is the time in which the beauty of the things breaks apart into a lurid play of colors. Immediately after Joachim's murder, the film returns to the salon, where the stage is still set up for Martin's performance. The light has agglomerated into two colors: a

cold turquoise green and a blazing orange. The catastrophe appears as the time in which the colors mix, begin to dim, and finally fade. The table that once united the family is empty; the objects have lost their human imprints. "I was drawn to the cinema," writes Visconti,

> because I wanted, above all, to tell stories of living men, of living men *among* things, not of things *per se*. What I am interested in is an "anthropomorphic" cinema. . . . My experience has taught me that the heft of a

human being, his presence, is the only thing which really fills the frame; that *he* creates the atmosphere with his living presence. It acquires truth and character thanks to the emotions he undergoes while his temporary absence from the screen will cause things to return to the state of non-animated nature.[47]

At the beginning of the film, the light is diffused in red-orange and green; blue light sprawls over Sophie's bed when she pressures Frederick to commit another murder. At the end, the blue and the red become a shimmering purple haze that covers the objects in the Essenbeck house when Martin performs the marriage of his mother to Frederick. It turns the leached-out violet tones of Sophie's dress and her pale face into an image of death, while the omnipresent black and red of the Nazi flags represent the new order. As if the celebration that began the film were continuing endlessly, we see the salon once again. The room has been redecorated as a dance hall with Nazi flags: half-empty glasses, smoke filling the air, furniture pushed to the side, snuffed-out candles, and the drunk couples lying around on the ground as though after a long night of carousing.

The film is not proposing this image as any allegory of fascism. Instead, its aesthetic construction puts the spectators themselves into a relationship with a historical reality that they cannot get any idea of; it puts them

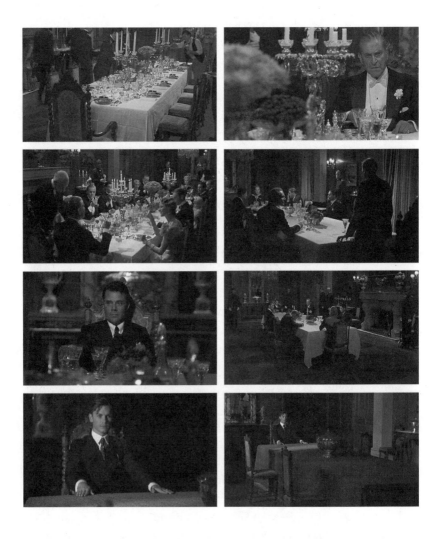

into relation to a catastrophe that cannot be restricted and fixed to any historical event, but instead persists in its effects as the psychic reality of contemporary individuals. This persistence is figurally expressed in the change in the interior. The light shatters into lurid colors, characters disappear, objects lose their vitality; one returns as a witness to the most abysmal murder . . .

4

AFTER '68

The Politics of Form

The experience that the forces of history cannot be grasped in the field of political institutions and discourses but instead pervade the sensations, sensibilities, and emotions of individuals provides a point of connection between Visconti's later films and the new film poetics characteristic of Western cinema in the late sixties and early seventies. Few periods of film history can be found in which films are so deeply entangled in contemporary political discourse and at the same time so skeptical in imagining the possibilities of politics; few periods in which the failure of politics is so vehemently decried and so much value is given, at the same time, to the possibility of aesthetic counterproduction; few periods, finally, in which European auteur film, despite all talk of a countercinema, came so close to Hollywood cinema, to the newly forming New Hollywood. Whether in the guise of British, French, Italian, German, or even American "waves," Western cinema was marked by the search for poetic concepts aimed at a new form of the political. The films indicate a perspective in which questions about love and family relationships, about the relation between the sexes or between friends, about individual self-expression and existential impasses become the central factors in the search for an answer to a palpable crisis in political thinking.

Against this backdrop, I would like to look more carefully at a few films that certainly could not be considered representative for the constellation I have sketched here, but that nonetheless clarify one of its fundamental tendencies. The films were made by three

very different filmmakers working in widely divergent areas of Western cinema—*Warnung Vor Einer Heiligen Nutte* (*Beware of a Holy Whore*, 1971) by Rainer Werner Fassbinder, *A Clockwork Orange* (1971) by Stanley Kubrick, and *The Exorcist* (1973) by William Friedkin. These films achieve their political perspectives less by participating in the contemporary protest movement and counterculture than by maintaining a skeptical distance from the distribution of the moral territory still associated with the models for identity in new youth and pop cultures. What these films have in common is an intellectual coolness, with which they address the antisocial and destructive forces that drive their characters, without creating any kind of moral distance for their individual pursuits of happiness.

I will first turn my attention to Fassbinder's work and to his engagement with Brecht's theories of acting. Following this I would like to introduce a further perspective from which I will investigate the relationship of visual censorship and taboo breaking at the end of the classical period of Hollywood cinema.

Fassbinder: Germany in Autumn

Among the filmmakers of the New German Cinema, Fassbinder is certainly one who was every bit as skeptical about the common presumptions of the protest and youth culture as he was about those of institutionalized political discourse. His films seek to fathom the basis for another form of the political by drawing attention to what drives individuals in the pursuit of happiness and to their failure to achieve it: the failure, to put it in the jargon of the day, of individuals to live up to society's demands. But it is exactly this formulaic resolution that is cast into doubt by the films. Indeed, in these films there is nothing so uncertain as the question of what these social forces are that individuals are failing to live up to. An answer to this question, however, is still expected from the films; at any rate their political conception is based on the idea that cinema is an appropriate way to make the social visible.

For Fassbinder, this problem is posed in light of a long discussion about the relationship between art and society. This was structured by the terms of realism, engagement, and the documentary and was also nourished by

the (Western) reception of Brecht as well as by debates within film theory. Both discussions are exemplary of the discursive constellations that existed toward the end of the sixties. On the one hand, among the signs of radi- calizing political partisanship, we find a purely functional claim on artis- tic activity by politics. This position is concisely formulated in the theses about the death of art, as represented by the journal *Kursbuch*.[1] On the other hand there was a return to the specificity of aesthetic forms of experi- ence, which were opposed to the logic of some simple idea of realism. The various tendencies fall under the vague label of the "politics of form," which insists on the inseparability of all experience from media and form. The model for this would be the films that Jean-Luc Godard made between 1965 and 1972. Art in general and film art in particular is thus viewed as some- thing that works on the forms of experience. This always includes the idea that the possibilities of political action are already limited and disabled in advance by the forms of communication. The structures of political public- ness themselves, their materiality as media, their forms of production and distribution always already form a network in which certain aspects of the everyday world (*Lebenswelt*) can be represented, while others are shut out. Oskar Negt and Alexander Kluge, in their 1972 summary of this discus- sion,[2] understand the idea of the public as the a priori limit of experience, which determines the degree to which individuals can conceptualize the conditions of the world they live in (*Lebenswelt*). Which experiential con- tents of their sensory-physical existence can be symbolized in such a way that they can become conceivable, for the subject of this experience as for others, as the condition of a common lifeworld (*Lebenswelt*)? Anything that cannot be represented within this limit must remain uncertain, unspeak- able, nonexistent. Based on all this, the politics of form refers to a poetic concept in which art is given the task of making visible, of making per- ceptible, everything that had been excluded from the limits of experience set by a commonly shared world, that is, everything that had not existed within this world. In the following I would like to attempt to define such a concept more precisely—using a film that explicitly sought to intervene in a particular social crisis.

Deutschland im Herbst (*Germany in Autumn*, 1978) is a so-called omni- bus film whose episodes were made by various German directors. The film is meant to be an answer by German auteur cinema to the turbulent events

of autumn 1977: the murder of Hanns Martin Schleyer, the skyjacking, the suicides in Stammheim, the gag order, major police offensives. The idea was a film that would take a position on the state of the nation, that would show what was going on in the country and what consequences this had.

Fassbinder's contribution was made under the direct influence of the events that had occurred in October 1977. His episode, which immediately follows the introductory documentary footage of Schleyer's funeral, takes a completely critical stance in relation to the obvious intention of the project as a whole. Instead of taking a firm political stand, the director sits down in front of the camera, mumbling to himself and dragging in his private life in all its unsavory details.

The film begins with a telephone call. Fassbinder is asking the other person to cut the last section of an interview he had just given. Obviously he has lost his nerve and is trying to keep his statements from becoming public. This is followed by a typical Fassbinder interview. The filmmaker speaks, as if extemporaneously, about marriage, which he considers a bad social institution, a social device that we only need because we have been raised to think that we need it. He would prefer it if his films caused marriages to fail . . . A statement that could have been taken from any number of conversations about Fassbinder's self-conception as a film auteur.

At a time during which German artists and intellectuals found themselves exposed to a massive critique for their actual or supposed sympathy for radical-left terrorism, one might expect something quite different—at any rate if it's meant to come across as an explosive public statement by a filmmaker known for his uncivil behavior.

Fassbinder knows very well how to gauge the West German audience of his film *Germany in Autumn*; he knows about their left-liberal sensibility, which includes a stereotypical critique of the institution of marriage as well as paranoid ideas about police action in a state governed by social democracy. He can expect that this audience will agree with almost any critique of state institutions. But he can also expect that it will immediately perceive the pat rhetorical device when the topic is not the institutional violence of the state, but of marriage.

Following this prologue, we see Fassbinder the actor, shown by Fassbinder the director, in the apartment that he shares with his lover Armin Meier. He is also played by Armin Meier, who had already had been used

as an actor in *Mutter Küsters' Fahrt Zum Himmel* (*Mother Küsters Goes to Heaven*, 1975)—and before Fassbinder dedicated a film requiem to him after his suicide with *In Einem Jahr Mit 13 Monden* (*In a Year with 13 Moons*, 1978).

The stylization of the characters' behavior is so self-evident that there is no doubt that we are watching actors. We are watching a play, and in its representation of the marital alliance between Rainer Werner Fassbinder and Armin Meier we see developed the first level of commentary on the statement given in the interview. What we see represented is a bad-tempered domestic tyrant bullying his partner until both of them end up in a brawl, and Armin Meier—as if he were replaying the lead in Fassbinder's *Händler Der Vier Jahreszeiten* (*Merchant of Four Seasons*, 1972)—storming out of the house, threatening to go get drunk.

Acting and Self-representation

What we see is a kind of self-representation presented as acting. We can therefore assume that not only the names and the apartment have been borrowed from Rainer Werner Fassbinder's real life but also the "plot," the way the protagonists behave. At any rate the film is clearly trying to suggest this—indeed, with the same emphasis by which he underscores the quality of acting in the action represented.

So what we have here is neither a documentary about Rainer Werner Fassbinder's everyday life nor fiction. We could perhaps speak of a demonstrative act in the sense of the Brechtian street scene. By presenting what goes on at home as an actor, Fassbinder acts out the answers to the questions posed at the beginning. What is state oppression, what is institutional authority? They are scenes from the everyday life of a relationship in which the conjugal union is represented as the lowest common denominator of the relationship between the individual and society: a social contract that associates the most unmediated forms of individual, instinct-driven expression with the organizational forms of state authority.

A second level of commentary in the film is created by an interview that Fassbinder has with his mother. They discuss democracy, civil courage, obedience, and denunciation. This conversation is also subject to strict staging techniques. As the film alternates between sections of this conversation

and scenes from the marriage, the way the scene is positioned is gradually changed, and along with it the character of the conversation. If at the beginning we see a conventional interview, the situation alters with every cut back to the scene. If the roles were clearly defined at the beginning—a close-up of the mother speaking while Fassbinder, usually off screen, poses questions—Fassbinder himself comes more and more into the frame as the film progresses. The discussion becomes increasingly heated and at the end looks like an argument at the family dinner table. Fassbinder starts shouting, aggressively insulting his mother.

What is foregrounded in the dramaturgical arrangement, however, is not the dubious position of the mother. On the contrary, the fact that she has doubts and expresses them is the only moment that gets beyond the pure power play. Exasperated by her narrow-mindedness, the critical son condemns his mother's wishes for a good father as the ideal leader, thereby only addressing the affective basis for any form of socialization. What slowly becomes visible in the back and forth between a difference of opinion and a family battle is the violence, the overpowering of a mother by the son. Without the least bit of self-doubt, he screams the correct political arguments at her. It is not the better argument that is overpowering, but Fassbinder's increasingly physical presence, his loudness; it causes the mother—and with her the experience of the fascist dictatorship—to fall silent.

This scene seems to reenact the fundamental way that politics was figured in the Federal Republic of Germany: the confrontation between the parents' generation, coming out of the fascist society, faced with the moral accusations of the youth. Seen in this way, Fassbinder's film can be understood as a cinematographic self-analysis of the reactions of the left to the German Autumn. Admittedly, he does not take this left from its public, representative side. Rather, he looks for the "we" or the "I" that takes itself to be part of the leftist public—or at least uses it as a reference point when forming its opinions and fantasies. The film thus attempts to grasp politics where it is realized in concrete social relationships, as a family matter and a complex of relationships. But this is in no way a familial constellation presented as a parable of society. Instead, what is enacted, scene for scene, is a kind of being-in-society that is a concrete experience to be carried out in the flesh.

A third level of the film is articulated in the recurring telephone calls. They form a kind of realistically staged interior monologue and formulate a kind of status report on the increasingly volatile psychic condition of the author: the paranoid fantasies of someone who believes that he's being followed, the insomnia of the fearful, the creativity blocks of the workaholic, the withdrawal symptoms of the drug addict. Mixed in with information on the project in progress, with news on the course of Schleyer's abduction and the death of the RAF founders in Stammheim, this monologue articulates the growing atmosphere of panic.

Fassbinder connects all this to the topic of drug use. The fear of an all-powerful state and the paranoid behavior of a drug addict describe one and the same situation, the same physical condition. When Fassbinder plays with his penis like a scared boy while he's on the phone, when he panics and throws the cocaine that was just delivered into the toilet because he hears police sirens, when he suddenly has to vomit, a highly calculated image of this condition gets articulated. What we can see is a physically real being-in-relationship and behaving-in-relationship; what is staged is an image of the social as an individual physical state.

A *Lehrstück* for Spectators

The film does not describe, as has been said, "the despair of the individual, but is also based upon the political situation."[3] It examines the positions and stances, the attitudes and reactions of those who individually respond to official proclamations and political measures, which as a rule they only know by seeing and hearing them on television or radio. It seeks out terror precisely where it is manifest in the state's critics: in the bodily stances, gestures, and conditions that have long abandoned the reasoning of critical opinion. This physical reality characterizes the transitions and connecting points between the economy of intimate relationships and the regime of state-regulated violence, between the aspirations of individual desire and those of social forces. It is not the private being shown as the political. Rather, general and incessant talk about the fear of the police state becomes understandable as a highly infantile being-present and being-in-the-middle.

These images demand the spectators' constant attention, for this visibility seeks to be unlocked by the audience. The spectator appears, in both a direct

sense as well as an extended one, as someone who painstakingly seeks to recognize, to grasp what is always threatening to escape his perception. The audience finds itself in the position of voyeur in a very concrete sense. It is a kind of Peeping Tom that literally looks through the curtains into strangers' bedrooms. Seen in this way, the film adds to the couples already shown—the tyrannical partner and the oppressed housekeeper, the son who's right and the mother who's mistaken, the police state and terrorism—yet another couple: the filmmaker, turning his public role into that of a character, and the spectator, who observes his fellow humans in all their physical vulgarity.

The film involves the spectator in a game with simulated realities. It gives him a position in the social constellations that he sees. It transforms the cinema into a visual space in which the spectators can understand themselves in their concrete physical being-wrapped-up-in-social-circumstances. They find themselves subjects of an overseeing gaze in a society of informers and paranoids: an embarrassing act of self-exposure on the part of the presumed victims, who see themselves figured as part of the system of oppression.

The fact that Fassbinder does not choose just any apartment as the shooting location, but *his own* apartment, that he carries out this examination on his own body, is the only difference from the director's other films and the other directors of the film project *Deutschland im Herbst*. Instead of using an actor, Fassbinder completely turns himself into a film character as a public figure. The film does not show the real life of the filmmaker as much as it transforms it into an image, occurring as the concrete social reality of the cinema. This literally self-disclosing image is neither authentic nor fictional, and its relation to lived life is no different than all of Fassbinder's other works.

We can reasonably assume that such a thing occurred, but that it was not previously visible, not perceptible—at least not as it is seen and heard here. Only the film staging makes it possible for an image, a gesture, a body, and a network of relationships between the bodies to come into being within this everyday behavior and talking. It gives rise to a physical reality that enters into the realm of conscious perception over the course of the film. This can be better understood if we look more precisely at how the visual space is formed—for instance the light. The rooms largely remain in darkness. Fassbinder's apartment is represented as a shadowy collection of

caves with uniformly dark walls, a dwelling without daylight; the lighting emphasizes only partial views of the characters or the furniture, causing the spaces to be seen as fragments. The same could be said for the level of sound: whether the diffuse exterior noises acoustically veil the characters' speech, whether this speech is lost in mumbling, or whether anyone unfamiliar with the Bavarian dialect will only understand what is said when Fassbinder deliberately repeats his partner's words. In the montage, these optical-acoustic fragments are connected to a black box in which the reality of the physical is prepared and projected out from its everyday interconnectedness, in which it is literally transformed into an image.

Just as Fassbinder, in his other films, rarely leaves interior spaces, just as he hardly ever opens the film up to landscapes and city scenes, since he is seeking landscapes and cities in the characters' sensations, in this film he shows the German Autumn as the affective interior of a film character, represented in the cavelike structure of the conjugal home. We could speak of a change in perspective in his address to the spectator, a change from the psychosocial interior logic of the actions represented to the aesthetic outlook, from the depiction of everyday events to an analysis of cinematic seeing and hearing.

The staging of the visual space emphasizes the gesture of sensation in the actions and behavioral patterns, a sensation that itself lies hidden in everyday behavior; it exposes a physical reality of the social in the bodies of the actors/characters. We could say it makes a "social gesture" visible in the concrete behavioral patterns and physical conditions of individuals. In so doing, the film staging does not represent any critical view on society, but produces the visibility of the social in the first place.

This perspective gives an unexpected twist to Brecht's theory of acting. Indeed, what is unquestionable in the conventional understanding— the possibility of representing social relations through actors who do not embody but narrate—here becomes the fundamental problem. Instead of being sober observers, the actors in Fassbinder's films can no longer attest to any social power relations external to themselves without at the same time placing themselves, in their real desires and needs, in their pursuit of happiness and their need for love, in their striving for recognition and their push to self-realization, at the origin of these relations.

But what then is the social gesture?

Brecht: The Social Gesture

From today's perspective the New German Cinema—the West German auteur film from the early sixties to the end of the seventies—is one of the most impressive testimonials in the history of the impact of Brechtian acting theory. Indeed, one could say that the renewal seen in West German film can essentially be attributed to a new way of acting. In contrast to the cinema of the fifties and to Hollywood mainstream cinema, this way of acting can be described point for point in its opposition to the conventions of realism associated with a kind of psychological acting.

Gestures are here brought forth as masks, and characters are connected to *tableaux vivants* that break up the flow of the action in a series of structural images of social constellations; lines are spoken as if they belonged to an unknown language, and actions of great cruelty are contrasted with facial expressions of sober indifference. Wherever the convention demands synchronicity, correspondence, and unity, the sequences are organized asynchronically, contrapuntally, and discontinuously.

It is not illusionary characters then, but speaking, gesticulating, indicating, narrating actors who dominate this new German cinema. They are comparable to the characters that conquered European cinema in the films of neorealism, the *nouvelle vague*, Bergman, and Wajda. We could even go so far as to say that Brechtian acting was the key with which the West German cinema finally found access to European cinema and then affiliation with international cinema.

Against this backdrop, Fassbinder's films provide perhaps the most impressive evidence of the impact of Brechtian acting theory on West German auteur cinema in the sixties and seventies. Appropriately, the acting style in these films has always been described in its opposition to the realist conventions of psychological acting. In fact, the films seem to reverse the illusionist principle of an art of acting based in psychology. Precisely in this reversal, however, they engage with an idea of the art of acting based on the principle of bourgeois theater, on the principle of that psychological understanding of the art of acting that even today characterizes fictional representation in Western film and television: the anthropological model of the art of acting in the Theater of Sentimentality.[4]

Film and the Art of Acting

In the classical dramaturgy of plot—in narrative cinema and bourgeois theater alike—the actor's gestures and facial expressions formulate an indirect complex of signs that allow us to recognize the character's general and mental constitution. This mimetic subtext discloses the psychological plasticity of the character within the stylization of behavior, while the behavior itself—as objective action and speech—is part of what is represented.

Often enough, however, this relation in the tradition of bourgeois acting can be described exactly in reverse. Namely, when the action—the objective events—merely presents the medium in which the mental reality of the characters can be made visible. The external events become a plane on which inner sensations, invisible and unspeakable per se, can be traced according to their effects. The action represented turns into something gestural, that is, following the psychology of bourgeois interiority, it can be deciphered as an expression and description of an inner sensation, of a living, mental event. The poetics of the bourgeois art of acting, which is maintained in the different varieties of psychological acting to this day, can be summarized as such. The becoming-visible of the invisible and unspeakable powers of sensation is the central visual event.

Even in Hollywood film, this variant is encountered much more often than might be suggested by the common understanding of classical narrative cinema. There are innumerable films in which the action of the actors is the primary conveyor of the expression of a mental event rather than a representation of an objective action.[5] The value consists in the illusion of visibly emerging internal powers; due to the context of the action, these powers get defined in psychological terms and as such become understandable to the spectator as an inner event. Formulaically, this describes the melodramatic core of classical narrative cinema.

In Fassbinder's early films, this mode of representation becomes the starting point for a further reformulation. Lacking the context of an organic relation to action and therefore lacking psychological evidence, the actors' action makes up the gestural play of sketchy fragments of characters and behavior. These can neither be connected to a referential structure of the dramatic action, nor to the psychological expressive logic of internal

movement and external effect. The gestural stylization of the external action does not provide any access to the mental internal logic of the characters, but instead isolates and prepares ways of behaving. Detached from the interior perspective of the acting agent, beyond the illusion of living interaction, they lose their character as the expression of living powers of feeling. What remains is the signifying material of a gestural rhetoric of sensations.

The film *Katzelmacher* (1969) is a case in point here, where this strategy can already be seen in the source of the drama, Fassbinder's play of the same name. The dialogue and scenes are not structured by the framework of the developing plot, however fragmented it may be. Instead they organize the gestural material in alternating series, distributed according to abstract categories like love affairs or love addiction—or group symmetry and asymmetry. In this way they sketch certain types of affects and construct a register of character types: envious, stingy, reckless, opportunist, daydreamer, calculator, narcissist—these may be used to classify the basic elements that are related in various constellations. One can also speak of a dramatic conflict, but this only represents a further alternation in the progression of social tableaux. So, for instance, the thematic motif of the alienated stranger merely forms one variation in a sequence of characterizations; the abstract series takes the place of the dramaturgical action, emblematic gestures of *sensation* take the place of sensing characters. In a quite peculiar way, these images seem to come back to the character masks that were so dominant in the role-play of European theater until well into the eighteenth century, before they were replaced by the bourgeois actor and his presentation of sensibility.

Even the basic referent of the actors' performance can be culled from the original play. The dialogue focuses on everyday activities, on people's banal speech and conduct—quite in the sense of a laconic declaration of Brecht's "new art of acting": "We are concerned with the kind of gesture that happens in everyday life and that gets its form in acting (not pantomime)."[6]

From this perspective Fassbinder's early films in fact seem like studies of the "social gesture" in the medium of film. A changed relation between acting and what is represented can be seen in them, one that replaces the illustrative-mimetic relations between actor and fictional character. In Brecht's writings, this altered referentiality of the actor's performance takes the central place in his reflections on the social gesture.

Starting with these reflections, I would like to make a few comments to summarize this understanding of the social gesture, and then—primarily through the example of *Katzelmacher*—to ask whether and in what way Brecht's concept of gestural play could open up a dimension of cinematographic representation in Fassbinder's work.

The Social Gesture: A (Too) Self-evident Term?

But what is the social gesture? At first glance, and in terms of content, it might seem that the term is perfectly clear. If we can believe the dictionary, the term *gesture* is a rare example of linguistic clarity. A gesture is an expressive movement of the hand or body. And even in the extended linguistic usage of the word the metaphorical logic seems fairly strict, for speaking of the gesture of speech, of writing and action, merely shifts the meaning one level higher in complexity. The presentation of gestures, lines, and actions can itself in turn be accompanied by a gesture. On second glance, however, even the differentiation of the physical gesture from the concept of gesture already includes the whole theoretical problem of the Brechtian actor. This remains to be discussed.

Initially, it is important to understand that the word *gesture* circulates in a clear-cut semantic field. In Brecht's theory of theater the term seems to have a similar specificity. If we follow the conventional understanding, the term *social gesture* shifts the referent of the actor's representation from a psychological idea of the character to the representation of isolated social behavioral patterns. The field of social relationships therefore immediately becomes a dramatic object.[7] Initially, therefore, the social gesture merely indicates the altered object of acting, which seeks to make the act of everyday speech and action visible without mediation.

In this reading, Brechtian acting theory, at least in part due to its impact on the West German auteur film and director's theater of the sixties and seventies, has become a popular common property. It would seem that the great adversary, the empathetic, contemplative, sensitive actor has been so fundamentally critiqued in Brecht's work that he has become the epitome of the naive acting of television soap operas, commercial cinema, and routine theatrical productions. In postwar western Europe, psychological acting, in

terms of art, seems to be lacking a significant advocate, a theoretical basis, and a methodological school.

As is well known, Fassbinder sought to bridge this gap between popular culture and aesthetic-reflexive forms of representation, between reflexive aesthetics and the melodramatic art of entertainment. In fact, in his early films he brings together two ways of acting that could not be more opposed; indeed, he relates Brechtian representational techniques to the gestural rhetoric of the melodramatic acting style of Hollywood cinema. It is this relation that give Fassbinder's films their particular stamp.

But even Brecht's reflections on gesture can be read differently in the context of Fassbinder's films than in that of the sociopolitical, functional definition of theater, such as dominated the West German reception of Brecht. Indeed, there seems to be some similarity here between Brecht's theatrical theories and the common understanding of gesture. The preconception seems to be so fundamentally developed and plausible that one has the idea that nothing could be left open to question.

Was Brecht's concept of the theater so successful, then, that his tenets froze into redundancy? This seems to be the case, at least for the theory of acting. We are indeed inclined, due to the all too self-evident quality of Brechtian teachings, to associate the term *gesture* immediately with its social-theoretical foundation and to base the artistic modes of representation, which are supposed to make social relations visible, unconditionally on a theory of these relations. So, in conventional understanding, the *social gesture* is considered less an aesthetic term than a theoretical anchoring of acting within a political definition of its function. By transforming acting into a diegetic mode, the social gesture makes it possible for the flexible fabric of social relations to be made visible in the characters.[8] Ultimately, the gesture would give expression, in poetic concentration, to what defines social conditions, the logic of capitalist domination.[9]

Seen from the perspective of Fassbinder's films, Brecht's arguments are presented less as statements of a sociological theory of theater than as the self-understanding of the problems of concretely working with actors. We should therefore first look into the status of Brecht's theoretical reflections on acting, into the particularities of his arguments, into—even this is formulaic Brecht—the gesture of the train of thought.

What is evident at first glance is a series of apodictic statements that are always related in strict negation to an overly constructed opponent. The texts confront the reader with vociferous directives, despotic directions, and polemical demarcations. They insist on the singular meaning of the argument and pile up antithesis upon antithesis—presumably trusting that the opposing theses to support the psychological method of acting already have an advocate in the reader.

So the texts describe a discursive arena in which the opposing arguments are called up point for point.[10] They propose a dialectical battlefield between the narrating and the empathetic arts of acting, and the theater, in the ideal case, can only relate to this battlefield as a means of synthesizing the positions anew in each case. Perhaps this is why, where the argument is not developed in speaking a role or taking on the characters' perspective, we can also speak of a dramatic form of the construction of theory where ideas are only fully formed in the concrete practice of staging.

The Individual Gesture and the Individualizing Gesture

But what is the social gesture? In a first step Brecht seems to be using the narrating actor to pull the gestural and linguistic material together. The social gesture is made up of equal parts gesture, facial expression, and words: "By gesture we understand a complex of bodily and facial movements and in general statements, which one or more persons direct at one or more persons."[11] This equation of linguistic and gestural material already marks one significant shift in relation to the conventional understanding of gesture. The opposition of the languages of word and gesture is indeed one of the fundamental intellectual prerequisites for an art of acting based on empathy. For empathy does not mean any autosuggestive trance technique, which would aid the spectator to dispose of the difference between the events on stage and reality, but a kind of mimetic perception that essentially refers to nonlinguistic, precisely gestural forms of expression.

Even today, the understanding of the word *gesture* is essentially marked in this sense by the idea of an unmediated, corporal, and silent expression of individual sensations. Facial expression and gesture, in their opposition to linguistic mediation and social convention, vouch for the truthfulness of

the nonalienated, natural expression of internal sensation; it is this sense of the word that, at the high point of the Enlightenment, becomes the fundamental psychological model of the bourgeois individual through the idea of a new art of acting. The psychological understanding of gestures, movements, and facial expression prevalent today has its basis in a poetics of the art of acting that understands the theater as a medium in which the individual asserts himself in his silent inwardness.

This does not mean the appearance of bourgeois individuals on the stage; this inwardness and this individuality could only be created in the first place by the theater. Within the poetics of the empathetic actor, the sense for gestural expression becomes the seed of a new subjectivity, the starting point of a process of individualization whose place and practice would be the theater. The theater first had to produce the sensitivity by practicing empathy. This is the sense in which Lessing speaks of the individualizing gesture. This does not represent any preexisting world of feelings; instead, it is the act of watching that generates empathy in the first place.

The body of the actor therefore takes central place in the bourgeois theater. The body exposed on the stage becomes the object of the practice of empathy. In the mimesis of the spectator to the illusion of an empathizing individual, the empathetic quality becomes a social, political reality.[12] It is precisely this sense, however, in which we could interpret Brecht's social gesture, which for its part is aimed at a missing, new form of subjectivity that can no longer be realized by the individual.

The poetics of the empathetic theater formed the basis for an art of acting that is still being debated as the norm of psychological realism[13]— even though what is considered realistic has changed according to the times. If Brecht polemicized against this norm, it was because the difference between individual and individualizing gestures had long got lost in the conventional understanding of the psychological art of acting. In the illusion of the character, the actor represents an unalterable constitutional reality of everyday individuals whose way of sensing is so familiar to the spectator that they easily think they recognize their own feelings in those of the character. This is the shorthand understanding of empathy that Brecht means when he writes: "Conditions are reported as if they could not be otherwise; characters as individuals, incapable by definition of being divided, cast in one block, manifesting themselves in the most various situations."[14]

Brecht argues against an understanding of empathy that reduces the activity of the spectator to identifying with the all too familiar emotionality. He opposes this act of self-reflection with the alienation effect and distance. It becomes clear that this is by no means a matter of expelling sensation through the intellect, when he writes that the good actor has to show more than just his character's feelings, namely he has to refer at the same time to other possibilities of sensation: "This does not mean that if [the actor] is playing passionate parts he must himself remain cold. It is only that his feelings must at bottom not be those of the character, so that the audience's may not at bottom be those of the character either. The audience must have complete freedom here."[15] At another place he writes:

> The actor can indeed be "grasped" in the fact that he creates sorrow by experiencing sorrow himself, but then all he is doing is discharging the spectator's powers of imagination, rather than adding anything more to his knowledge. We could say that the one experiencing feelings increases his knowledge of himself, but this is exactly what is not good. Better he should learn to neglect what concerns his feelings, and experience those (the others) of the others! He'll even experience his own better if they're put forward as those of someone else![16]

What lies in the foreground here is the indeterminacy of feeling, the difference from the all too familiar emotionality. With these reflections Brecht is pointing to the experience of a way of sensing that is different from that of ordinary consciousness. He is pointing to an open form of acting that could manage to relate a wide variety of various behavioral and sensation patterns in their difference from one another—instead of assuming a general psychology of human emotional life. The complex of this relational network is the social gesture.

Alienation: A View Outward

We could also say that Brecht simply reversed the matter; in the idea of the gesture he made the implicit theater of everyday social relations into the primary object of aesthetic representation, while the fictional characters, for their part, became the way to describe the social gesture. "Among other

things, a person who sells fish exhibits selling gestures. A man who writes his will, a woman who tries to attract a man, a policeman who beats up a man, a man paying ten men—social gestures lie in all of these."[17] The term *social gesture* shifts the focus of representation from the character to the social fabric of relations in which it moves. Within this field of relations the social gesture forms the constant in a way of behaving (a calculated action, a way of sensing, a type of desiring) that can replace the character's unity.[18] The gesture exceeds and overburdens the character; it destroys the illusion of the character's psychological integrity and replaces it with a reference to the everyday world of the spectator's life. What the actor shows on stage is the social act of everyday speaking and acting. From this perspective the switch from psychological empathy to gesture merely denotes the ideological reversal from psychology to behavioral studies, from bourgeois moralism to historical materialism. The staged mode of representation remains untouched by it.

The social gesture, however, is neither given nor to be emulated as "unmediated." It does not exist before being established and prepared by the actor in everyday behavior. As a poetic concept, the "social gesture" fundamentally redefines the mode of representation in acting. It is aimed at a new form of referentiality, a new form of relations between the social and aesthetic reality of the spectator. The gesture no longer points from the external appearance of a represented body to its inwardness, but refers this body—in its relation to other bodies and things—to an external, alien seeing.

Brecht focuses on this constructed visibility when he seeks to make the logic of the social transparent in the actor's gesture. Gesture denotes the jump from one kind of seeing to another, from the psychological internal logic of a seeing that understands, that perceives and interprets representation as an illustration of the everyday, to the external perspective of a seeing that is alien to representation.

Everyday behavior is not represented in the gesture, but is subjected to another perspective. This other perspective, rather than reproducing the logic of everyday perception, allows the communication acts themselves to become visible as a form of entering-into-relationship.[19] In the social gesture the everyday social world of the spectators can be viewed and examined from the outside as a form of their being-in-society. It represents no

ideologically critical view on the social, but becomes for the spectator the medium of an externally located, alien view on his own, everyday behavior.

Seen as such, it is clear why Brecht poses the term of gesture so starkly against that of psychological illusionism. In setting off the gesture from every form of imagination (empathy, illusion), the gestural can be positioned as an aesthetic modality of experience beyond the dichotomy of semblance and reality. Due to this positioning, the gesture gets back its character as a medium (as the form of experience "watching," as it is developed in Lessing and Diderot), which mediates between everyday reality and aesthetic reality. With the social gesture, the theater of everyday behavior becomes a spectacle for the spectator, who lives this theater as everyday behavior. This distinguishes the social gesture as an artistic form from everyday gestures, whether they are imitated by actors or are part of actual social behavior.[20]

The Invisible Body

If Brecht replaces the illusion of an integral character with gesture, then this is also to deprive the character of the all too self-evident integrity it gains through the actor's physical presence on stage. The body of the actor is released from its reference to the character as its sensually graspable entity and is directly referred to the seeing and acting of the spectator. It is no longer the focus of the spectator's psychological projection, instead becoming an unmediated object of theatricalization in its external forms of appearance. How the actor behaves, his actions, his gestures and movements, all become unmediated—that is, without having to go through the expressive logic of the individual psyche—isolated signs of a body that is no longer disclosed to the spectators as the unity of the consciousness of the self and the physical body. To put it somewhat emphatically, they become gestures of a body whose integrity and life the spectators must realize as a new form of consciousness. The social gesture is the construct of a body that does not correspond to any sensual form of appearance in the spectators' everyday consciousness. This is why Deleuze can say of the Brechtian gesture that it places actions in relation to a body before actions, before becoming visible, and before form.[21] This body is no longer the physical body of self-consciousness;[22] on the contrary, this consciousness is one of innumerable manifestations of this body.

Fassbinder will transfer this concept of the social gesture into a poetics of the cinematic art of acting; even if the ideas considered here produce different consequences for the screen than for the stage. For Brechtian actors, the position of narrating is joined with the representation of what is narrated; they are at one stroke narrators and narrated characters; their bodies, however, their actual physical presence, is separated from the one as it is from the other in order to mediate between the one and the other and the reality of the spectator. In film the narrating position is occupied by the camera, and the real physical appearance of the actors is always already fictionalized by the camera's gaze. Their bodies and their actions are expression, articulation, fiction in every way they appear—they are always already the image of a body, a style of movement, a gestural diction. In this sense the activity of acting in Fassbinder itself becomes part of what is represented. The actors in front of the camera act to the same degree as they represent, and are observed by the camera in this action as the object of the performance. Their gestures and ways of behaving, their visual appearance as performing actors marks one level of expression in the reality represented; it is one part of a cinematographic image of standing-in-relation and being-in-society.

Making Social Relations Visible: *Katzelmacher*

In Fassbinder's early films as well, the theater of everyday social communication is the subject of the acting. In Fassbinder's case we can also say that the actor produces gestures that are already contained in their own everyday existence.[23] But this everyday theater in Fassbinder's work does not at all mean some kind of role-playing of social behavior, but the acting out of empathetic individuals, the private theater of hysteria, the passion of sexual cravings, the pathos-laden expressive forms of the suffering ego. Granted, this pathos is stripped of any illusion of vitality. As if the everyday gestures and ways of speaking, the contemporary hairstyles, the miniskirts, and bell-bottoms were artifacts that had simply been found, the film's staging conducts a kind of autopsy on the ensemble of actors; it draws a relation between the actors in their acting to the dissector's scientific gaze. The gestural play of expression falls apart under the camera's lens into the artifacts from an acting of empathy from which all life has vanished.

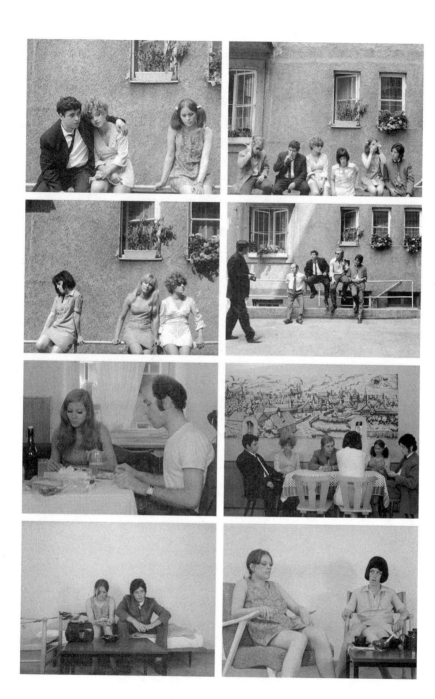

This is what gives the impression of dilettantism, for measured against the norms of the psychological style of acting the fictionalization of characters fails. We always see the same actors, who often give their first names to their characters, but never their bodies. Instead of producing an image of the character's physical presence, they perform gestures as if they were costumes, brought out from the collection of an everyday theater of empathy.[24] In this sense as well, we can speak here of nonmimetic acting.

In Fassbinder's films this shaping principle can be traced in how the dialogue functions. Without any reference back to a sensory illusion of the character, every linguistic expression stands for itself. Spoken by the actors, the lines become what they indeed are: preconceived and written out linguistic gestures, read from a prompter. The dialogue has no connection to any organic entity of living communication, instead forming a compositional arrangement of various speech gestures and lines that, like musical voices and themes, become connected through poses and gestures. A spoken line may remodel the expression of the listener's indifferent face, transforming it into astonishment, or a fixed gaze into the distance may deflate the emphasis in vows of love, but these relations are essentially always abstract and random. The same goes for the actors' physical performance. The various levels of acting—pose, gesture, facial expression—form separate series of signs and levels of expression whose relations have become variable. The organic connection is replaced by an abstract system of combination—repetition, variation, opposition, correspondence, counterpoint. Such a combinatory system can be seen at all levels of the visual space and the montage.

Montage, Combinations, and Series

In *Katzelmacher*, montage is restricted to a very few stereotypically repeated shots: a tracking shot, the long and medium shots of the group, the double portraits and couple scenes in medium close-ups. The close-up is left out. The hermetic framing and the decor, reduced to a very few elements, emphasize the serial character of the individual shot; the visual spaces, isolated in this way, in turn set up a structure of thematic repetition and variation in their assemblage. Their temporal arrangement is pure

succession. The montage therefore does not form any progressive chain of events according the logic of the plot, but a series of fragmentary scenes in a few thematic variations.

We see four couples of varying stability: "Marie (Hanna Schygulla) belongs to Erich (Hans Hirschmüller); Paul (Rudolf Waldemar Brem) sleeps with Helga (Lilith Ungerer); Peter (Peter Moland) lets Elisabeth (Irm Hermann) support him, and Rosy (Elga Sorbas) does it with Franz (Harry Baer) for money" (Fassbinder). This system of unstable equilibrium and changing relationships is thrown into disorder when an immigrant worker, Jorgos (Fassbinder), a "Greek from Greece," arrives and rents a room from Elisabeth. "Instinctive" dislike for the foreigner and sexual jealousy of the supposed potency of southern Europeans unites the group, with the exception of Marie, who "dates" Jorgos. The four men beat him up one day, hoping "to put him in his place." But Elisabeth, who is overcharging him, wants to keep him as a tenant. Helga and Paul decide to get married because she's pregnant, but then break up. Erich goes into the army: "It's better than working." The future for Jorgos and Marie remains a question.[25]

The focus is formed by the figurations of the group, lined up in changing constellations, perched like birds on the railing in front of the facade of an urban apartment house. The couple scenes stand in opposition to this. The reduced decor defines the individual scenes as signs of the most elementary social relations. These are as if reified in the figurations of kitchen, couch, and beer table, in the settings on seats, chairs, and cots. The network of relationships between the characters, reduced here to the semantic value of furniture, has become decor, represented to the spectator as an emblematic structure.

Finally, we should mention the tracking shots, which are inserted like a refrain. They show the alternating pairs of friends, always walking up the same driveway as if they were taking a Sunday stroll. These stylized walks are the only scenes in the film with music. The repetitions and serial combinations join together into semantic units that are more like allegorical symbols and parables than realistic narratives. An example of this procedure is the interweaving of dialogues, gestures, costumes, and props in variations on the metaphor of the "straight and crooked gaze."

The Gestural Parables of Social Relations

In the classic mode of representation, this metaphor formed a psychological subtext that, for instance, exposed one character with its oblique gaze while it confirmed the other in its authentic sensation with the "straight gaze." In *Katzelmacher* the metaphor is worked out into a fundamental gesture that unfolds a symbolic system of references in its repeated modulations. This system defines the position of each of the agents within the field of social power relations, and these relations are consistently defined as sexual.

At the level of dialogue the metaphor is initially associated semantically with the opposition between real love and love that is for sale, in order to describe the "twisted calculations of the sex trade" and the "straight-forwardness" of erotic desire as inextricably intertwined in ever new variations.

In ostentatious gestures—embarrassedly-averting-the-gaze, awkwardly-looking-aside, staring and eyeballing-from-the-sides—the motif is presented as the rhetoric of strategic communication in facial gestures (slander, lies, hypocrisy, betrayal), which both the audience and the actors know from their everyday reality. Correspondingly, in the empty or open gaze-into-space, looking-straight-ahead variably becomes a gesture of naïveté, blindness, and nonknowing.

Like two incessantly commentating orchestral voices, the moralizing talk of the women about honest and deceitful love encounters is intertwined with the gestural thematic line of the "crooked gaze." When the metaphor is introduced with Helga's comment—someone like their friend Rosy, who has sex for money, would end up punishing herself, because such a person could no longer look straight ahead—Marie looks aside ostentatiously. In doing so she comments on the actions of her lover, who had just urged her to turn tricks for him. When she appears shortly afterward with dark sunglasses, which no one wears except for herself and Paul, we understand what she is trying to hide; for Paul—as the spectator already knows—only wears his glasses when he secretly hires himself out as a hustler. The hidden gaze behind the glasses, which we cannot see, is, like fixing one's hair, one of the signs of the direct sex trafficker.

Marie will hold the sunglasses playfully in her hand when she looks "straight ahead" past her lover Erich, gushing about Jorgos, the Greek. She breaks up with Erich and then talks in stereotypical phrases about the straight gaze of the stranger. Finally on her heartthrob's side, she also wants only to "look straight ahead," barely casting a glance at the man next to her. Jorgos, however, looks straight ahead because he literally does not understand the world around him. His stupid grinning does not go unnoticed by Peter and Franz. Both are marked as sexually dependent in the group's schema of relationships and attest to their servile position by an obtuse gaze into empty space. Only once—when Peter lets himself be paid for sex by another woman—does he hide his gaze, wearing sunglasses.

It is a different story for Elisabeth, the character of avarice, who, with heavy false lashes glued on her eyes, is at the same time the character of the wry look. Her power calculations are obvious in all her possible relationships; with a skewed glance, she stares outright at what she might be able to get from the other. Her antipodes can be seen in two characters: Gunda (Doris Mattes), who always speaks in asides, desperately and unsuccessfully trying to conceal her envy, and Rosy, whose dreamy glance is turned to the mirror, reflecting a beauty that no one but herself can perceive.

When Marie and her friends sit on the park bench, slightly apart from one another, and toss bitchy vulgarities lethargically into the void, without even daring to glance sideways at the others, this is no illustration of destroyed human compassion; just a further variation in the realization of this theme. This gets raised a notch in the next scene, when Paul and Erich berate the foreigner next to them at the beer table, all three staring blankly and impassively ahead. Only when Jorgos, not understanding a word of what has been said, raises his head to toast with his stupid grin, do they turn directly to him with open smiles.

In this chain of motifs, as in the film as a whole, the directorial strategy develops a spectator position in which the stereotypical way that human patterns of relationships appear is represented as a serial chain of signs, all of which refer to sexual desire as the basis of social power relations. In the end, and this could be said about all Fassbinder films, the staging of the gesture is aimed at the level where the social relations of individuals are represented as a power relation that utterly penetrates the sensibility and the desire of their bodies.

An Altogether Artificial Life

The action of the actors is executed in constant transition between the different levels of reality in the film without ever finding closure in any character. (For this reason, while there are certainly differences in the actors' physiognomic makeup and their virtuosity, there are hardly any in their acting style.) The acting constantly develops new relationships between the various registers of aesthetic as well as everyday reality, without them ever being brought into any clear arrangement with each other. This is the fictional reality of the film narrative and the represented social reality of West Germany in the first half of the seventies; this is the reality of working actors and that of an audience that watches these works; this is the reality of fictional characters from other films, from novels and plays, and that of the people who watch these films and read these novels.

In Fassbinder's early films, the act of performing is essentially defined by these transitions, a kind of ritual repetition with which the actor shifts from one mode of reality into another, from one actuality into another. I would like to comment briefly on some of the various relations that are at play here. On the one hand, there is a reference to everyday behavior in the act of performing; on the other hand, the relation between ordinary speech and literary language; furthermore, there is the rhetoric of the sensibility-laden gesture, of the psychological performance of feelings, and finally the self-referentiality to the act of performing itself. We almost never find these various relations in their pure form, even if one or the other variation might be dominant in individual films.

The representation principle that we have described seems particularly telling in the relation between the spoken dialogue and everyday language. In *Katzelmacher* it is Bavarian dialect, refashioned into rigid formulas. The framework of an artificial grammar of double negatives and the displaced indefinite article is precisely not any kind of mimesis of living, colloquial speech. Rather it takes the place of the illusive living language. In this way the vernacular qualities are fragmented into an ensemble of abstract linguistic gestures. They are spoken by the actors like words from a language that they don't know, that they are practically reading from the page. They read the lines as expressions of a life that is foreign to them, and this act of reading becomes the primary object of the film's performance. It is

not the result of the reading—the actor's interpretation of the dramatic characters—but the act itself, the spelling out of the linguistic gesture, that takes central position. The actor's reading exposes the character to us as the abstract mental reality of a life that is radically external to us, namely as literature: *Pioniere In Ingolstadt* (*Pioneers in Ingolstadt*, 1971, TV), *Fontane-Effi Briest* (1974),[26] *Berlin Alexanderplatz* (1980), and Fassbinder's last film *Querelle* (1982) are the telling examples of a highly specific form of cinematographic engagement with the lives of literary characters based on this concept of acting.

We have already mentioned the reference to everyday behavior. This is the focal point of *Katzelmacher*. In this film it is not living characters that are represented, but actors whose appearance, language, and gestures describe isolated complexes of thinking and feeling. They unfold, gesture for gesture, line for line, an allegorical contact sheet, varying the emblematic and affective qualities of the stock type, which evades any direct identification as a character.

Instead of the expression of living feelings, we see the rhetorical gestures of envy, fear, avarice, contempt, and greed; instead of an organic relation, we see the corresponding signs of the same old story: desires for love and trafficking in sex, subjugation, and deception. As in baroque paintings of beautiful women who represent allegories of moral temptation and virtue in their sensual objectivity, every detail of how social reality is represented here gets infected with an abstract symbolism. All that remains of the gestures of living sensation, which psychological acting had spawned, are depleted attitudes. We see a rhetoric of emotions and desires disclosed in the symbolic images, which has the same relation to sensitive expression as a death mask has to a living face.

This signifies the fundamental meaning of the third system of relations, the reference to the aesthetic reality of the rhetoric of acting. This relation clearly takes the foreground in those films that are based on a strictly codified system of theatrical behavioral patterns—for instance the early gangster films or the Western *Whity* (1971). The plot prototypes of genre cinema are released from their linear narrativity and reshaped into series of repeating and corresponding gestures. Going back and forth between the relation to everyday behavior and the theatricalized gestures of genre cinema, the actor's performances describe a space in which the only thing about

a character that is still visible is his habitus. It is a fragile visibility, which emerges between the registers of mimetic behavior and the artifact of the gesture of feeling that is being cited. The acting describes mimetic figurines such as those made up by children when they imitate their favorite stars in front of the mirror. In *Whity*, for instance, these are the gestures of cowboys, the way the body stands when it is loaded up with revolvers, the ritual of barroom brawls and the brawl as ritual, to which completely ordinary behavioral patterns are referred. The characters in these films are "actors who have seen a lot of Westerns and gangster movies."[27]

In the end, we can also describe the acting in its self-referentiality, in its reliance on the dimension that Brecht called the gesture of showing: the actors in their reality as acting persons. In *Warum Läuft Herr R. Amok?* (*Why Does Herr R. Run Amok?* 1970) the relation to reality of the act of performing proves to be fundamental representational principle. The film shows actors constantly looking for the lost text, the definitive gesture, and this is exactly what their characters are: actors who are hastily grasping at gestures of expression that elude them, who stumble from a failed gesture into a resigned silence that increasingly calls up the image of a helpless actor. In *Warum Läuft Herr R. Amok?* the distress of the actor, who continually fails in the transition to his character, who is constantly off target and nonetheless does not stop grasping for it, becomes the image of the sensitive character.

The actor's reality becomes visible precisely because the actor does not embody any integral character. Instead, there are transitions between the action being played out and the image of the actors before this action, their motionless, mute waiting between gestures and lines that they have to present in the next breath, the visible emptiness of the time elapsing before their cue. As structural elements, these empty spaces merge into the configured time of the cinematographic image, into the performance. So we could describe the acting in *Katzelmacher* as the interval between putting-into-gesture and the state of waiting, between acting and just being there in front of the camera. And this mere being-there-for-the-camera of the face and of the body should be distinguished, as the reality of the acting ensemble, from the gestures of boredom and waiting that gives form to the group life presented here. It is the time that elapses when Irm Hermann enters the frame and waits before repeating the gesture of despotic

rage—without being connected to or derived from any emotional life of the character. The actress, waiting for her cue, allows for a space of resonance to arise that produces exactly the intensity of expression one expects from the living emotional gestures in psychological acting.

In *Katzelmacher* these moments of the pure elapsing of time before action, of the emptiness in the faces before facial expression, and of the actor's habitus before gesture introduce empty spots into the acting that give the film a vitality that is lacking per se from the acting. It is an altogether artificial life. With *Warnung Vor Einer Heiligen Nutte (Beware of a Holy Whore, 1971)* or *Chinesisches Roulette (Chinese Roulette, 1976)* we can retrace how the movement of the camera and the characters is connected to a choreographic spatial description that allows us to understand this life as a force passing through individuals, enclosing them and putting them into relation with one another, joining them up into couples, groups . . . into the life of a community, taking shape in the artificial figurations of film composition.

The Life of the Community: *Beware of a Holy Whore*

The group is the focal point of Fassbinder's first films: the band of gangsters in *Liebe Ist Kälter Als Der Tod (Love Is Colder Than Death, 1969)* and *Götter Der Pest (Gods of the Plague, 1970)* or the clique of friends in *Katzelmacher*. The films present the group as a social network containing all possible social relationships; there are sexual, economic, and emotional exchange relationships made up of connections based on love, friendship, and work. All relationships, that is, but familial ones. The characters in these films originate from models taken from genre movies, not from living parents. One might assume that these fatherless connections would form an image of free communities.[28] But these relations, unchained from the shackles of patriarchal order, are presented highly ambivalently. Fassbinder's early films show the group as a horde of brothers and sisters who have gone wild after the death of the father.

The relationships within the group develop according to one and the same pattern. The small change of erotic attraction, like the high stakes of friendship, functions as an investment of equity capital in the business

between bank robbery, small-time crime, and everyday prostitution. But this is not a critique of the economic basis of all relationships. Instead, money is the transformer that translates emotional bonds, as well as business connections, into sexually based power relations. The desire for friendship, love, sexual union seems, like the desire for wealth, inseparably bound up with the desire for subjugation and oppression.

The films are therefore far from proposing any image of community in the group that could somehow get beyond patriarchal forms of socialization. Nonetheless, they explicitly refer to such a utopia; they refer to the group as the idea of a community free from domination, such as was circulating in political discourse at the time.

1969, 1970 . . . —these are the years in which this communal ideal arose out of the experience of failure in the classical politics of the public. Consequently, attention was increasingly turned to the social bonds of family and gender relations. In this context the group appears as a form of collectivity that, with one stroke, would replace the old love and family relationships as well as those of work and economy—if not for the masses, then at least for the few. It represented an ideal of the social that sought to test out the reality of the commune as a straightforward community of free persons, loving, working, and discussing together. Enriched by the emphasis of youth, pop, and hippie culture, the group became a utopia of sociality to be realized in the here and now of bad social conditions: "Paradise Now!"

This is the title of a play that caused great furor when the Living Theatre performed it in Paris and Berlin during May 1968. The happening sought to put real social conditions together with the utopia of liberated sensibility. It celebrated the fantasies of merging into an unlimited community of lovers, unburdened from the shackles of social conventions. Bringing together actors' ensembles and a young audience as an intermingling of bodies, writhing naked on stage, it claimed this fantasy as an immediate reality. This utopia formed the projection surface on which Fassbinder's early films, for their part, made visible how much the reality of the group was always already imprinted with that of society.

Preparadise Sorry Now is the title of one of Fassbinder's first plays, and *Warnung Vor Einer Heiligen Nutte* explicitly refers in its final sequence to the play by the Living Theatre as an emblem of contemporary political youth culture.

In a hotel somewhere on the Spanish coast, a film crew waits for the director, the star, the equipment, and the production money from Bonn. The mood swings from apathy to hysteria. When the director Jeff (Lou Castel) arrives with the star (Eddie Constantine as Eddie Constantine), he finds himself instantly surrounded by chaos. Couples and groups intermingle. Eddie, who is twenty years older than most of the other members of the team, is as neglected as a fossil until he makes contact with Hanna (Hanna Schygulla). Meanwhile, preparations for the film move along. Jeff explains an especially complicated shot to the cameraman, and tells Eddie the basic idea of the film, Patria o Muerte: it will be a film "against state-sanctioned violence."[29]

The summary conveys the atmosphere of a confused lack of orientation that dominates large sections of the film, well before the audience gets any indication of a space, a location, a story. *Warnung Vor Einer Heiligen Nutte* presents the group in a state of waiting, of blocked action, of time standing still as a spatial figuration, something between a meticulous study of milieu and the grotesque.

The film looks into the power relations in the erotic and emotional bonds of a group that in some ways took itself to be a countermodel to the reality of social relationships. For *Warnung Vor Einer Heiligen Nutte* shows us a community that had been in all nine of the films that Fassbinder had shot to date: namely the production team that had its origins in the artists' group of the "Anti-Theater," which Fassbinder had been working with since 1967. This artists' group saw itself as the test case and experimental field of a new form of collectivity.

A Self-experiment in Film

Warnung Vor Einer Heiligen Nutte has therefore been discussed, both in film criticism and in academic film studies, as a key film that rather pessimistically sums up the first period of Fassbinder's artistic work; the film marks "the end of a collective which came together in the Action-Theater and *Anti-Theater*, and made up the crew in his earlier films."[30]

This is consistent with a poetic process that constantly mirrors two realities: the internal, performed reality of the film and the production reality

of film. The film describes what it is itself: a film production that is bogged down by money problems, conflicts in relationships, and group dynamics. It puts a *mise en abîme* into the work that, in place of a first and a last image, opens up the visual space to multiple mirrorings. Fassbinder, who plays the production manager Sascha, and Karl Scheydt, who plays the producer, are still wearing the costumes they had worn for a film shot a few months earlier, the gangster suits from *Der Amerikanische Soldat* (*The American Soldier*, 1970), while the plot and locations refer to the shooting work on *Whity* (1971), the film they had just completed in Spanish Almeria.[31] Lou Castel, who plays the character of the director Jeff, wears Fassbinder's leather jacket, and although Irm is played by Magdalena Montezuma, her voice is dubbed over by Irm Hermann. Hanna, the female star, is a silhouette portrait of Hanna Schygulla, the star of the troupe, and the American star actor of bygone days, Eddie Constantine, plays the American star actor who can still get a role in European cinema playing in homage to himself.

But the film would not be worth talking about if it were merely articulating a statement like "This group is unbearable; I'm not going to work in it anymore." In fact, in *Warnung Vor Einer Heiligen Nutte* we see the first development of a form of staging that will be taken to a new level a few years later in Fassbinder's contribution to *Deutschland im Herbst*: the constant turn to the self of performance, an I and a We of the film, which in its psychic models of reaction and social interaction incorporates two opposing things within itself—the desire for freedom and self-determination and the desire for subjugation and oppression.

The film is a kind of self experiment. It describes the position of the victim of social structures of repression as that of a subjugated subject inextricably ensnared in the mechanism of oppression by his own desires and actions. The group, which is working on making the power mechanisms of social relationships visible by means of art, watches itself as the object of this work. It examines the social structures of domination not as some sort of power lying outside the group, but as its own internal life.

With the turn toward the self, the subject of the critique itself becomes an immanent relation of the power structure represented. In the film's inverse mirroring, the conditions of friendship, love, and work clearly become the reciprocal position of mutual repression. Even the critique of these conditions is only a further ploy in the game of alternating positions

between being the subject and object of overpowering, of exclusion, of rejection, of humiliation, of overreaching, of deception, of violence . . . and even of criticism.

When Lou Castel, as the director of the film in a film, says that they wanted to make a film "against state sanctioned brutality," then on the one hand that is—on the diegetic level—a stock phrase of contemporary political jargon, but, in relation to the actual film production of *Warnung Vor Einer Heiligen Nutte*, this is a pointed comment on what they are trying to make visible in the emotional embroilments of the group (which they themselves are)—the physical basis of those abstract powers called society and state.

But how can what is excluded from the limits of experience within a given sociality be made visible? Indeed, the entanglements of desiring individuals and social mechanisms are not visibly available per se in any way that would mean simply turning on the camera and capturing an image of the group as a social fact. Neither the forms of how the relationships between individuals appear nor the forces with which the one impacts on the other and by which they are interconnected are visible or depictable on their own. This is even more so for the mechanisms by which every individual, and the group as a whole, become components of that power structure which the artistic work is fighting. They are part of state repression and social oppression. These mechanisms necessarily lie outside the group's self-images and self-descriptions; they lie outside the limits of perception that the group making the film *Warnung Vor Einer Heiligen Nutte* shares with the group shooting a film within the film. The visual space in which this off space of external perception and self-perception becomes visible must first be created—as a form of perceiving social conditions.

A wide variety of directorial operations are needed to take a given place (for instance a hotel lounge in the nowhere of a Mediterranean vacation destination) and a given ensemble of actors (for instance the troupe of the Anti-Theater, which produced a quick succession of theatrical performances and films) and to get out of them an image of the social conditions that this group is—an image in which behavioral patterns and gestures can make the physical reality of the group visible as a social fact. Only by staging the cinematographic movement image can a visual space arise that the spectators can grasp as the image of a social structure, precisely to the degree that they can see themselves located as a movie audience in this space.

Couples, Groups, Production Conditions

Given this problematic, the beginning of *Warnung Vor Einer Heiligen Nutte*, or more precisely, the first fifteen minutes of the film, is an appropriate place to trace the directorial operations that produce the image of the group as a medial form of perception.

The film begins with a prologue: We see Fassbinder's friend, the director Werner Schroeter, telling a ludicrously comic story. The prologue serves to set the mood. It sets the zero point of the actors' performance, in which the spectator sees an actor improvising, searching for the next word, until finally he looks into the camera, expectantly, insecurely, as if he were waiting for a cue to signal the end of the take.

We hear a piece of popular music. A cut reveals two women, Babs, the script girl (Katrin Schaake), and Billi, the makeup artist (Monika Teuber). Their gazes, concentrated and observant, indicate a space outside the frame. Obviously they are discussing another couple that they have in clear view. "Look how he's offering him a light." Another cut shows two men; their gazes are intertwined, as are the gestures by which one of them lights the other's cigarette (Marquard Bohm as the actor Ricky and Herb Andress as Coach). The women's line of sight is positioned so that it perpendicularly cuts the line formed by the male couple in profile. We see the two women again—one of them leans back in her chair, fixing her eyes on the other woman, who is playing with her curls, lost in thought; she seems spellbound by the view of the two men outside the frame; now the sight lines form a right angle within the shot.

Another cut: We see Fassbinder in the role of the production director Sascha and Scheydt as the producer Manfred. Sascha screams into the telephone while Manfred watches him. Once again the sight lines meet in a right angle. In what follows, this geometrical figure is repeated in ever new variations: two intertwining gazes form a line that is cut at a right angle by a gaze from outside; then this arrangement is repeated within the shot.

The succession of the sight lines, related to one another in strict angles, articulates a tension that is soon seen to be a disharmonious network. One person looks sternly at another, while the latter is unaware that he's being looked at. Then characters appear whose walking transforms this tension into lines of movement. The lines of movement follow the same principle:

sometimes they cut one another into dynamic right angles; sometimes they meet in direct opposition like the intertwined gazes; sometimes they continue on from each other like in a relay race. There is no master shot, no preconceived space. Instead, a movement image is gradually assembled: loosely attached segments, individual characters, couples in conversation, all connected with each other by the arrangement of the lines of sight and the lines of movement created by people walking.

Finally, the last element is added with the movement of the camera. At first it follows the characters walking, only to develop a movement of its own soon thereafter, which gives it enormous presence. Even before a space of action becomes perceivable to the spectator, a diagram of a network of relationships has been set up.

The first piece of music ends, and an utterly unrealistic sound of waves crashing and surf sets in. These background noises can be heard time and again, whenever a moment of silence occurs between two pieces of music (which are almost always played through to the end). Uli Lommel, the best boy of the team, has his entrance. His steps conform to the music as it dies away like the rhythm of a tap dance. They delineate a semicircle that the camera follows in a sideways movement. The space turns out to be a wide circle, strictly marked out by columns in the foreground and floor-length windows in the background. Lommel reaches the group of characters at the bar. In the actor's passage, the various elements of the emerging space consolidate into a movement image.

Time Becomes Space

The camera frees itself from the walking actor in order to continue this linear movement in an independent circular movement. From here on this circling provides the fundamental movement; within it, the camera and its unforgiving gaze become insistently present. Over the four or five minutes of the piece of music, a visual space is created that translates all of this—the tension in the fragments of dialogue and sight lines, the conflicting gestures and the characters' walking—into a single movement.

We get the impression that the circular movement was already contained in the montage of the scenic fragments, even before it took off from Lommel's walk as an independent camera movement. In the distribution

of the couples, the montage not only describes the given space, the circle of the hotel lounge, but the circular movement of the camera simultaneously. When the spectators finally identify this circular space as the space of action, this merely marks the first dimension of the cinematic visual space.

After Lommel's entrance, a new piece of music is introduced: "Suzanne" by Leonard Cohen. The song marks the beginning of the second part of the opening sequence. The production is on the skids because there's no money, because there's no film stock, because there's no director, because Jeff is not there. The production demands are shouted about noisily—Fassbinder/Sascha runs around screaming, insulting, arguing—while matters of love are quietly discussed in couples—sometimes in English, sometimes in German, sometimes in French.

The opening sequence shows actors waiting for their director and characters waiting for the author; it opens up a visual space in which the state of waiting becomes visible. In the dialogues, in the derogatory words articulating envy, resentment, and lechery, this image is semantically specified as a parable of social relations. We could describe this as the second dimension of the cinematic visual space.

We have to look at the temporal structuring of the entire film in order to get at the specific meaning of this sequence. After the prologue (Schroeter's talk, which lasts about three minutes), we see the long opening sequence, which itself is subdivided by three pieces of music. Then there is a ten-minute interim section showing a succession of brief scenic fragments, loosely connected, all grouped around the director's arrival at the shooting location. Then, in the twenty-ninth minute, the dance in the round of the hotel lounge is reintroduced. This time it lasts a good twenty-five minutes, once again subdivided by pop songs.

Only at the beginning of the second hour does the film change its representational principle. Now we see fragments of scenes grouped around the shooting activities at the villa. Finally we see an epilogue, which strings together individual scenic miniatures as loosely connected, reflexive commentary.

During the majority of its running time, *Warnung Vor Einer Heiligen Nutte* circulates in two interior spaces: the lounge of the hotel, where the group is living, and the entrance hall of the villa, the shooting location of the film that the group is making. In a mutual mirroring, both interior

spaces are developed as a polyvalent frame of reference. This is done first as the locations of the action, then as an allegory of social conditions, and finally as the time in which the artists' group becomes visible as a social fabric. We could describe this time of becoming-visible as the third dimension of the cinematic visual space.

A Choreography of Relationship Models

Exterior shots are inserted like intermezzi into the interior views of the hotel: small scenes on the set made up of Mediterraneanlooking hotel terraces, gardens, and sea views. These idyllic postcard views constitute an exterior that vaguely refers to the stereotypes of holiday advertising. Even the shots through windows appear as if they were framed landscape pictures, organizing the background of the visual space like oversized photo wallpaper murals.

Between the windows hang the kind of kitschy paintings that could be found in department stores in the seventies—boys crying, girls playing, and monumental paintings of animals. On the side facing the windows, a no less kitschy religious statue is set up like an altar.

In the camera's circular movement, this space appears like a cathedral, composed of a series of side chapels. This impression is made even stronger by numerous columns. Finally, the hotel lounge is represented as a circle with several subdivisions, surrounded by pictures and statues like an arena surrounded by spectators. This space may occasionally experience other semantic attributions, according to which action is being presented in the center of the circle. But regardless of whether we see it as a site of battle or a site of sacrifice, it is always a site of spectacle, a stage where the actors try to place themselves into performance as the characters of this film.

Thomas Elsaesser has pointed out that Fassbinder's characters are often defined by the drive to be seen; they force themselves onto the stage of self-representation as if they were fearful of what was outside the field of vision:

> Their desire is not roused by the bank-robbery, the contract-killing, or the hold-up, and not even by the acquisition of money or women (though all of these appear as overt goals). A more ambiguously coded desire animates

them . . . to play a chosen part "correctly." Both men and women have a conception of themselves, determining their behaviour and gestures, of how they wish to appear in the eyes of others: as gangsters, pimps, tough guys, prostitutes, *femmes fatales*.[32]

In turn, the characters enter into an exchange play of schematically fixed roles and positions. Sometimes they appear as desiring lovers, sometimes as the object of desire; sometimes they take up the position of the excluded third party, sometimes they stage themselves as an object for the envious gaze of others. This is as true for work relations as it is for erotic bonds: whether it is the stars and leaders of the group presenting themselves as such, whether it is the team as a whole putting itself on display for those who do not belong: for instance, someone who applies for a job on the film but is only assessed on the basis of her erotic surplus value, or someone who promotes his sexual qualities, but is only disdained for doing so, or the servants who not only take orders but also have to deal with filth and abuse.

In quick succession these positions are exchanged without dissolving the blockade, without the plot being able to get out of this self-circling mirroring.

Each of these positions in turn is to be alternately occupied—at one of Sascha's aggressive commands, Babs has to give up her position as observer to enter the circle of working activities, while Billi forms a new couple with Ricky. An interplay thus develops over the course of the sequence, gradually accelerating, between the positions of erotic couplings, the working group, the excluded other, and the superior observers.

Once the circular space of the hotel lobby has been defined, the alternating shots between the individual couples, the group at the bar, and the characters' walking, followed by the camera, thwarted and then continued, quickly gain a certain dynamic. A barefoot girl enters the middle of the space and begins to dance. The fragments become smaller, the characters' lines of sight and movement become opposed ever more quickly: here a dialogue, there a returned gaze, a man at the bar, a man on the telephone, a walk that connects the one with the other, a new character whose walk cuts the line of the previous one, another walk, from the opposite direction, that newly opens up the depth of the space. The offers of love, gestures of humiliation, subjugation, and subordination are exchanged in ever quicker succession; the snatches of dialogue and the actions of approaching, rejecting, and triumphing in love and work become ever more dense and concise.

The music changes again: doing nothing, talking at each other, talking over each other, observing, slandering, commenting, yelling. Until the telephone rings—the music goes quiet, the conversations end, the dynamic embroilment of the lines of sight and movement dissolves into visual accord. All the characters pause for a tense moment and turn to look at Sascha, who is speaking with the director on the telephone.

The camera's movement allows for a temporality, a duration to arise that is contained in every element of the scene represented: in the characters that enter the field of vision as well as in the tension of the lines of sight and movement cutting into one another, in the attacks from the looks and words as well as in the changing music and the characters walking.

Every element becomes part of this circling, becomes an element of a strictly constructed movement image. This intense visual entanglement is repeated at the level of the score. Indeed, the conversations, cries and

whispers, the noises, the steps, are embedded in the musical composition in the same way that the gestures and looks are in the camera's circling. The words, the alternating volume, the abrupt changes in the mode— raging, apathetic, slandering, reflective—are spoken to the music just as the steps are inserted as the beat and reverberation of the music, rhythmically accentuating it. In the interweaving of acoustic and visual structure, an optical-acoustic visual space comes into being—a visual space that turns within itself, built from the gestures, words, and looks of the actors. This image turns slowly into a dance whose choreographic logic starts to take in the spectator little by little. The lines of sight and movement form a visual beat pattern that inscribes itself into the acoustic space of the music like the circular movement of the camera, which formulates something like a counterpart to the dynamic angles.

The Time of Becoming Visible

When the director flies in on a helicopter in the eighteenth minute of the film, as if he were the star of a political thriller, this spatial construction is run through once again; the dance is started over again from the beginning. Like two overlapping transparent images, in the variations between the first (minutes 3 to 18) and second sequence (29 to 55) in the hotel lobby, the group's relationship patterns start to become visible within the changes and deviations. For now, in the repetition, the leaders are all present: Jeff, the director, Eddie Constantine, the male lead, and Hanna, the female lead. (Jeff berates the team, just as Sascha had berated his co-workers. Hanna Schygulla, the female star—gentle, absent, as if she didn't belong—marks the upper end of the hierarchy. Eddie Constantine makes up the observing third party, so strange and excluded, as if he, the star, were actually a guest from another galaxy.)

If the gestures of work were separated and contrasted with those of eroticism in the opening sequence, now every work relationship is imbued with erotic desire and every impulse to love is impacted by the hierarchy of work. Sexual relations are reduced to subjugation and dependence, work to sexual desire. A sweeping shot from the camera, showing the circle of the entrance hall in a wide shot, introduces the sequence. In the middle of the arena, Schroeter and Montezuma dance; the groupie is lying on

one of the couches, lost in sex games with two men, on another couch the makeup artist is making out with the lighting technician.

Little by little the space is filled up; the entire staff of the film shows up. Like an allegory made flesh, Magdalena Montezuma plays Irm, the betrayed beloved, who was promised marriage and now finds herself rejected. At one and the same time she is cheated out of her wages by her boss and fired without a thought. Jeff enters the arena like a dilettantish stage actor and knocks the woman down. Apathetically, and with hushed expressions, everyone around follows the action, which seems more like a rehearsal for a big stage appearance, as if they had studied the gestures of abasement that they are respectively performing or having performed on them.

In a countermove, the cameraman turns up; followed by the circling camera, Jeff paces out the space with him, quietly explaining his idea for the film. This purely professional conversation is added into the picture of a seemingly unbearable network of relationships like a utopian counter-model, as if the pure working relationship could assuage the horror of the everyday being-in-relation for a short while. With this conversation the camera escapes from the network of relationships, almost floating on the steps and words that the cameraman and director are exchanging here. Little by little we start to understand the explanations Jeff gives the camera-man for the film. In fact, the apotheosis he is describing applies to the scene that he has just played out when he knocked down Irm/Montezuma. In the conversation with the cameraman, Jeff describes how the main character of the film knocks down his wife. The film that he wants to shoot, "against state sanctioned violence," is founded on the violent relations of the group that is producing it.

The hall empties out again, until twenty minutes later, when the second sequence also comes to a climax in a slow rotation of the camera, measuring out the circular space of the lounge in its entirety; the space is empty; in the silence we can hear waves crashing. The four men at the bar are singing a chorus of suffering and pain, a last appearance, a last self-presentation, a fade-out in the fifty-fifth minute. In essence the first hour of the film is the time, the duration of the group's coming-into-representation.

In the partitioning of the space, the circling camera breaks down the duration of the characters' coming-into-appearance. On the one hand, by attributing to every couple, every face, every body, every gesture a place in

the spatial network of relations; on the other, through the fact that each of these attributions and relations itself represents a moment in the creation of the movement image at the same time. For the spectator, it is represented in the end as a circular protrusion over the sea—a rotation, a circling, which is as concrete in space as it is abstract in time.

In fact, the presence of the camera marks a position that lies entirely outside the group; it refers to the spectator, whose attention the actors are competing for. We could say that the camera articulates the time in which the ensemble of the Anti-Theater, Fassbinder and his film crew, becomes visible, forming themselves as characters. It is the time in which the group of Fassbinder actors—in their desperate endeavors to represent characters, which they themselves are—seek to be seen and understood by the spectators, the audience.

In *Warnung Vor Einer Heiligen Nutte* all social forms of expression are led back to the desire and suffering of the individual. The film represents a drama of sex in even the most banal activities, a drama that completely obeys a logic of submission and domination.[33] We could, paraphrasing Gilles Deleuze, say that in the endlessly repeating description of the gestures of sexual violence and submission the body of the individual, its physical form of existence, emerges as an incommensurable matrix to which all social conditions—even acting—are related.[34] Social forces are not represented as an externally located structure of domination, but as endless ramifications of a desire that has its basis in the bodies of individuals, in their desires and needs.

The idea that the cinema has the aesthetic potential to make this entanglement of psychic, historical, and social reality viewable can once again make the utopia of aesthetics the formative sign of Western cinema in the late sixties and early seventies. It defines European auteur cinema as much as it does the films of New Hollywood.

5

BEYOND CLASSICAL HOLLYWOOD CINEMA

Shock Values

The term *postmodern cinema* is problematic in many respects. We use the term to describe a cinema that no longer operates within the dichotomy of classical narrative cinema and auteur cinema, instead drawing on citation, pastiche, and crossover to refer self-reflexively to the history of cinema, using it as a reservoir of images, styles, narrative forms, and generic phrases.

Now self-reflexivity and self-referentiality are phenomena that may be taken as typical of aesthetic modernity. They also characterize the fundamental innovative movements in Western cinema from the *nouvelle vague* to the New Hollywood. In retrospect, this period of cinema from the sixties and seventies has proved to be a time when the old orders and boundaries of film culture were dissolving and the entire field of visual culture was restructured.

This restructuring was carried out as a constant attack on the boundaries between what was permitted and what was prohibited, between clean and dirty images. We might see this as an expression of a libertarian spirit. But that would merely reduce the problem to the question of a more or less effective politics of censorship. The more important question is, what gets defined through the forbidden images? What economy do the bans follow? What are the ideas associated with dirty images? Or with the notion that such images unleash highly destructive effects?

In fact, Western cinema during the late sixties and early seventies seems precisely to be trying to organize these effects. Using the shockingly obscene, the morally reprehensible, and the hideously repugnant, it focuses on a specific potential of experience in the medium itself: a potential of experience that is similar in some ways to the use of illicit drugs—namely in the possibility of getting beyond the moral regime of everyday perception.

Before this backdrop, postmodern cinema appears to be the reconstitution of such a moral regime, albeit with new demarcations. In order to develop these thoughts, I would like to start by examining the film concept of an auteur who is often taken as typically postmodern, Quentin Tarantino. Continuing on from this, I will then attempt to define the concept in its reciprocal relation to other modes of cinematic representation. Finally, we can examine Stanley Kubrick's *A Clockwork Orange* (1971) as the representative example of a film-poetic concept in which the power of the shockingly obscene image becomes the focal point.

Dirty Pictures, Brilliant Entertainment

At the very latest since *Pulp Fiction* (1994), Quentin Tarantino has been considered one of the most important representatives of postmodern cinema. His films—from *Reservoir Dogs* (1991/92) and *Jackie Brown* (1997) to *Django Unchained* (2012)—make use of the iconographic rhetoric, codes, and scenarios of all the representational forms of visual culture: from auteur films and the *nouvelle vague* through the genre of gangster film and blaxploitation movies up to Asian martial arts films, from pulp fiction to comics and animated films.

Part of the internal logic of, for instance, both installments of Tarantino's *Kill Bill* (*Vol. 1*, 2003, *Vol. 2*, 2004) is that the effect of any provocation, any violation of the boundary between pure and impure, ugly and beautiful, good and evil, is external to them—although their iconography is defined by the topic that is in fact associated with such boundary violations: the fragmented and oppressed body.

It is a quite different matter for another film that, like *Kill Bill: Vol. 2*, was released in the cinemas in 2004: Mel Gibson's *The Passion of the Christ*. This film seems to be working with the same representational modes that

Tarantino instituted; in both cases ritualized acts of violence are central to the performance, in both cases the same phantasms of the tortured and oppressed body can be found. But while *Kill Bill* was a successful film, even if Tarantino was accused of not really having anything new to say, *The Passion of the Christ* was a scandal.

In one case, we see the stations of the cross, carried out as the realization of unfathomable suffering; in the other we see a woman's campaign of vengeance, staged as the transfiguration of her body going through every imaginable agony. The one refers to a mode of religious experience in Christian culture; the other to the fantasies of a similar form of experience that is attributed to Asian culture: the path to clarification and overcoming the self by learning a martial art.

Why does the one cause offense, the other not? The answer is as simple as it is complicated: because Mel Gibson's film disturbs one of the fundamental conventions of postmodern cinema that Tarantino's films, among others, had established. This convention maintains that everything that we are shown is not from this world. The imaginary quotation marks accompanying the image at every moment place every character, every action, every thing within the realm of a precisely locatable territory of fantasy. Everything remains entirely embedded within the cosmos of martial arts movies, pulp fiction, and comics—and therefore clearly separated from any reality of our everyday sensibilities. The same principle applies to these films, that Stanley Cavell applied to the cartoon characters of animated movies, in differentiating them from human figures: "The difference is that we are uncertain when or to what extent our laws and limits do and do not apply. . . . The most obvious abrogations of our limits and laws concern those governing physical identity or destruction. . . . The abrogation of gravity is manifested in everything from the touching movements of these creatures as they trace their arabesques in the air . . . to the momentary hesitation before a long fall and the crash which shakes the earth but is never fatal." Cavell describes the immortality of these characters in such a way that his definition could easily include the numerous characters executed in *Kill Bill*: "Or rather, what is abrogated is not gravity . . . but corporeality. The bodies of these creatures never get in their way. Their bodies are indestructible, one might almost say immortal; they are totally subject to will, and perfectly expressive. Reversing the economy of human expressiveness, their bodies bear the brunt of

meaningfulness. . . . They are animations, disembodiments, pure spirits."[1] All the hyperrealistic carnage in Tarantino's *Kill Bill*, every obscene act of violence in slow motion, every dissecting cut through the body becomes nothing more than the logic of this poetic cosmos of pure "meaningfulness." It is quite another matter in Gibson's *The Passion of the Christ*.

The film erases the quotation marks of postmodern cinema and shifts to another mode of performance. It does not represent the suffering of Christ, but shapes the spectator's perception process itself as a recreation of the Passion, a corporal, physical realization of the suffering. The film transposes a religious act of ritual repetition into a cinematographic mise-en-scène. In analogy to the Stations of the Cross, the cinematographic vision of Christ's suffering is here literally staged as a "show trial," which the spectator follows by seeing and hearing. The obsessive fixation on the representation of sadistic violence is primarily due to this directorial concept. For this suffering is meant to be grasped entirely at the level of the corporal. The film represents itself as an act of physical realization. The fact that the character whose sadistic torturing we are watching is subject to the same physical laws as our own bodies is the fundamental precondition for this.

The film seeks to go beyond the boundaries of aesthetics to get to religious experience. The sadistic visions, which become physically present in the spectator's seeing and hearing, are aimed at a completely real consciousness of guilt. As such, the discussion about the film's anti-Semitism was only slightly misleading. Ultimately the film situated every person, no matter what their religious denomination, whether on the screen or in the cinema, as a potential member of the Catholic community of believers: if only the vision of suffering made him conscious of his own guilt.

A Reterritorialization of the Empire of Signs

Independent of the question of the degree to which this kind of missionary behavior has been or even could be successful, *The Passion of the Christ* falls back on the very same modes of representation that have been held up as film art in Tarantino's films: the grotesque iconography of the dismembered, chopped up, martyred body, which first entered Western cinema through cheap horror, splatter, and slasher movies and then through Asian martial arts films.

We can see two opposing modes of current cinema in the two films we have mentioned. In *Kill Bill* the reservoir of forms and signs from popular entertainment culture becomes a medium of lighthearted nostalgia. The cartoon characters, music, and movie iconography are formulas from a fairytale world that refer not to a distant, prehistoric past but to the closest personal memories, to the storm of emotions and fearful fantasies from childhood and youth. Tarantino's films quote images with strong affects, which are always trying to be just images. They are audiovisual reminiscences of feelings that are lighthearted precisely because nobody has to experience them anymore. The images are pure meaning, utterly disconnected from the experience of one's one corporality. Tarantino's films open up a realm of pure signs, free from heavy, real corporeality—but unburdened, as well, from the existential foundations of aesthetic reflection.

If *Kill Bill* appears in this sense as the late emblem of a postmodern cinema, *The Passion of the Christ* formulates the Catholic antithesis. It reintroduces the laws of pain, vulnerability, and desire to which the ordinary body is subject back into the modes of splatter fantasies. It merges the images of the tortured body with the physical self-sentience of the spectators, with the consciousness of their own corporeality as a source of pain, loathing, and disgust.

Stanley Kubrick made this kind of link between the spectator's real corporality and the bodily violence represented one of the central points of his 1971 film *A Clockwork Orange*. This film is also a kind of Passion. In a grotesque distortion, it emphasizes the sadistic pleasure inscribed in all visual representations of the Passion—the pleasure taken in the martyred body. Alex (Malcolm McDowell), the leader of a terrorist youth gang, incarcerated for murder, fantasizes about himself as a brutal Roman soldier, deliciously executing his craft, while presenting himself to the prison chaplain as a remorseful sinner who faithfully studies the Bible. The fact that the pleasure of the spectator in the cinema is exactly mirrored in this "innocent" reading will become clear at another point. Alex places himself at the disposal of the medical experiment "Ludovico," a kind of Pavlovian conditioning program, by which the sadistic pleasure of looking at scenes of sex and violence is meant to get recoded.

In a voiceover, Alex describes his wretched situation, strapped to a movie seat with cables attached to his genitals and wearing a crown of

thorns made from electrodes and measuring instruments. In fact, he is at the start of an ordeal that is in every way fashioned as a "Stations of the Cross." In every way, that is, with one exception: the order of the stations of martyrdom follow an Old Testament law. After his successful therapy, Alex goes through the locations of his shameful acts and—eye for eye, tooth for tooth—gets his evil acts reciprocated.

Strapped to the chair and prevented by clamps from closing his eyelids, he watches the scenes of violence and rape. Immobile, exposed to the sensory stimulus by the machines connected to him, he is less a metaphor of the movie spectator than a kind of allegorical translation of avant-garde film theory. The basic material of film art is the spectator, as Eisenstein would have it. Film composition therefore means "influencing this audience in the desired direction through a series of calculated pressures on its psyche." Film is an art "that deliver[s], because of [its] formal characteristics, a series of blows to the consciousness and emotions of the audience."[2]

Here as well, in his corporal-sensory perception, in his physical presence, the spectator marks the place where the suffering actually occurs: as "a series of blows to the consciousness and emotions." An injury to his senses, his moral sensations, his way of seeing the world. In Kubrick's film, the chief scientist of the "Ludovico" project summarizes this form of experience as follows: "One of our earlier test subjects described it as being like death, a sense of stifling and drowning, and it is during this period we have found the subject will make his most rewarding associations between his catastrophic experience and environment and the violence he sees."

A Clockwork Orange reflects the cinema as a structure in which the mechanics of our feelings can be understood as a completely social reality. What is neatly separated in *Kill Bill* and *The Passion of the Christ* is, in this film, inseparably interconnected. It is simultaneously a play of thought and "a series of blows to the consciousness and emotions."[3]

Seen in this way, we could approach Mel Gibson's *The Passion of the Christ* as a contemporary form of countercinema. It reintroduces a dimension of cinema experience into the postmodern poetics of the pure play of signs, a dimension that found its emblematic images in Alex's grotesque martyrdom. In order to be more specific in this thesis, I would first like to examine the signs of dissolution in the categorization of the areas of classical genre cinema, which culminated in the provocative films of the late

sixties and early seventies. Kubrick's *A Clockwork Orange* is then a film to be discussed in more depth, one that brings this development to a point by seeking to understand it as an immanent reflexive movement in the realm of aesthetic thinking.

Forbidden Images, Broken Taboos

At one of the first Berlin Lessons, Billy Wilder talked about shooting with Marilyn Monroe on *The Seven Year Itch* (1955). He described how inventive he had to be to make the completed act of adultery visible to the spectator, despite not being able to explicitly refer to it, not to mention the utter impossibility of showing it. Wilder coquettishly played with the idea that not only his way of directing, but the ways of directing in Hollywood cinema as a whole had taken essential impulses from the creative omission of the taboo zones created by voluntary censorship, the so-called Production Code.[4]

In fact, classical Hollywood cinema has been structured by the logic of establishing and breaking boundaries since its very beginnings. In the sixties and seventies, this boundary breaking became more the rule than the exception, and genre cinema itself became a field of constant aesthetic infringement and moral provocation. The terrain of classical cinema is occupied by images and sounds that for a very long time had been literally forbidden. Almost systematically, what was filmed was what classical montage omitted—the physical effects of violent actions, the sex act between two love scenes. The films use the checklists of self-censorship as a cartographic instrument in order to mark off anew the sensory realness of social reality. With its edits and jumps, the model of classical narrative cinema becomes a searchlight that designates the neuralgic zones of a kind of social self-conception that has restricted and disavowed broad areas of physical reality as impure and evil.

In fact, the youth and pop culture unfolding at the time created cinematic areas that provided a place for those things that Hollywood did not film. While Hollywood defined the realm of the visible according to the Production Code, an independent film production has developed since the fifties that has addressed exactly these excluded areas. This low-budget cinema owes its appearance to the divided cinema markets. Alongside the big

movie house chains, which almost exclusively screened Hollywood productions, arose drive-ins and smaller movie house chains that filled their programs with cheaply made films featuring horror, sex, and violence.[5] Using the exploitation label, this cinema targeted a youthful audience and their pleasure in watching.

Its economic success was based directly on the attraction of the forbidden. In this parallel visual universe, what was previously clearly divided was now interconnected. The action scenes expand to include the image of corporeal effects, of blood and wounds, violent action to include the visualization of sadistic pleasure, the degradation and violation of the woman.

To what degree these two largely separate cinematic worlds communicated with each other can be retraced in one of the most famous scenes in film history—the shower scene in Alfred Hitchcock's *Psycho* (1960). If we understand Hitchcock's film as a reflection on the cheaply made horror film, we can in turn describe the emerging slasher film as more or less a genre of what was omitted between the two shots in Hitchcock. In the slasher film—that is, in the genre in which a serial killer brutally massacres his victims with a knife or other deadly weapon[6]—the shower scene is literally disrobed of its aesthetic sublimation so as to turn the pure action of violence in the serial murder of women into the central point of the film's attraction. Herschell Gordon Lewis's *Blood Feast* (1963), which is considered the prototype of the genre, takes off precisely where Hitchcock's art of editing aesthetically sublimates the dismembering of the woman.[7] If the calculation of the cuts in Hitchcock is aimed at the spectator's imagination, at their fantasies of fear, the images of the gaping wound and the cut-up body in the slasher movie target the reality effect of the film image, naked vision.[8] Starting with George A. Romero's zombie film, *Night of the Living Dead* (1968), this representational principle became definitively established as the generic logic of an evil cinema.

Something similar can be said about sex films and pornography, which also developed out of the exploitation cinema of the sixties. On the one hand they are horror films, which became the vehicle for staging nakedness and sex, on the other they were a kind of grotesque sex comedy. The most well-known examples are the films of Russ Meyer. The commercial success of these so-called sexploitation films not only opened the door to official Hollywood culture (in 1970 20th Century Fox produced Russ Meyer's

Beyond the Valley of the Dolls); this success also opened up the market for hardcore pornography. In 1970 the first commercially exploited hardcore porno film was released in cinema format; this was followed in 1972 by the very famous *Deep Throat*.

Seen in this context, we can speak of another modality of repetition: a kind of return of the repressed.[9] It is no coincidence that serial murders and sex acts form the basic dramaturgical structure of both the splatter horror film as well as sex films and pornography. Taken as a whole, these films turn out to be a series of acts treating the body as an object of a highly ambivalent pleasure in looking. The obsessive repetition of the very same phantasms— of trash, perversion, antisocial violence—insists on the incommensurability of an experience of the body that would seek access to official visibility.

Parallel to this literally *other* cinema was the development of the so-called underground cinema. These films profited, much like the sex film, from the availability of 16mm projectors, and a new audience was opened up to them. The underground came from the art world and in the sixties stood for everything experimental, avant-garde, and independent. A special place in all this was occupied by those artists whose work is distinguished "by . . . willful primitivism, taboo-breaking sexuality." These are films with a relation of "obsessive ambivalence" to American pop culture, mainly to Hollywood cinema.[10]

The Pleasure of Breaking Boundaries

This underground was, alongside exploitation cinema, one of the sources of the so-called midnight movies, late-night screenings that have developed into a wildly popular format since the end of the sixties. A subculture formed around them with highly idiosyncratic aesthetic preferences; bizarre findings from a past Hollywood era were mixed together with B movies from the horror and science fiction genres and the visual attractions of exploitation cinema to form a combination of Hollywood trash, sex, and violence.

Here films like John Waters's *Pink Flamingos* (1972) or *Female Trouble* (1974) became what would then become known as "cult films." These are films that radically violate every kind of generally accepted standard of taste.[11] This subculture is conceived as the community of the happy few,

those who know how to enjoy a good laugh. Indeed, the injury is only painful to the sensibilities of those others who have always belonged to proper society anyway. In a way, the shock values fuel the malicious joy that establishes the commonality among precisely those who see themselves as excluded from this society.

The principle of constant boundary breaking, which reigned in Western cinema between 1965 and 1975, can only be understood in light of this background. It opens the floodgates, letting what had asserted its existence in the repetitive loops of underground, horror, sex, and exploitation movies flow into the mainstream of official culture: the insistent consciousness of an experience of the body as the unfathomable foundation of all sense-oriented world disclosure.

Of course, a certain liberalization of Western society is expressed in all this, but the attacks on bigoted prudery are something quite different from a film poetics that seeks to stage a morally reprehensible seeing and showing in this shockingly obscene corporeality. This poetics is precisely what forms the common denominator between European auteur cinema and the New Hollywood of the late sixties and early seventies.

All this, however, is not merely a question of breaching moral prohibition. Rather, by breaching the aesthetic order and the perceptual sensations of their audiences, the films try to call into question the very foundations of moral consciousness. The exposed wound, obsessive violence, and deregulated sexuality do not represent any forbidden wishes per se, but refer to aesthetic processes that open up the cinematic visual space as a medium by which to enjoy the body, which is neither morally reasonable nor sensible—nor is it complacent.

Whether this breaking of boundaries pertains only to the Production Code of the film industry's self-imposed censorship or concerns the identification of a poetic imagination with the plainly evil; whether, as in Arthur Penn's *Bonnie and Clyde* (1967), the shots forcing their way into bodies signal the end of censorship or, like in Pasolini's *Salò o le 120 giornate di Sodoma* (*Salò, or the 120 Days of Sodom*, 1975), the ritual martyrdom of youthful bodies becomes a mythopoetic sign of fascist hubris: the injury to perceiving sensation is always carried out as a heretical act. Whether, as in Bernardo Bertolucci's film *Ultimo tango a Parigi/Le dernier tango à Paris* (*Last Tango in Paris*, 1972), the play of the actors constantly undermines

the border separating their sexual encounter as a fictional event from the reality of their bodies in front of the camera or, as in Sam Peckinpah's *Straw Dogs* (1971), the exploding violence is represented as a paranoid perception of the sexual: their shock value is always drawn from the dissolution of the territorial order of the cinema, from blurring the boundaries of trash and art, Hollywood and underground, pornography and star cinema. They parade the dirty pictures from the other cinema in the glorious robes of artful cinematography and the opulent styles of a new auteur cinema.

The Foundation of Aesthetic Pleasure: *A Clockwork Orange*

Few films have so decidedly aimed to violate the general feeling for the beautiful and the true, and even fewer have been as completely successful in this, as *A Clockwork Orange*. The fact that the film could simultaneously be banned as pulp, celebrated as a cult film, and admired as an art film gives it a unique place.

If Stanley Kubrick had posed the question of nonhuman thinking, or nonhuman intelligence, with his 2001: *A Space Odyssey* (1968), *A Clockwork Orange* can best be understood as the search for the nonhuman base of sensuality, affects, and sensation. The Clockwork Orange—a metaphor for the intertwining of mechanical and organic principles of organization—positions this foundation of our emotional life askew of the register of the natural, technological, and social orders. The film presents this driving force as a mechanism represented in the most diverse forms of expression from art, pop, everyday design, fashion, and youth culture.

In its directorial technique, *A Clockwork Orange* is itself a kind of midnight movie. In fact the film creates a visual space that plays with the various strands and forces active in the aesthetic constellation of cinema in the early seventies, relating them to one another in a monadic mirroring. When Alex, strapped to the cinema seat, his eyes fixed on the screen, describes the film images that he cannot look away from, he speaks of them in the same way one talks about the dirty images of horror and sexploitation movies. He names, fairly precisely, the visual world of unofficial youth culture, a world that came into being at the same moment Hollywood was granting this youth culture a place in the system of genre cinema, particularly in

films with Marlon Brando and James Dean. The key scenes of this genre form the iconographic basic structure that *A Clockwork Orange* mirrors very specifically.

We might think, for instance, of Nicholas Ray's *Rebel Without a Cause* (1955), of the appearance of James Dean's rival, surrounded by girls. We might think of the knife fight, staged like a dance, and of the thrill of the car race, when the rival is accidentally killed; we might think of the conflicts between Jimmy and his parents, of the father in his grotesque apron, of Jimmy reaching into the refrigerator and taking a big gulp of milk. We will notice that *A Clockwork Orange* displays the internal antisocial violence in each of these scenes in a kind of grotesque mirroring. The girls surrounding the hero literally become decoration, and the gulp from the milk bottle becomes a spurt from the breasts of plastic sculptures; the dance of the knife-wielding rivals is accompanied by lively music, and the exhibitionist necking of young people becomes a live rape on a public stage. Even the dilapidated theater construction is reminiscent of the abandoned villa: inside there's the love scene with Natalie Wood and James Dean, of which we only get to see the first kiss, while outside young men beat each other up with chains and pipes.

Even the play with the colors red and blue is borrowed from the James Dean film. Here the oedipal scheme of becoming a man is played out in the opposition between red and blue. In the end, James Dean exchanges his red jacket for his father's jacket, while poor Plato (Sal Mineo), who is wearing one red and one blue sock, has to die according to the rules of the strict division of the sexes; at least he takes James Dean's red jacket with him to the grave.

In *A Clockwork Orange* the clear opposition between red and blue appears right at the beginning of the film. The monochromatic colors of the titles alternate between red and blue, only then going to a close-up showing Alex's face. Subsequently the opposition disintegrates into all kinds of mixtures and breaks: beginning with the relatively clear distribution of color in Alex's bedroom, through the washed-out and tasteless mixtures and contrasts of these colors in the parents' rooms and clothes, up to Alex's curious appearance in a record store as a seductive dandy in crimson and violet. The opposition to this color play is the white of the gang's outfits, of the sculptures of women, and of the milk in the Korova Milk Bar.

The Passion of Art

Just as the genre scenes of Hollywood teenager films are patched together in grotesque mirrorings with the scenes of sex and violence in horror and sex-ploitation movies, *A Clockwork Orange* presents itself, sequence for sequence, as a succession of ever new fusions in which the formulas of pathos taken from art and kitsch, pop and pop art melt into one. This quality of taking things almost literally as images, this grotesque mirroring indicates a dominant, aesthetic procedure in the film, one that uses every kind of inversion, reversal, dissolve, and montage to couple beauty with evil, violence with art, good with repulsive, and the social with utterly miserable kitsch.

This procedure is most noticeable in the film music. Indeed the soundtrack of the teenage movie, rock 'n' roll and beat, is exchanged for variations of classical music: Rossini's *The Thieving Magpie* and Beethoven's Ninth Symphony. This, however, in no way functions as a citation, a crossover of the codes and sign systems of high and low culture, pop art and high art, or as a play on the lighthearted mementos of youth culture. It is striving much more for a corporeal effect on the spectator, for shock. But the shock values are precisely not grounded in seeing the physical violence, the bodily wound, the sex act, but in such a connection between the forms of the highest aesthetic sublimation and the most primitive expressions of affect.

Alex's family home is located in a housing complex that looks like a concrete architectural fantasy, in which there is only a hint of the reality of social housing developments; in fact the complex represents a deserted nowhere, an outer post of civilization, which has long been abandoned by its inhabitants. We see a mural like those found on firewalls in big city ghettos. It is a reproduction of pseudoancient frescoes, which might recall the wall decorations in a Venetian Renaissance villa as they were imagined in Mussolini's time. This mural is littered with obscene drawings of male genitals, which is reminiscent of both the scribblings in public toilets as well as cave paintings. In relation to the architectural ensemble represented, this ambiguity corresponds to that condition, within the world represented in the film, in which we cannot tell whether it signifies a place before or after human civilization.

Just as, in this image, the most mundane manifestations of affective expression are laid over the symbolic plagiarism of past high culture, the film

as a whole joins the artifacts of emotional life between high art and primitive fetish into one mechanical figure. In its strictly formal arrangement, it practically forms the blueprint of a machine that, propelled by permanent short-circuits, produces nothing less than the affective basis for forming community. The song about the great pleasure of fusion, which associates the least sex act with the cosmic frenzy of union, Schiller's "Ode to Joy," is given a highly idiosyncratic interpretation in this blueprint as the guide for the initiation, through art, of various cultural processes of fusion and separation: "Thy magic powers re-unite / What custom's sword has divided / Beggars become Princes' brothers / Where thy gentle wing abides."

"Brothers"—this is the term that Alex, the first-person narrator in the film as in Anthony Burgess's novel, uses not only for his friends but also for the spectators, as part of one big gang, with which he will mark out the steps of this fusion. These steps are each indicated by the order of art.

The first station, the Korova Milk Bar: "Whoever has had the great fortune / To be a friend's friend." Alex presents himself, his "droogs," and the milk, which can be ordered with various mixtures of drugs. Sculptures of women make up the decor: "a kind of intensified pop art," sculptures, with bared genitals, whose breasts function as drink dispensers, bellies and buttocks as tables.[12] With their combat boots discarded on the sculptures' naked behinds, Alex and his friends themselves seem to be sculptures of a somehow future subculture.

The second station, the Irish folksinger, a homeless man under a bridge: He sings of the most beautiful girl in Dublin. "In Dublin's fair city / Where the girls are so pretty / I first set my eyes on sweet Molly Malone." Alex, a policeman with good taste in music, thinks otherwise: "One thing I could never stand was to see a filthy, dirty, old drunkie howling away at the filthy songs of his fathers, and going blerb, blerb in between as it might be a filthy old orchestra in his stinking rotten guts." What disgusts him is the physical reality of a fervent, sexualized interiority, a reality that becomes all the more palpable when the Irish folksinger's song is directed at the girl with the mussels and oysters.

The third station, the theater: what we see is a quite different, ultra-brutal way of scoring with a comely lass. The dance of a rape on the stage of a decaying theater to the champagne sounds of Rossini's music, mixed

together with the screams of a mistreated girl. Alex and his friends give the audience a little while, biding their time in the darkness of the theater. Then they interrupt the show. The music, however, transforms the dance on stage into the choreography of a fight in the audience. And even the frenzied car ride through the night is integrated into this figuration of movement by the music.

The fourth station, literature: once again, the action is transformed into choreography; Alex and his droogs severely beat a writer in his country house; his wife is raped and beaten to death. This time, Alex himself sings "Singin' in the Rain." As opposed to Gene Kelly, who splashes his foot to the rhythm in big puddles in the 1952 film of the same name, Alex makes the rhythmic accents with forceful, heavy boot stomping and the thuds of his club.

The fifth station, the opera diva: a clique of upscale culture consumers with a taste for underground culture is stranded at the end of the night in the Korova Milk Bar. A woman, made up like an opera diva, and whose makeup is done for the spectator in the very last row, starts to sing from a sheet of music: "Joy, beautiful spark of gods." Alex is kissed by the muse, smitten by art. A few scenes later he experiences the sparks of inspiration in this music, which discloses physical terror to him as the high art of the tyrannical formation of community.

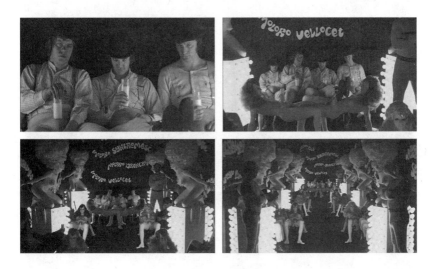

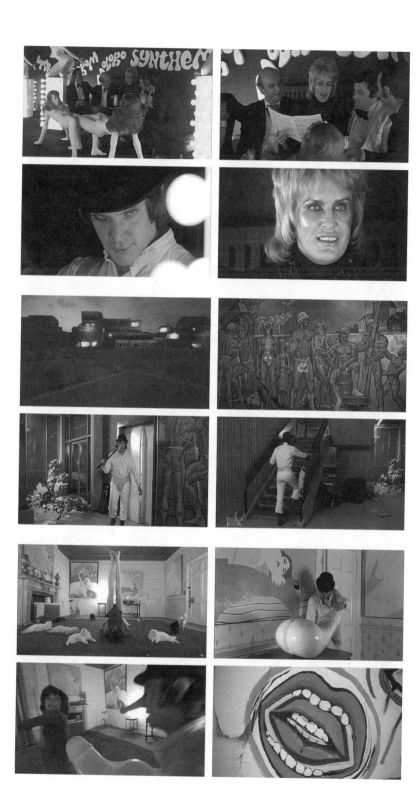

The sixth station is the architecture described earlier: Alex returns home at dawn. Following closely on one another and intimately connected by the music, the stations represent the entire succession as a choreographed unity, as a dance that slowly breaks out, becomes ever more dynamic, and ends in happy, satisfied exhaustion.

The seventh station is the painting gallery: on the next day, one last dance, this time with the art collector. An oversized penis made of white porcelain, a "priceless work of art," as the owner stresses, the Golden Calf, over which the two of them scuffle until Alex strikes the art lover with her collector's item. Instead of a bashed-in skull, we see a cartoon image flash across the screen—or is it a pop art painting? The succession of shots, restricted to a few individual images, cannot be neatly categorized. Alex is arrested and starts his therapy in the seat of a movie theater.

Beyond Good and Evil

If *A Clockwork Orange* shocks, strikes, and hurts, it is not because of its images, not because of what there is to see in the film, but because of what it leaves us to think: What if beauty is only a manifestation of the malign, and high sentiments are only one of the many shapes of wicked instincts? What if humanity is always founded on a "we" that includes terror against those who are excluded in order to form the bonds of the group, the family, the society?

After Alex's "treatment," the clockwork starts up anew. As he goes through the steps of his crimes a second time, the reverse of the large and small forms of community formation are carried out on him station by station, with the same mechanics that ruled his violent acts. The parents, the bums, the policemen, the intellectuals form themselves, in their very hatred for him, into members of a capable society. One after another, Alex is excluded from the society of those to whom revenge becomes the highest rapture: "Indeed, whoever can call even one soul / His own on the earth! / And whoever was not able to must creep / Tearfully away from this circle."

What does it mean if even the great songs, of "hopes and aspirations" that "no free man can really refuse," tell of the pleasure that spectators

can share with Alex only to the degree that they start to find all the evil of his world attractive, seductive, and beautiful? The film gives its audience a shock that only feeds on the perception of hurtful images in the first moment; its entire impact is disclosed in the act of grasping the obscenity of the cinematic idea—in positioning the well-trained free human being, drawn to good and committed to beauty, as the accomplice of Alex's brotherhood. The shock is generated almost intellectually; it comes from a blasphemous thought that hurts.

Alex talks about this hurt, strapped into the movie seat. While we can see images from Leni Riefenstahl's *Triumph Des Willens* (*Triumph of the Will*, 1935) being projected on the screen, he speaks, raving in sadistic fantasies, as if the torture in the concentration camps were happening before his very eyes. Until he recognizes that even his musical ideal comes from this world: the beloved Beethoven symphony—for Alex the epitome of good— sings about the very pleasure that they are trying to drive out of him now as part of the goal of resocialization. "Joy is called the strong motivation / In eternal nature. / Joy, joy moves the wheels / In the universal time machine": a clockwork orange.

Regardless of whether Alex rapes, beats, robs, and annihilates, or whether he himself is debased, tormented, and beaten—the sound made by the music is always the same. This sound governs the Irish bard, the theater, the writer, and the opera diva; it permeates all the expressive forms of art, pop culture, and youth culture—in its socially acceptable manifestations as well as its antisocial ones.

The dissolution of the boundaries between the registers of culture, of elaborate art, and the raw expression of feeling, is itself the act of violence. It targets the affective base of social belonging: the dissolution of the order of our everyday sensibility. Its expression is found in those representations of violence that stubbornly refuse any semantics. The film stages a kind of aesthetic pleasure that does not so much lie beyond good and evil, but removes the possibility that the spectator can both enjoy and maintain his moral position at the same time. In Great Britain the explanation for banning *A Clockwork Orange* was given as "violence for its own sake."

Seen in this way, the film can be read as a reflection on the aesthetic disposition of Western mainstream cinema in the early seventies. Indeed, the

films of this time systematically attempt to destroy the territorial limits of cinema between art film, auteur, and genre cinema, between mainstream, pop, underground, and exploitation.

Either they introduce the elements of the underground, the effects of sex, splatter, and horror, into the realistic method of representation of classical Hollywood cinema—as was accomplished by *The Exorcist* (1973) or by Steven Spielberg's *Jaws* (1975)—or they insert a contingent element into the iconography of classical genres by shockingly representing violence, an element that bursts forth from within the old mythopoetic system. Examples of this reach from Arthur Penn's *Bonnie and Clyde* to Terrence Malick's *Badlands* (1973) and Martin Scorsese's *Taxi Driver* (1975/76). In any case, the films attempt to disturb the territorial order of cinema. On the one hand, they celebrate sadistic joys in debasing the good and, on the other, they thematize evil as the stigmatized victim of the good, as an excluded, unrecognized suffering.

A Clockwork Orange seeks to fathom the logic of this dissolution itself. And this logic in no way follows the schema of the forbidden corporeality that was now claiming its rights. Rather we are left with the impression that it is violence itself, with no other function, no sense, and no reason, that is seeking to be presented and to be seen.

Hollywood and Evil: *The Exorcist*

In the sixties, the horror film played a prominent role in the alternative cinema of midnight shows, drive-ins, and the underground. Many of these horror films were produced in the Italian film factory Cinecittà more or less exclusively for the American low-budget market. They speak to a kind of pleasure, a sensation that was not so much disavowed in classical forms of film and television entertainment as it was relegated to the realm of the invisible and the imagination. What the classical horror film or the psycho thriller had draped in fantasies of fear and erotic images of desire is here quite literally disrobed. These films create a kind of reverse mirror image to classical Hollywood cinema, something like its silhouette or negative.

Despite the fact that the horror film took central place in the other world of the cinema of youth culture, the genre initially played no role in the

renewal of Western cinema. This situation changed dramatically with a single film: William Friedkin's *The Exorcist*. The film was not only commercially the most successful horror film that had ever been made. Its spectacular shock effects made it one of the most sensational cultural events of the season 1973/1974 worldwide and fundamentally changed Hollywood cinema.

1973/1974: this is the time—hardly any critic fails to point out—in which the crises of Western societies culminate in several striking events: Vietnam, Watergate, youth rebellion, terrorism, the oil crisis, and ever increasing crime and divorce rates. The effects of destructive social powers seemed palpable.

But 1973/1974 is also the time in which a new Hollywood system was being built out of the New Hollywood—that movement of young directors, actors, and producers who had been combining the forms of the auteur film with those of genre cinema. It was a cinema in a mythopoetic system that had to be established for each individual film, whereas in classical Hollywood cinema the aesthetic standards and narrative models of the various genres had seen to this. They are films that diverge from the stereotypes of genre cinema in order to construct a poetic order of their own out of their modules, an individual mythology of horror, of the Western, of the gangster film, that had to be newly devised from film to film. *The Exorcist* is one of the most prominent examples of this newly forming postclassical cinema. With this film, the obsessive gawking associated with the splatter film—the endlessly repeated portrayals of the martyred, wounded, opened, and sexually mistreated body—irrevocably found its place in the official visual world of Western cinema. "A twelve-year-old spits up venom and bile, distorts her face into grimaces, rotates her head, and hurls blasphemous words all around her."[13]

Due to these shock effects, William Friedkin's film has itself become a classic, an ideal of a new form of cinematic horror. Evil here—as one can read in any theory on the horror genre since Freud's reflections on "the Uncanny"—is closely associated with the sexual. But sex appears here—unlike in the classical genre—precisely not in the phantasmal veiled garments of recurring, repressed, forbidden desires. Instead it is drastic words, images, and sounds that do not veil, encode, or obscure anything, instead seeking to name clearly, attack directly, hit precisely, and hurt effectively. In every detail the staging of sexuality is a physical attack on

the spectator's moral and aesthetic sensations—and not some game with the powers of imagination.

The film concerns sexuality, not as the reality of fantasy, but as a reality of the physicality of the human species. Its images strike at the reality of a vulnerable, mortal, sexual body, and not at phantasms of sexual desire. But, in so doing, *The Exorcist* shifts something into the image that was in fact excluded, forbidden in classical genre cinema—something that lay beyond the boundary lines that determined what may be shown, may be made visible and what should be cut out, what had to remain omitted, invisible. The reality effect of the cinematic images confronts the phantasms of the cinema, while the physical reality of the perceiving spectator, its fleshy presence, confronts the imagination.

This is why *The Exorcist* has much more in common with the horror films of subculture than with the classical genre. Indeed, it makes itself the medium of an obscene pleasure in images that had been excluded from classical Hollywood cinema, images aimed at the biological reality of the human body. What it claims about its protagonist, the twelve-year-old Regan (Linda Blair) is true for the film itself: it is the medium of an experience that had been excluded from the order of the cinema as evil and dangerous.

So it is also not surprising that the film was less attacked for its theme than for how it was filmed. When religious fundamentalists spoke of evil embodied in celluloid,[14] when they claimed that *The Exorcist* itself set up the stage for the devil's attacks, then they were thinking of the suggestive power by which the images of the film took the audience in. Indeed, it did appear to be the medium of a morally dubious desire that took possession of the spectators in a way every bit as spectacular as the devil does the girl.

This power, however, is completely in keeping with the film's poetic logic, its aesthetic program. The wild excesses of the obsessed Regan, the images of the tortured virgin girl, which had already been circulating in subcultural channels, now took possession of the perception of a worldwide audience numbering in the millions. The fact that this experience of suggestive shock effects, of being overwhelmed and possessed, was a question of the pleasure and enjoyment of this audience can most obviously be seen in the commercial success of *The Exorcist*.

But the film is not simply a highly polished version of the shockers known thus far only from low-end movie theaters. Instead, it develops

its theme—the devil, the incarnation of evil—by directly reflecting on the constellation described: that is, by reflecting on its aesthetic formal guidelines. The film relates the question of believing in the devil to its own representational problem: to the forbidden images of an obscene, antisocial, and repulsive corporality, to the shadows, the reverse mirror image of Hollywood.

Believing, Knowing, Perceiving . . .

In the sadistic treatment of the twelve-year-old girl—no longer child, not yet woman—this obscene pleasure is manifest, on the one hand, as the devilish per se, taken from Christian devil belief, the desecration of an unsullied virgin. At the level of cinematic production, on the other hand, it stands for the boundary of a moral-social taboo. How to deal with such a role, how to handle the child actress, what can be shown, what should be avoided, so that the actress herself does not become an object of sadistic attention? In the end the film creates a third level by relating the girl's ritual torture to the increasing use of modern medical practices and technologies before turning to the old Christian rituals of exorcism as *ultima ratio*. Of course, the medical acts of dissection, the real bodily incisions and wounds with their cold, technical conciseness, are much more difficult for sensitive minds than are the phantasms of a demonic creature who is tormented with words and signs, pictures and fetishes of the Christian symbolic order. The one belongs to our everyday reality, the other to our fantasy world, perhaps to our world of belief.

The staging of the film can be—to sum it up schematically—related to three different dimensions of the consciousness of corporality: first to everyday knowledge about our mortal and carnal body, as it is represented, for instance, in medicine. Second, to the representation of the sexual in our fantasy world, perhaps in our world of belief, as is shown expressly in the phantasm of the sullied virgin. Third, to the pleasure in disrobing images of the human body as a moral limit case from the sphere of aesthetics. They belong to the series of material visual objects and artifacts, to statues, talismans, amulets, and panels, in which the film sees the consciousness of the mortal, vulnerable, and carnal body running through all periods of time in Western culture, from archaic belief in demons to modern scientific thought.

We can speak of three different dimensions of our corporal conscious-
ness, of which the first belongs to the knowledge of our everyday reality,
the second to the reality of the worlds of belief and fantasy, and the third to
the reality of images (from religion, through art, and up to the entertain-
ment culture of audiovisual mass media). The reality that the film itself,
as an audiovisual image, is trying with all its might to meet is that of the
spectator, who experiences himself in the perceiving space of the cinema
as a wounded, mauled, battered corporality. This is what distinguishes *The
Exorcist* from classical genre film.

The classical horror film thematized the ego in the tension between
inner and outer reality, its relation to the bottomlessness of one's own imag-
ination. In a certain way, its phantasmagorias always already move inside a
reality of consciousness. The fear, the uncanny comes out of the demonism
of an endless relativism of seeing and hearing, out of the negation of osten-
sible reality through the power of deceptive images and the inability to dis-
tinguish the real from the unreal. The perceptual field of the horror genre
refers the spectator's consciousness back to the unbounded scope of his
own imaginary, to the endless mirrored flight between imagination and
perception, inner and outer reality. This is answered by an affective process,
a fluctuating back and forth between pleasure and fear, overwhelmed by
the power of phantasms, devoured by the powers of the imagination, hav-
ing become the fodder for one's own imagination.

An Everyday Reality

How far *The Exorcist* departed from the poetic logic of the classical hor-
ror genre will become clear with this point. Indeed, the film does not at all
move in the mirrored flight between imagination and perception. Instead,
we are given a highly detailed and precise description of the everyday life of
the protagonists: an undoubtedly existing social reality, diligently described
in great detail, that would correspond to the everyday reality of the specta-
tor in its every point. Evil, in turn, the devil, is positioned here not as a
fantastically delusional manifestation of an individual consciousness but as
an inner element of this outer reality. The only thing remaining from the
classical horror film is the iconographic reminiscence, the brick Gothic of
the Jesuit seminaries and colleges in Georgetown, Washington, where the

action of the film takes place. This is where the famous actress Chris Mac-Neil (Ellen Burstyn) is living with her daughter, the twelve-year-old Regan, while she's shooting a film. An ordinary family life, even if it is not the ideal family world: Regan's father is in Europe and even forgets to call his daughter on her birthday.

Along with the housekeeper and the secretary, Chris and Regan would form a purely female household if it were not for the older butler Karl (Rudolf Schündler), of German origin and with a Nazi past—at least this is insinuated by Burke (Jack MacGowran), family friend, director, and Chris's admirer. Not far away there is a Catholic seminary in which Damien Karras (Jason Miller), a young Jesuit, works as a psychiatrist. It is in the middle of this ordinary, realistic world that evil takes shape. Regan starts behaving oddly; her mother takes her to a doctor who prescribes Ritalin. Father Karras, in the meantime, finds himself in a deep crisis of faith. His mother lives alone in a dilapidated part of Brooklyn before having to go to a psychiatric clinic. Father Karras visits her one last time; pitifully strapped to her bed, she reproaches him heavily. Regan's condition becomes increasingly alarming, the medical treatment increasingly more drastic, until she transforms into the demon who says he is the devil himself. Burke, the family friend, is found dead, his face turned completely backward. He was, speculates the commissioner, murdered in Regan's bedroom and then thrown from the window.

Chris asks Father Karras for help. He gives the compulsory answer: exorcisms are not performed anymore now that illnesses like hysteria and schizophrenia have became known; one would have to travel into the past to find an exorcist. But then he does come, the exorcist Father Merrin (Max von Sydow). We have already seen him at the beginning of the film: a prologue shows him as an archaeologist at an excavation site in northern Iraq, near the biblical city of Nineveh.

What this synopsis describes are the two thematic complexes from which the film develops its subject, belief in the devil: the representation of specific social relations, on the one hand, and that of the mistreatment of the body on the other. How does the film work out these themes in audiovisual terms, placing the spectator in a state of physical agitation that is in many ways comparable to that of the child displayed in the film?

In fact, the film develops a dense net of relations between its few characters. Usually this is in short conversations that use tiny details to depict

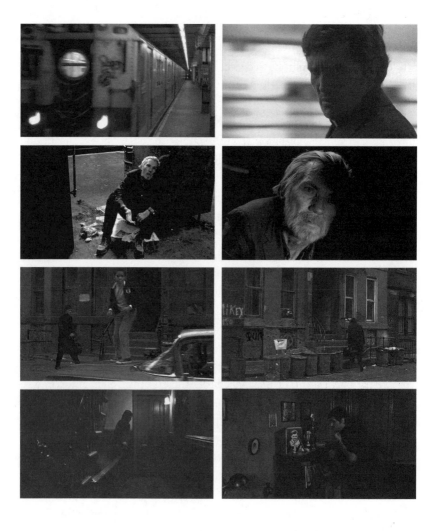

the emotional embroilments of the characters, outlining an intimate image of social relations: Chris talking with her daughter before kissing her goodnight, Father Karras visiting his mother, Chris's first discussion with the doctor about her daughter's behavioral abnormalities, Karras in conversation with a spiritual adviser to whom he confesses his crisis in faith.

Horror takes shape as the inner component of the characters' most intimate surroundings. For every detail of these social miniatures contributes to an image of shattered familial relationships, the decaying order of fathers,

the conflicts between the generations.[15] In each still incidental detail, the film tells of the everyday world of these crumbling forms of human community, of the dwindling of friendliness. We can think of Father Karras's visit to his Greek mother: a loving greeting, home cooking; with the same devotion he wraps up her wounded leg. Both are brought together by their mutual concern and care for the other.

The realistic detail in this scene is a good example of the directorial process. It suggests an intimate proximity to the characters' world—every gesture fills the mother's cramped and stuffy apartment with tender homeyness. But this world is nonetheless permeated with the signs of dissolution. The mother's isolation, her physical frailty; the dilapidated buildings, the neighborhood that has become a slum; the bum who can still startle the priest but cannot move him to pity, despite admitting he's a Catholic; the children demolishing a car on the street purely to pass the time; the hallways and apartments so narrow and dark that we can almost smell the stuffy air. It is as if everyday social life is permeated with the signs of increasing decline. And this is associated here with demonic powers for the first time: the arrival in the subway station, the thundering of the oncoming trains, the storm of light that changes the homeless man's face to a grimace, the terrorizing street kids . . .

Doctors, Priests, Exorcists

It is no accident that the film develops its world in strict parallel construc-
tions: if the father visits his mother, Chris spends the evening with her
daughter. When Chris brings Regan to a medical examination for the first
time, the priest's mother is taken to a psychiatric ward and strapped to a
bed, just as happens to the possessed and uncontrollable girl slightly later.
The mother-daughter relationship mirrors the mother-son relationship just
as the doctors in their white lab coats mirror the black-clad brotherhood of
Jesuits. The one group approaches the girl with the most modern medical
technology, the other with archaic formulas and rituals.

At the same time that the film is meticulously portraying social reality,
creating fragmentary miniatures, it is disclosing a mirror world in which
every detail is doubled in reverse. Evil, the devil, is literally staged as an
inverted, reverse mirror image of our everyday physical-sensory reality.
This principle creates a quite different effect than the classic horror film.
It is no blurring between fantasy and perception, but an endless moral
ambiguity, a deep ambivalence that afflicts every character, every event,
every thing: a mother who selflessly and devotedly loves her son—and
curses him before she dies; a loving daughter who from one moment to
the next becomes a merciless terrorist. A friendly mother who fulfills her
daughter's every wish—and who delivers her to the torments, first of the
doctors and then of the priests; the iniquitous son who lets his mother die
alone in the psychiatric ward, sacrificing himself at the end of the film. For
a moment he himself becomes quite the devil, attacking the whimpering
girl before throwing himself out of the window. Is what appears to be good
an expression of evil, and is evil nothing more than a monstrous mirroring
of invisible, unnoticed, ignored suffering?

And how is this intertwining of world and counterworld created? How
does the film unfold a form of perception in which the one is mirrored in
the other?

I would like to address this question more thoroughly through an analy-
sis of the film. I will concentrate on the beginning of the film, more pre-
cisely on its first fifteen minutes: a nighttime street, a house, a light shines
in a single window, the light is extinguished; a figure of Mary, filling up the

image in a three-quarter profile; the title and then the prologue, beginning with the sunrise and ending with the sunset.

The nighttime world, the house, the figure of Mary, are contrasted with a world in glistening sunlight: droves of diligent workers digging in the earth with pickaxes at a large excavation site in the Iraqi desert. Ancient Nineveh: the city that the Bible reports was so big it would take three days to inspect it all. We then see the bustling markets and streets, the babble of voices of an Arab city, contemporary Nineveh.

At the end of the prologue the sun sets on the horizon. An old man, a Jesuit priest whom the workers address as Father Merrin, stands on a hill. Across from him, also standing on a hill at the same level, a statue with a demonic grimace and a mighty phallus. Its hand is raised, less a greeting than a threatening and commanding gesture. It is the demon whose grimace we have just seen on a small talisman: one of the two archeological finds that Father Merrin was able to recover that day.

Two finds that do not match at all. If the talisman represents the Assyrian demon Pazuzu, the other find shows St. Joseph carrying the Christ child on his arm. A Christian amulet in the remains of the old capital of the Assyrian empire—these things that have outlasted the times, united in the cavity at the dig, belong neither together nor really there: "Not of the same period," as Father Merrin's colleague succinctly states.

Devils, so it seems from the prologue, are fallen gods, extinguished beings of light from conquered and perished empires and cultures: Lucifer! But it is more complicated here. For the dissolve of different levels of time is no metaphor, but instead forms the film's basic directorial procedure, used to reveal the world in light of the belief in the devil.

The workers' attentive looks at the excavation site, the impermeable faces of the Arab inhabitants of the city, the grotesque grimaces of the stone icons of an archaic culture, even the faces that Father Merrin sees unswervingly watching him belong to different time periods. And he himself, as a priest, belongs to a different time than that of modern scientific archeology, and as an exorcist he belongs to yet another time, a time of ritual expulsions that are much older than any Christian customs. In fact, he clearly seems to stand closer to the demon than to the inhabitants of the modern Arab city. Obviously the Jesuit is meeting an old acquaintance in Pazuzu.

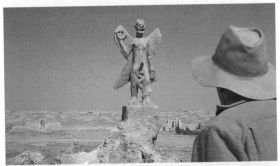

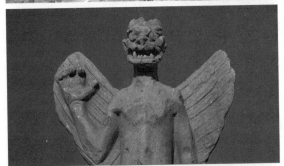

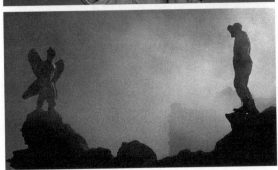

The photograph shows the authentic representation of an Assyrian demon: Pazuzu, a mighty demon who is called on to protect the sick from other demons. His hand, raised like the exorcist's gesture, his tail a scorpion's stinger, has become a phallus in the film; clothed in a garment of wings, it is not difficult to recognize the later fallen angel.

Cross-fading of Time

Pazuzu's garb is covered with one of the oldest scripts known to us. We can read the incantation: "I am Pazuzu, son of Haluga am I, king of the evil spirits of the air which issue violently from the mountains, causing much havoc." If, in Murnau's Faust film, the devil stands for darkness opposed to light, *The Exorcist* stages the devil as an enervating noise that rises out of silence and swells into the bluster of a violent storm. The film develops a sound composition in which everyday noises—insects buzzing, animals howling, dogs snarling, human singing, the babble of voices—merge into the uninterrupted flow of the musical composition.[16] Thus *The Exorcist*, on the one hand, creates an acoustic dimension of space that makes the spectator's experience of listening an unmediated component part of the film's composition; on the other hand, the acoustic trace functions as an essential level of the mirroring in which the various temporal levels are fading into one another.

The nighttime house, the extinguishing light, a buzzing as from insects; this turns into a swelling noise reminiscent of the tuning of instruments, mixed with the sound of footsteps, the sound of an oncoming car, dark bass instruments, shrill pizzicati. A cross-fade: the face of Mary, flawless white stone, lowered gaze, dramatic shadowing; black film, the red title—a dull thud ends the high notes of the strings. An Arabic prayer is introduced. As in an overture, all the sound elements that instrumentalize horror are assembled.

A fade-in from black to a black-and-white image of the setting sun, which then is gradually filled with the red of the morning sun. Then a long shot with almost no color, a pale brown desert landscape in glistening white light. The ruins of the old Assyrian capital are barely distinguishable from the rocky peaks and sand dunes: we see an image of hallucinatory unreality.

Another cut: the archaic scene is given a concrete shape. The bleating of sheep blends with the sound of prayers. We see men dressed in the Arab style—black-and-white figures on a pale brown background, their pick-axes forming an abstract moving pattern that corresponds to the rhythmic clacking and hammering of the sound composition.

So far the imagery is arranged as a moving composition, closely borrowing from the musical composition. The movement of the fade-in, from black to black-and-white and on to the appreciably deepening red, changes

to a monochromatic brown from which the herds of sheep stand out in their movement; barely distinguishable specks of color, a movement of pale brown on brown. What is created is a constantly shifting visual structure where even the movement of the sheep and the rhythmic hammering represent a moment of movement in the gradually emerging image. This dimension is maintained in what follows, so that the whole sequence is presented as an optical-acoustic musical composition.

Another cut, another level of the cinematic composition: an almost abstract visual arrangement in close-up—sand, rubble—a pickaxe strikes. The sound gives the image a concrete, graphic character. And, while this sound sustains the proximity, the image changes to a view of the ancient ruins: the gates of Nineveh and the caption "Northern Iraq." With a long, drawn-out tone, the singing comes to an end, drowned out by a plethora of hammers and strikes. The legion of workers, the overlapping rhythmic lines of their hammering and the babble of voices do not so much suggest an archeological excavation site as they do a labor camp.

In very few shots—a boy running, two short dialogues—we hear about the finds. The sound of the rising wind as Father Merrin digs into the hole in the earth; this becomes hissing and whistling, swelling into the buzzing of an angry swarm of insects—or is it a musical instrument? The sound stops; the film dissolves to a minaret in the red of the sunset. We hear a babble of voices, the rhythm of drums, and further hammering, which soon turns out to be the mechanical rhythm of three blacksmiths gathered around an anvil.

A busy square, the loud hustle and bustle of an Arab town. We see Father Merrin. In his feverish weakness, the surroundings suddenly appear strange and repellent to him. A cut, a hissing storm of fire, the blacksmith's furnace. Father Merrin approaches the three workers who are beating on the anvil. One of them has only one eye. The beat of the hammers dies down; the image is dissolved into a clock's pendulum.

While the following scene is inserted like a long silence in the dramatic sound composition, the rhythm continues on the visual level. In quick cuts we see the stone faces of the icons they have found. Another short dialogue; Father Merrin sets off, faltering with weakness, for the excavation site.

The priest stands across from the statue. The sound of the approaching wind rises out of the silence. The buzzing of insects, the crunch of the pebbles, angrily yapping dogs, high pizzicato strings come together into a single swelling howling: the statue of the demon, who is called upon to drive away other demons, and its opponent, the exorcist. "I am Pazuzu, son of Haluga am I, king of the evil spirits of the air which issue violently from the mountains, causing much havoc . . . "

Taken as a whole, the prologue can be seen as a single audiovisual composition, which develops this clamoring howling as a leitmotiv that will

soon fill Chris's house. The sounds, tones, and instrumental musical arrangements come together, sensually and concretely forging those links that turn the everyday life represented here into a self-reflecting time image. Within the troubling sounds, the devil from the empires of ancient Mesopotamia is always already present in the world of mother and daughter, long before horror reaches over into the realm of the visible.

The sun sets, the red changes to the blue of an evening cityscape, the howling merges into the roar of a plane landing—silence; Chris switches on a nightlight. She hears an unaccountable, uncanny noise, gets up, looks

in on her daughter again; the window is open, the bedsheets are rumpled. In very few shots we learn about the inner life of the house, the outside of which we have already seen in the film's opening image. And we cannot decide whether or not at the beginning we had already seen Chris switching off the light after having—as we now know—looked in on her daughter. Just as we do not know if Father Merrin is thinking of the exorcism that he will perform on Regan when he says during the prologue that there is something that he still has to do. We cannot know because the film refers both worlds back to each other in a temporal mirroring. The sun sets, the airplane alarm trails off . . . Over the duration of the cross-fade the capital of the oldest world power is joined with the capital of the youngest.

An Ancient Enmity

The melding of the prologue with the sequences that follow allows us to determine the axioms that form the basis of the film's poetic logic, its representational principle. The one is the principle of mirroring reversal: the statue of the archaic demon and its Christian revenant, the Jesuit exorcist. The other is the cross-fading of various temporal levels: the Assyrian, the Christian, and the modern time period.

From this perspective, the film proves to be permeated by a strict dualism. In the beginning we see the nocturnal world, the maternal home, the Holy Virgin; this is contrasted with a thoroughly masculine world in glistening sunlight—a world of fighting dogs, diligent workers, and hollow-eyed blacksmiths whose strikes on the anvil continue the rhythm of the workers in the bustling streets of Nineveh where, in fact, we only see men. Only when he reaches the quiet streets far away from the center does Father Merrin meet veiled women, dressed in black. They are comparable to the nuns that Chris meets only a few shots later, walking home from the shooting location.

The rhythmic hammer strokes of the blacksmiths resonate in Mike Oldfield's famous "Tubular Bells," which accompany Father Merrin as he wanders, shaky and obviously exhausted, through the streets of Nineveh. And, in fact, the slightly off-putting impression of not belonging seems to return again in a lighter variation in a major key as Chris walks home. There are priests and nuns whose figures and clothing strike Chris in a curious way,

similar to the effect of the foreign faces and veiled figures on Father Merrin. And when Chris, attracted by the sight of the priest, briefly overhears Father Karras speaking with a fellow priest in the seminary courtyard, the sound of the airplane returns and drowns out the last few words of their conversation. This disrupting noise not only forms an initial connection between the old exorcist and the young priest; it also contrasts the encounter between the priest and the woman with that between the exorcist and the demon.

In fact, the encounter between Karras and Chris is staged as one between a future, potential love couple. Just a little later, at her party, Chris asks a Jesuit friend for detailed information about the young priest. She learns that he has held an important position in the hierarchy of the order for some time already because of his gifts as a psychiatrist. And the spectator learns along the way—by seeing photos showing Karras as a boxer in a ring—something that Chris noticed at first glance: this priest is exceptionally attractive.

Father Karras also took notice of Chris long before she sought him out for help. We see him at a shoot for Chris's new film, laughing and smirking, he stands among the extras. Obviously Father Karras is struck by the Hollywood star's humor. "What in the world was the screenwriter thinking—why do the students want to tear the building down?" Chris asks her director Burke. He doesn't know how to answer, and they can't ask the author; he's in Paris "fucking." Chris laughs at his language, half ashamed, half complicit. She hugs her friend and director. This hug makes it quite clear that this admirer is out of the question as a potential lover. Burke's role is to toss out venomous remarks: whether it is taunting the German butler as an evil foreigner with a Nazi past who put a pubic hair into his drink; whether it is making fun, as he does here, of Chris's marital fidelity. Indeed, the dirty joke about the screenwriter is aimed at her husband. And here Father Karras has to laugh too. Like all other nuns and priests, his very clothing signals what defines the entire constellation of characters, the rejection of all sexual relations. Nothing is as radically excluded from this film as the love scene between a couple, which is announced right from the beginning. There is a wide gap between Father Karras and Chris MacNeal.

The sequence as a whole describes the course of a possible sexual encounter between the characters, their attraction, their repulsion, their tension.

This possibility is indeed negated in numerous details. Over the course of the film, evil manifests itself as an insurmountable antagonism between the sexes: mothers who are left behind in humble apartments or magnificent houses and—just around the corner and yet endlessly separated—the house of the Jesuit brotherhood; fathers who define the scene as priests in black or doctors in white, exorcists, directors, and screenwriters, but who are never present as loving sons, husbands, and fathers. There is war in all familial relationships, between mothers and sons, fathers and daughters, women and men; there is war between the world of the mother and that of the father. Indeed, it is precisely here that the film formulates its characters' everyday reality as an inverse mirroring of the archaic world of the prologue.

This mirroring cannot be grasped at the level of the plot, but only at the level of the audiovisual image composition, at the level of the spectator's aesthetic experience of perception. The storm and the thundering of the airplane landing, the "Tubular Bells" and the hammering of the blacksmiths, the nuns and the veiled Arab women, the encounter between Chris and the priest and that between Father Merrin and the statue of Pazuzu—just as the visual space of the film is revealed to be a hearing and seeing by which the spectators perceive themselves, the cinematic world of the characters is revealed to be a reversed mirror reflection of the world of the prologue. In the end, it is the presence of the living spectator, it is his perception, in which the film image is realized as a temporal cross-fade between the older and oldest visual objects of a world of faith. And while, in the classical horror film, the affect emanates by blurring the lines between the real and the unreal, between phantasm and perception, horror in *The Exorcist* arises from mixing the various temporal levels of everyday consciousness: modern scientific knowledge, the phantasms of the world of faith, and the temporality of its images, their insistence, their duration, their return.

Shortly after the exposition of the characters' everyday world, the film finds an emblematic image of this mixture. For when we see the stature of Mary for the second time, this time defiled with blood, furnished with pointed breasts and a phallus, she is contrasted with St. Joseph carrying the Christ child on his arm. We may be able to account for this highly idiosyncratic motif in the handbooks of occidental iconography, but here it obviously represents the reversal of the motif of the virgin mother with child that is seen in every Catholic church: a father, holding on his arm a

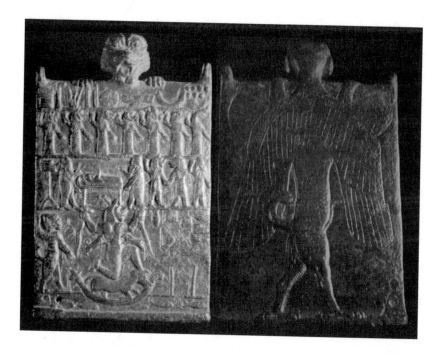

son, with whom he has no carnal connection, and, contrasted with him, a demonic female figure. The memory of the archeological find at the beginning of the film—the talisman of the demon Pazuzu and the amulet of St. Joseph united in the hole in the ground—invokes the image of a different female figure.

The reproduction shows a Mesopotamian table of incantations meant to guard against the female demon Lamashtu. It represents a ritual of expulsion by which Lamashtu is forced to return to hell. On the reverse side of the table, Pazuzu is represented. He is invoked to expel the demon who is his wife.

Father Merrin is rightly, therefore, the title character of the film, even if he only turns up in the prologue and in a few sequences at the end. He is the devil's adversary and, at the same time, the temporal mirroring of an ancient enmity toward the female sex. It is in this mirroring that the film fathoms its subject, the logic of belief in the devil, the reversal of good in the satanic mirroring. This not only means referring to the corresponding satanic symbolism—the upside-down cross, the face turned completely

backward; above all it means reversing the symbol of divine purity, the sacrosanct virgin. In the possessed girl this symbol becomes the figure of a monstrous corporality in which death pangs fuse together with sexual ecstasy. She throws obscene words around; she pisses on the carpet before the eyes of the party guests; she pukes green slime on the meddlesome men; she beats, kills, and transforms into a sprawling, oozing body. And yet all of this is only a mirroring of the expectations directed at her, an answer, an echo of the imagination, that dominates the everyday consciousness of the spectator.

This is not done especially to provide the film with a line of interpretation. The knowledge that the devil is nothing more than the figure of condemned female sexuality is part of the subject presented here. Indeed, it was in the act of stigmatizing the first woman—Eve—as a temptress that the archaic demon Pazuzu, as Satan, first found its way into the Judeo-Christian religious world. What is significant here, however, is that the spectator is once again positioned within this mirroring.

When at the end of the film Father Karras throws himself out of the window, the spook is finished off with a single stroke; lying on the floor is a whimpering girl, tormented, defiled—also tormented by the spectators, who have been avidly following the process. Was it not justified to use any means against the monster and its triumphant malice? Was it not a pleasure to watch his torment, his suffering, his agony? What remains after the spook has been exterminated, however, is a helpless child.

Throughout all of the obscene demonstrations and shocking excesses of hysterical theatricality, the body of a twelve year old becomes the fearful echo of a reality that itself lies in the spectator's own corporality. *The Exorcist* reveals this reality as a kind of seeing and hearing that the film's spectator realizes in her own flesh. In the thrill, the horror, the aesthetic experience of the film, she becomes aware of herself as the wounded, maimed, stigmatized body. His shock, his fear, his abject pleasure become comprehensible as what belief in the devil has always demonized. In the spectator's morally ambivalent pleasure, as well as in the violation of his perceptual senses, an experience of his own corporality becomes a reality that cannot be reconciled by any symbolic espousal of the human: the perishing of the body, carried out at every moment, the heterogeneity of pleasures, the asymmetries of the division of the sexes.

6

A NEW SENSITIVITY

With *The Exorcist*, horror becomes the medium for an experience that the classical genre had banned to the offscreen realm of forbidden imagination. In so doing, the film highlights a dimension of social reality that is in fact highly terrifying and frightening. It concerns aspects of everyday life that can also be found in numerous other films in Western cinema in the seventies: the inextricable silence of the physical basis for human existence, the destructive powers of a demonized sexuality, and the antinomies in relationships between lovers, friends, and family member, which are permeated, even in their most minute ramifications, by a dominant desire that dictates everything. No matter what experience of destructive forces was dominant in the contemporary discourses in the seventies, these experiences became sensually graspable in the deterritorialization of classical cinema. They became, to use a formula from Utopia Cinema again, visible as part of the physical reality of our everyday social world.

In this social respect, both sides of cinema are inseparably intertwined. That is, film as the phantasm of a corporality that is pure thought, a pure play of signs, free of all the earthly heaviness, and film as the physical-affective reality of the spectator, as a "series of blows to the consciousness and emotions of the audience."[1] Herein lies the distinction between the films from this period and the new territorial allocations of postmodern cinema.

In fact, in the arabesques of the brilliantly edited mutilations in *Kill Bill* and the obsessive torture in *The Passion of the Christ*, the

two sides of cinema are neatly separated from one another. They denote the poles of a new organization of genre in postclassical cinema, poles that no longer measure the territory of audiovisual culture according to the iconography of mythopoetic concepts of the world, but according to types of affective stimulation and standardized modes of arousal. Within this reterritorialization, the potential to exceed boundaries and break taboos, which has become associated with the dissolution of classical genre cinema, seems to have been exhausted.

Nonetheless, a poetic perspective can still be ascribed to contemporary Western cinema that follows neither the strategy of boundary breaking nor the logic of postclassical genre cinema. Unlike the auteur films of the seventies, these are films that are not so much concerned with the hidden mechanisms of power and with destructive forces in social behavior and in the relations between the sexes; instead, they examine the possibilities of living together well, the possibilities of friendship, sexual partnership, and family, on the level of an everyday consciousness free of its humanistic self-images and ego ideals.

In a certain way, the perspective has been reversed. Instead of making visible the microstructures of power that pervade everyday feelings, thoughts, and behaviors, the films attempt, within the endless monotony of a world of prefabricated ways of existing and experiencing, to identify those forms that make it possible to revitalize a shared life. Their logic is precisely not that of deconstruction, but instead follows the emphasis of a new sensitivity, which seeks to ground itself in the worn-out platitudes, stereotypes, and cliché forms of a feeling and thinking that has become thoroughly mediated.

Not unlike in the early seventies, we find these films in all areas of Western cinema, in Hollywood—for instance in films by Paul Thomas Anderson, Ang Lee, or Sam Mendes—as well as in European auteur cinema. If I concentrate here on the films of Pedro Almodóvar, it is because they are as exemplary as they are singular: in them the primary constellation of Western European cinema repeats itself. Their view of the everyday consumerist media world—of its forms of sensitivity, of ways of experiencing and forming the self—is determined as much by the memory of a society organized by fascism as it is by the more or less consistent promises of happiness from American-style popular culture.

Almodóvar: Leaving *Bernada Alba's House*

The first scene of Almodóvar's first feature film, *Pepi, Luci, Bom y otras Chicas del montón* (*Pepi, Luci, Bom, and Other Girls on the Heap*, 1980): Pepi (Carmen Maura) in her apartment. She lolls about on the floor among pillows and rugs, pasting little pictures in a movie star album. On the windowsill cannabis plants are growing. Loud music is playing, squeaky female voices. The doorbell rings; it is the policeman (Félix Rotaeta), a neighbor who lives in one of the dingy apartment blocks opposite. He has seen the plants from his window. Pepi tries appealing to his baser instincts. She offers to let him kiss her sex, in return demanding that he keep quiet about the plants. When he wants to penetrate her, she refuses him: She's a virgin and not yet ready. The neighbor uses force to take what he thinks was part of the deal. A cry of pain from Pepi, as artificial and piercing as the girl group's singing.

It is relieving to know that the scream is only playacting. But within this play a reality comes clearly into focus. The scene, between drug deal and rape, is trying to represent certain basic social circumstances.

The man, a policeman, informer, and voyeur, represents fascist state power, and the woman moves in with her sexual plea bargaining, in which her virginity represents symbolic capital resources, completely in keeping with the logic of an archaic-patriarchal society, like that described in Federico García Lorca's plays. Pepi wants to avenge herself, and it is as if the film about Pepi, Luci, Bom, and the other girls is celebrating the daughter's departure in García Lorca's 1936 drama, *La Casa de Bernarda Alba*. It is the departure from a world in which all social relations are structured by an extremely pointed antagonism between the sexes. The film shows girls who no longer wish to be wives, mothers, aunts, and daughters. Instead, they initiate a masquerade of sexual desire in which not only the music clubs and theaters, but every street and every café becomes the stage for a performance of passion.

Almodóvar's films then stage a world in which the play of sexual desire is allowed to be anything except one thing: a matrix of social systems of order, power, and morals.

One scene from a later film, *Volver* (2006): Sole (Lola Dueñas) drives to her childhood village, to her tía Paula's house (Chus Lampreave), to her

parents' grave, and to her old friend Agustina (Blanca Portillo). Her aunt has died. She enters the house, fearfully imagining the dead woman in every sound, every movement. And, in fact, Irene (Carmen Maura), her dead mother, appears to her. Sole tries to escape the house and go outside, into the light; she rushes to the patio. It is full of men whose gazes cause her to turn back, banished back into the house . . . Inside she finds a dark room, murmuring women gathered around the aunt's corpse.

It has often been said that Almodóvar's films show a world of women in which the male characters can only hold their own if they know how to assume and imitate the positions of women and can manage to integrate themselves into the sisterly alliance. The other men are failures on this path or they are the heroines' adversaries, the representatives of an old order, a burdensome guilt—public prosecutors, policemen, husbands, priests. It is a world in which fathers are often entirely lacking, or they are absent-mindedly slipping toward death, caught up in amnesia like Rosa's (Pené-lope Cruz) father in *Todo sobre mi madre* (*All About My Mother*, 1999). If necessary, they are forcibly removed, as if they were a bad dramaturgical choice that needed to be corrected. This is the case in *¿Qué he hecho yo para merecer esto!!* (*What Have I Done to Deserve This?*,1984), when Carmen Maura as Gloria strikes her husband Antonio (Ángel de Andrés López) with a hambone; or in *Volver*, when Penélope Cruz as Raimunda deposits her husband Paco (Anotonio de la Torre), who has been stabbed to death by her daughter, into a freezer. Almodóvar's films show a world in which the patriarchal system of order seems to be little more than a memory.

The Masked Play of Gender and the Logic of Sentimental Consciousness

This is in part why Almodóvar's films have continually been seen in terms of carnivalesque reversal and erotic transgression. The use of drag, the parodic reversals, have been thematized as strategies to upset social rela-tions, primarily those of gender, to lay them bare and dissect the ways that they are bound up with power.[2]

In this sense Almodóvar's films are considered paradigms of a politics of sexual boundary breaking and of celebrating the endlessly multiplying masquerade in sexual love. It is this play of masks that would seem to give the films their overflowing liveliness, their beauty.

But beauty would seem to be a highly inappropriate term to describe the films of a director who, in his first feature film—*Pepi, Luci, Bom y otras chicas del montón*—appears as the lead singer in a punk band. And even the friend that accompanies him in this appearance, the actor Fabio McNamara, would seem more to conjure up the idea of repulsive ugliness when he plays one of the stars of the drag queen scene in Almodóvar's next film, *Laberinto de pasiones* (*Labyrinth of Passions*, 1982), where he presents himself at a photo session with the decor of a splatter movie and, moaning lasciviously, simulates sexual ecstasy while he is being molested with a drill.

In the world of these films, what is beautiful is by no means simply what is pleasing, but rather what appears as desirable from a particular standpoint, a particular perspective. Fabio McNamara is beautiful to his fans, and this goes for all the characters that portray stars in Almodóvar's films: for the punk singer Bom as well as for the singer Becky (Marisa Paredes) in *Tacones lejanos* (*High Heels*, 1991) or the actress Huma (Marisa Paredes) in *Todo sobre mi madre*. Victoria Abril is beautiful to Antonio Banderas in *¡Atame!* (*Tie Me Up, Tie Me Down!*, 1990), and Antonio Banderas to Nacho Martínez in *Matador* (1986). Elena (Francesca Neri) is beautiful to Víctor (Liberto Rabal) in *Carne trémula* (*Live Flesh*, 1997), and Víctor to Elena; the writer Leo (Marisa Paredes) is beautiful in *La flor de mi secreto* (*The Flower of My Secret*, 1995) in the eyes of Ángel (Juan Echanove) from the very beginning; while it is only at the end that Ángel seems, if not beautiful, at least comfortable to Leo.

In these films beauty is the mode in which the characters and things are represented to the desiring gaze of the other characters. It is the veil that these other characters, driven by their longing, snatch from the bodies and from the things that they want to possess.

Almodóvar's films are stagings of such erotic dances of veils, always connected to the gaze of a desiring ego they try to capture. They stage beauty as a perceptual process of the characters, which the spectator then experiences as the perceptual process of another ego. This may be the color composition of an interior set or the graphic stylization of the decor; it may be a view into the landscape or the ensemble of rocky coastlines, the sea, and a lighthouse; it may be a pristine male body in pure white underpants or a Chanel outfit worn as if it had been designed specifically for the legs of a particular actress.

From this perspective, we can easily lose sight of which dominion, which conformity, which identity it is that is being surrendered up to the masquerade. In the first films, in fact, the dominant force is still the motif of sexual boundary breaking—in *Pepi, Luci, Bom y otras chicas del montón*—the carnivalesque reversal of the sacred—in *Entre tinieblas* (*Dark Habits*, 1983)—and the celebration of the play of masks of sexuality—in *Laberinto de pasiones*. But already in *¿Qué he hecho yo para merecer esto!!*, a quite different theme turns up.

Almodóvar's films are not only—not even in the first place—about the erotic longing of sexual love. Alongside the wish to possess the desired body, there is, with no less intensity, the wish to merge together with this body, to lose oneself in it. This, however, in no way amounts to the same thing. Indeed, this longing and the hope of fulfilling is applied to the past and not to the future. It is the longing for childhood happiness, the wish for the return of a former love. It is Raimunda's longing in *Volver*, when she suddenly smells her mother in the bathroom, and Rebeca's (Victoria Abril) longing in *Tacones lejanos*, when she collapses on the cot in prison while the voice of her mother can be heard on the radio: a mother who stylizes lovingly embracing a child in her stage appearance, turning it into a gesture of the highest pathos. We could call it sentimental longing.

Manuela (Cecilia Roth) follows this longing in *Todo sobre mi madre* when, after her son's death, she travels back to Barcelona, into the city of her girlhood years; Pepa (Carmen Maura) obeys it in *Mujeres al borde de un ataque de nervios* (*Women on the Verge of a Nervous Breakdown*, 1988) when she cannot tear herself away from the Don Juan who, with his loving-lying talk spins her into a voice whose body makes itself literally unreachable. It is the memory of the vibrating warmth of a body, a scent, a voice, before one was aware of one's own body, infinitely separated from the other one.

The beauty in which this desire is represented, in which it is staged as the perceptual process of the film's characters, is that of kitschy landscape poem, moving pop song, tearful melodrama. It is grounded in the pathos of painful love, that spoken about by old songs, by flamenco dances, by the ethos of the matadors. It is the beauty of the village, which the old woman recites in a poem in the back seat of a small car, the memory of a village

street... This beauty, however, is always also the pathos of old Spain, a sentimental reminiscence of Francoism.

The first scene of the film *¿Qué he hecho yo para merecer esto!!*: We see Gloria working as a cleaning lady in an Asian martial arts school. Here, as well, the separation between the world of men, with their sports uniforms and ritual fighting exercises, and that of women is sharply accentuated. Gloria's attempt to take part in the men's game—she wants to have sex with one of them in the shower room—ends in humiliating frustration. She stays behind in the gym after the others have left. In a rhythmically repeating loud scream, she performs the striking technique that she had previously seen the men practicing. Toward the end of the film she will use the same technique to slay her husband Antonio with a hambone. The death of the father dissolves the family ties in which Gloria had been trapped: Toni (Juan Martínez), her older son, goes back to the country, to the family village with his grandmother (Chus Lampreave). Miguel (Miguel Ángel Herranz), the precocious hustler, whom Gloria had previously sold off to a pedophilic dentist (Javier Gurruchaga), returns to the apartment, and mother and son, much like grandmother and grandson, form a new constellation of characters, a new possibility of relationships beyond the paternal family. At any rate, the triumphant saxophone in the film's final sequence seems to promise a way out of the realm of the fathers. What can be seen, however, is a world of destroyed social relations.

The bleak apartment blocks of the satellite town—the grandmother and grandson move among them as if every abandoned plot and every pile of rubbish had been transformed for them into a fantasy landscape of nature and adventure—describe a deep wound, a pain. And when this couple says good-bye to Gloria at the bus station to travel home to the grandmother's village, the film leaves its spectators very little hope that the two could actually find this fantasy landscape in the native village.

For the grandmother and grandson, the trip out of the sad suburban zones and back to the native village is defined by a deep ambivalence. We learn from the conversation in the bus station waiting room between two old women, two former neighbors, that many of the village's men have died in the meantime, just as Gloria's husband has—and we can guess that they were cut from the same cloth as he was: representatives of the old Franco

Spain who ruled the country the way Gloria's husband had ruled the marital home.

The patriarchal family arrangement is the fundamental figuration by which Almodóvar's films thematize a form of socialization based on violence and oppression. In no way, then, do the native village, the country, the mother's birth house indicate the site of unbridled happiness. The motif of return, the trip home, always implies both: it means both confronting pain, which holds the characters back, and searching for the early happiness of the lost home, which constantly sets them in motion.

What gets lost in the celebration of sexual transgression is this deep ambivalence. This becomes clear if we view Amodóvar's films as a whole. The films articulate an insistent investigation into a pain that cannot be shaken, of injuries incurred in labyrinths of passion, which cannot be eradicated by any use of drag.[3] Little by little, the films begin to focus on the motif of return, which has now been announced by the very title of one of the later films, Volver.

In La flor de mi secreto the protagonist Leo, after having attempted suicide, travels to the country with her mother (Chus Lampreave). The journey to her native village marks the middle of the film and the starting point of a movement that will lead Leo out of the phantasms of love in which she is trapped. The mother is played by the same actress that, as the grandmother, had already made her way home in ¿Qué he hecho yo para merecer esto!! Here we see her arriving amid the rapturous greetings of old women receiving her like a movie star: "La Jacinta, La Jacinta!" This village, inhabited only by women, is shown as the site of the unmarred happiness of the motherly home.

When, ten years after La flor de mi secreto, it is precisely this mother's village, this street, this house that returns in the film Volver, it is in fact still inhabited by the same actress, no longer playing the mother, but an aunt. The parents are dead, burned in a fire, and Raimunda, the film's main character, returns to a home that was an exile even in childhood; a sanctuary offered by the aunt, because the naive-ignorant mother did not know how to protect her from the father who was abusing her.

When the village women talk about the constant wind that kindles the forest fires threatening the village, this is clearly a nod to La Habanera (1937)—the film with which Douglas Sirk paid his respects to the racism of

fascist ideology and which, at the same time, tells of the captivity of women. In this film Zarah Leander speaks of the hot wind from the south in quite similar words. The memory of her song, her voice, had already been introduced in ¿Qué he hecho yo para merecer esto!! as an imago in which the husband's desire finds its ambivalent expression. Indeed, Zarah Leander's singing here does simultaneously characterize both the memory of a great love and a sentimental reminiscence of fascism. Almodóvar's films show a world in which the patriarchal system of order is, on the one hand, only a memory, but which, on the other, remains a memory that is difficult for the characters to bear.

In La Habanera the wind brings fever, in Volver it starts a fire that engulfs the evil parents. Volver is also a fairy tale about the miraculous return of the dead mother.

How can we accommodate these memories without giving up the sentiment of the old pathos for the ghosts of the past? This is the question that drives the films of Almodóvar. As if the cinema could become the medium of such a miracle, the films try to wrest an image of past love, of early happiness—a face, a voice, a house—out of the most ambivalent past. They continually move into deeper and deeper regions of sentimental consciousness, into the world of melodramatic love scenes and love-struck songs.

Does this mean, as has been claimed, that Almodóvar has returned to genre cinema and melodrama in his later films? And does this mark a fundamental turn in his work, which increasingly replaces the burlesque drag of the early years with a dramaturgy of sentimentality?[4]

Not from This World . . . the Being of Characters

"Don't say that. I'll start to cry, and ghosts don't cry." These are the last words in Almodóvar's film Volver. Carmen Maura says them to keep her daughter Raimunda from talking. The daughter who wants finally to say everything—her pain, her injury, her parents' guilt.

At first glance it seems that this describes the poetic logic of the melodrama—a pain that goes unspoken, instead continually spawning new forms of expression: a sad song, a weeping face, a composition of color, a poem, a dance. In Almodóvar we find each of these manifestations of sentimental sensitivity, and yet his films do not follow the logic of the melodrama.

From his earliest to his most recent films, we can observe a constructed-ness in the perspective in which the psychology of melodramatic character types is radically externalized. In place of the one subjective inner perspective of the sensitive ego, what appears is an endlessly self-mirroring relativism of each individualized view of this ego. The characters in these films do not achieve their affective dimension from any psychological illusionism, but from the transparency of their staged construction. They are ascribed an utterly artificial way of being that is always present to the spectator as a relational system of reference.

A well-known photo of Almodóvar can illustrate this poetic principle. We see the director in front of a chessboard; the pieces of the game bear the faces and costumes of the characters from his films. We should, however, not be too quick to take this self-stylization on the part of the director as referring to the mastery of the author. For it is not the directing gaze that is represented in this picture.

Almodóvar's characters are always already found, discovered as a reality of art, fiction, entertainment culture, the media. Coming from the surrounding realms of popular culture, television, theater, and literature, they are always already cloned. They enter into the world of Almodóvar's films as manifestations of a sentimental consciousness (as a mirrored doubling, as pairs of opposites, as a displacement from one genre or medium into another), meld together, and divide into every new arrangements of perspective. The characters always bring their own lives, a previous life, with them, a set of laws of movement and possibilities for action that needs to be explored. They are to be understood in relation to their own rules, their own lines of power, and their own possibilities of relationships. What is attached to them in terms of their potential of affect and thinking? What radius of the possibilities of experience can we measure with them?

We could say about Almodóvar's characters in particular what Stanley Cavell has said in general: They have a life that is much like ours and yet is fundamentally different from it; they are projections of analogous conditions of the world from which we nonetheless remain radically excluded.[5] The characters are made up of the most diverse perspectives on our everyday world of experience, but they cannot be detached from the poetic order that—as part of the world of art—produces them. For this reason they are also not subjected to our laws, our morality, our psychology—not even our

physiology. They can kill without racking up guilt, as Gloria does in *¿Qué he hecho yo para merecer esto!!* and Raimunda's daughter Paula (Yohana Cobo) does in *Volver*, or transform themselves seemingly effortlessly from hardworking truck drivers into full-breasted women in fake Chanel outfits like Agrado (Antonia San Juan) does in *Todo sobre mi madre*.

In a certain way, these characters therefore also do not know death. If they ever do actually die, they do so only to turn up again in one of the next films—as a character trait, a name, an actress.

They arise as configurations made up of doubled characters, genetic derivatives, mirrored reversals, and short-circuitings between the actors, the reality of the production, the cinematic fiction, and the reality of the spectator. It is as if a nonorganic life presided between them, in which even the most extreme pain can be turned over into good within a comic scene. It seems possible for them to proliferate among themselves—to divide and regenerate. In the film *La ley del deseo* (*Law of Desire*, 1987), the character of the director Pablo (Eusebio Poncela) shifts this act of proliferation itself into the focus of the performance. From then on, the discovery and self-discovery, the writing and extrapolating of a character by another character, their mutual creation as written, filmed, staged projections is a constitutive element of the construction of characters in Almodóvar's films.

This representational principle has been thematized time and again as self-referentiality and therefore seen as a characteristic of postmodern poetics. But the manifold references to all areas of art and popular culture in no way follow the logic of ironic self-commentary or postmodern citation. Neither the self-references within the work nor the intertextual references are meaningful in and of themselves. Rather, the referential structure itself, the tightly woven net of references, forms the material basis of the characters, the medium in which they are presented. The echo of reminiscences, the network of intertextual references, characterizes the specific *raison d'être* of the film characters, their living element—their materiality in the medium. This is why the characters cannot be separated from the relational references, the perspectival mirrorings and reversals: they consist of nothing other than these references. From film to film they are connected to a true cabinet of mirrors of figurines that mutually double, parody, travesty, or reverse into their opposites. It is this play with a self-generating system of actors and characters that fills Almodóvar's films with

overflowing life: a life that is thoroughly artificial and yet connects with the reality of our world of feelings. The characters seem to us to speak to our innermost ideas, although they stand before our eyes as the most artificial constructs of human emotional states. They form themselves into an ornament of possible ways of viewing a human life, free from the burden of being a human being.

From film to film the gestures, phrases, and stereotypes of sentimental consciousness are taken up, only to be detached from the monopathic one-dimensionality of melodramatic pathos. They coalesce into figurations that replace the psychological hierarchies of internal and external worlds, objective and subjective, imagination and perception, with the relativity of mutually defining, shifting, mirroring perspectives.

So Raimunda in *Volver*—in the prompt reaction with which she moves to protect her daughter—is not only an answer to the past ascribed to her in the film (she was molested by her father) but at the same time becomes a new perspective on the figure of the mother that had been developed in the previous films. When Raimunda goes to great effort to make her daughter's guilt literally disappear—the vast amount of blood and the corpse of the stabbed man—when she, not knowing what to do in the initial shock, tells her daughter: "Whatever happens, I'm the one who killed him," then the character simultaneously represents the countershot, the perspectival reversal of the mother that Marisa Paredes embodied in *Tacones lejanos*. Becky, the famous chanteuse, who sings on stage of endlessly attentive love, but who—completely taken over by her career and her relationships with men—provides her daughter Rebeca with a mother in only the biological sense. In the egocentric behavior with which she follows her desires for devotion and attention, Becky is a child, a perpetual girl like Pepi and Bom, who does not wish to be anyone's wife, anyone's mother, or anyone's daughter.

For Becky, there is an eternal opposition between sexual love and a daughter's need for love; for her it is impossible to be a girl like Pepi and a mother like Raimunda at the same time; impossible at the same time to satisfy childhood longing and sexual desire. Only on her deathbed does she become what Raimunda is from the beginning in *Volver*: a loving, protective mother. Becky obliterates her daughter's guilt, burying it forever by accusing herself of the murder before she dies. Only as a corpse does the

body finally become reachable to the daughter; Rebeca crawls, now herself just a child, to the dead mother's bed.

As if to correct the failure of this mother figure, the actress Marisa Paredes, in her next role as the writer Leo in *La flor de mi secreto*, invents the story of a good mother. Leo's latest novel tells a story that will give Raimunda in *Volver* directions on how to protect her daughter; she invents the woman whose daughter has stabbed her mother's husband to death and who then lets his body disappear into the freezer of a restaurant that is being sold.

The Melodramatic Primal Scene: *La flor de mi secreto*

More than any other of Almodóvar's films, *La flor de mi secreto* spells out the opposition between the childlike need for love and sexual desire, which had been developed in the figuration Becky/Rebeca. More than any other film, it operates with the distinction between the two forms of desire, the erotic and the sentimental. Consequently, *La flor de mi secreto* works out the poetic logic of the melodrama more than any of Almodóvar's other films. Indeed, this logic is essentially marked by the antagonism between love and sexuality.[6]

Leo—like Becky—moves within the seemingly irresolvable conflict between these two models of love. As a writer, she—like a man—wants to write of the real pain of life and not of the happy ends of sentimental fantasies. She has renounced the "women's novel," with which she has become famous as Amanda Gris; Leo tells her publishers that Amanda Gris has a problem with colors. She only knows sky blue and pink. She does not know any kind of pain, only sentimentality. So her success only brings her the necessary money to finance the upkeep of her mother and sister (Rossy de Palma)—even in this constellation she takes on the male position of the father.

As a lover, Leo holds onto the opposition of the sexes for a long time—and onto Paco (Imanol Arias), the man who ignores, humiliates, and disdains her. In turn, she cannot see the other—Ángel—who is actively interested in her novels and her beauty and goes to great lengths for her as a potential love partner. For Leo's sight is stamped by the pathos of an archaic

opposition of the sexes, by the black and red of a self-perception that considers only pain to be true—the truth of the battle of the sexes as flamenco dances celebrate it.

It is just this perception that the film puts into play as a subjective sensation of the world. When Leo wears red, then the air is on fire with her desires, if she throws a gray coat, wet with rain, over her shoulders, then her condition is also gray: capped by the bleached-out sky blue of the hat drawn deep over her face and framed by the rectangles of graded mixtures of red and blue on her scarf—violet, purple, pink—which, not unlike the painfully tight black boots, are a memory of the absent lover. A way of staging, then, that utterly follows the rules of melodrama. But, in the same stroke, by which the film stages the protagonists' ways of sensing, it exposes the Manichaean logic that governs this world of perception.

From the point of the view of the spectator, this costuming associates Leo with one of the great female legends of Hollywood, who—after she reached the peak of her fame as a beauty—no longer allowed herself to be photographed, always seeking to be incognito. And, in fact, not only is Leo a famous star in the pastel blue-pink sky of entertainment literature, hiding behind a pseudonym. She is also a woman who wears a short red dress like sexy lingerie to greet her too young lover and baggy gray or beige coats, like a man who is trying to bulk himself up. In the loose coat she is the woman who is as ashamed of her charming beauty as she is of the success of her sentimental romance novels: a kind of late Greta Garbo existence. In fact, Leo as a film character is, on the one hand, what she in no way wants to be as a writer: a textbook melodramatic heroine. On the other hand, she is a man who is ashamed of being a woman.

So the melodramatic apotheosis is also not lacking in this film: Leo sees herself—finally—betrayed by her lover and recognizes that she has been abandoned. She breaks under the sharp contradiction between her child-like need for love and the logic of sexual desires. The staging of the time of this coming-into-consciousness, the successive unfolding of the interior perspective of this consciousness, however, is the endlessly repeated primal scene of all melodramas.[7]

And, in fact, Almodóvar rarely comes as close to the poetics of melodrama as he does in this sequence. But the apotheosis here does not mark the dramatic high point, but instead a turning point in the exact sense of

the word. It marks the axis of a reverse movement in which the interior perspective of the sensitive ego is opened outward. In the background we recognize Leo leaning against the doorframe, a blurry red; Paco's face can be seen quite close in the foreground. A close-up of her face and his departing footsteps, then his disappearing shadow and once again her face. Leo sobs, the music starts. The following close-up is slightly jarring. It shows Leo's face once again, mirrored in a shiny red lacquer cross. A grip of the hand turns the red thing into a medicine cabinet.

Leo—just like a melodramatic heroine—takes pills in a suicide attempt. The telephone rings, a short pause. It is the voice of her rival, not of her lover. A sharply accentuated shot: Leo in red satin, her contorted body, shut up in the rectangle of the edge of the bed. Then in detail: her hair, her truncated face, the pores of her powdered skin, her eyes, the red of her shoulders. The music stops, the image slides into darkness. Up to this point the scene is a highly conventional paraphrase of the melodramatic primal scene we see time and again in numerous films.

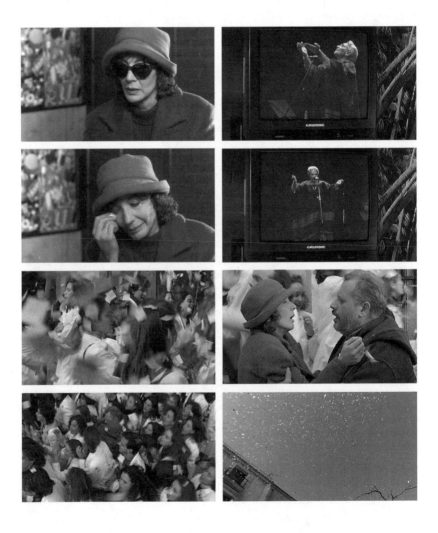

Once again we hear the telephone, the click of the answering machine, this time it is the mother's voice; a dissolve: opening her eyes, Leo answers the tinny voice; in the countershot the answering machine: an image of the greatest abandonment and a mirrorlike reversal of the melodramatic primal scene.

Her mother's voice literally wakes Leo from the phantasm of the pain of love. The dialogue with the answering machine leads from the darkness of phantasmatic interiority into the world of social relations. The film, however, stages this awakening, in clear allusion to the horror film, as a birth, a rebirth. She opens her eyes again, she regurgitates the pills, quite literally the most internal aspect of this suffering is turned outward.

The Dissolution of the Ego Perspective

When Leo lifts her head out of the bathtub in which she has showered fully dressed, it is, despite the comedic playing with the idea of the return of the dead, an image of extreme corporeal exhaustion. The representation of the interior world has entirely become the image of a physical condition. The expression of this condition, the cry of pain, is—like the voices on the telephone—separated from this body. It comes from the television. Leo has fled to a bar; above her on the wall is a monitor in which we can see the

"funny screaming contest" to which Ángel had invited her the day before, only to be stood up once again. Even the song, which gives Leo's suffering its stereotypical shape, is separate from her body, artificial sentiment presented as an image set apart within the image. We see an old woman singing on television who is as connected to Leo as is the voice of her mother on the answering machine.

Step by step, the staging of the melodramatic primal scene dissolves in its own elements. Instead it unfolds a system of references that can no longer be detached from the surface of the image: as if the interiority of the sensitive ego, turned outward in a perspectival prism of mirroring aspects of the ego, had entirely become the visible surface—sounds referring only to sounds, images to images, voices, bodies, colors, geometrical forms, that only correspond to other forms . . . In no way is this a strategy of ironic distanciation.[8] For the musical and visual compositions are thoroughly directed at the sensations of a sentimentally gifted spectator. But this sensation is inserted as such, as an aesthetic enjoyment present to itself, as a further perspectival mirroring in the construction of the characters. For the spectators, the pain is always an artifact, an audiovisual composition, that the film pulls out of melodramatic phrases. For them, the pain is always a song, an artfully constructed cry, the carefully calculated image of a contorted woman in red. They always already observe the character from an angle that lies outside the character's inner perspective.

If the coat is royal blue, Leo finds herself in a sea of pain. If she is then encountered with a coat in brownish shades of red that surrounds her and holds her in its arms, amid a turbulent sea of white frock and black shocks of hair swaying back and forth, she is saved despite the painful state of being lost.

We easily follow the logic of the white that, released from the smocks of the protesting medical students, descends like thick rain in the form of white handbills falling from the blue sky onto the city: a whirling shimmer in which the metaphors of snow drifts and falling autumn leaves casually melt into one another like the floating camera with the song that is now to be heard; the most important line of which has already been spoken several times in the film—"Si sólo queda en mi dolor y vida, ay Amor, no me dejes vivir" ("If all that's left in me is pain and life, love, don't let me live").

At this point as well, when an abrupt counterpoint is placed precisely at the highpoint of the melodramatic presentation of pain, we should not be too quick to speak of ironic distanciation. For in the pan that rips us out of the snowdrifts to a blue summer sky—we see the lettering of the department store Fnac and placarded on the front of a midsized skyscraper is the advertisement for the new Amanda Gris novel—two opposing models of relationships are intertwined.

This becomes clear when we see the symmetrical mirror constellations with which the film establishes its relational network of characters. As if they were standardized studio design models, two kinds of family television series are opposed. On the one side are Leo's mother and sister, the sitcom of a trashy-lower middle-class family of quick-witted, cantankerous women, dressed in the most sordid color combinations of sweaters, jackets, and frocks all layered on top of one another. On the other side there is the bourgeois household, in which all colors and forms are neatly separated, where everything is framed and neatly arranged, with Leo as the nervous lady of the house who has alcohol problems and Blanca (Manuela Vargas) as the caring housekeeper who dances flamenco with her son Antonio (Joaquín Cortés).

Given this background, we can also understand the other mirroring, that of Paco and Ángel. Ángel, who is associated with muted colors and who even takes the edge off of flamenco when he gets drunk and starts to dance, and Paco, who is assigned to the sharp separations of rectangular framing and whose mastery of the telephone game surrounds Leo with his absence. We not only understand why Ángel effortlessly knows how to write female love fantasies but also why he mutes the lush red with yellow, as if his apartment were a refuge of friendliness. These colors correspond not only to the somewhat muddled red of the dowdy jackets and sweaters that Ángel won't discard after his first encounter with Leo. They are also appropriate for an apartment in which everything that is normally rectangular—windows, doors, views—becomes round.

Precisely the obvious affinity of the film *La flor de mi secreto* for the poetics of melodrama allows the distinctiveness of Almodóvar's constructivism to come forth clearly. While the poetic logic of the melodrama seeks to give expression to the subjectivity of a sensitive ego within audiovisual

representation, these films enact a radical externalization of everything that is the mental state of everyday consciousness. On the one hand, they dissolve the everyday forms of expression of inner sensation (the gesture, the cry, the face) from their relation to a silent, invisible sensation and turn them into the building blocks of disjointed and multiplied figurations of relationships; on the other hand, the compositions of light and colors, everyday objects and graphic abstractions, lines of movement, rhythm, and figurations of movement, gestures and appearances form a surface of audiovisual figurations of the image that keep the spectator's own perceptive activities transparent. Time and again, her seeing and hearing is referred to this compositional surface and, as such, to herself, to the act of aesthetic perception. She is confronted with the film images as a composition of colors, graphic patterns, collages of everyday objects, and forms of repetitive visual phrases and sentences, as a visual surface that, much like the music-sound arrangements, becomes a complex aggregate of sensations of perception becoming aware of themselves.

Time and again her seeing, as the self-actualization of aesthetic perception, is excluded from the world of the characters, only in the next moment to be sucked up again into the way things appear in this world, to be locked up in it. So the spectator's perception occurs in a constant back and forth between the baroque ornamentalism of the image's surface and the endlessly dividing and multiplying world of the characters' feelings.

La flor de mi secreto crosses the Manichaean order of sentimental fantasies, the opposition of the motherly love of merging together and phallic sexual love.

This is, on the hand, the performance of the flamenco dance: Blanca, who loses the battle with her son—of red against black, of the line against the circle—a woman in a red dress, buckled over on the floor, rejected by the son in black, who celebrates a narcissistic solo on the stage.

On the other hand, it is the mother's village, to which Leo returns after her breakdown, the wondrous transformation of her mother, the women in the village, their singing.

It is as if the film were seeking to etch the social dimension, the reciprocal coming-into-relation and being-in-relation, out of the phantasm of motherly love and that of sexual love, to carve it out as a possibility of coming together.

The exhausting arrangement of the flamenco—of the endless opposition of black and red, man and woman, bull and matador—is opposed in the film by a principle of the imitation of motherly love, a becoming-motherly by the editor in chief and a becoming-daughter by the writer.

Seen in this way, *La flor de mi secreto* is the attempt to separate out the figurations of motherly love from preestablished melodramatic characters and constellations. It is as if the film itself were completing a passage like that of the mother and daughter's outing to the country: the car ride out

of the sprawling suburbs past the sallow meadows and depleted fields at the edge of the highways, as if they had to pass through the landscape cut through by cordons of utility poles into order to find the village again. The trip becomes the movement of returning, in which not only has the view of the wasteland landscape changed but, at the same time, the mother has transformed from the cantankerous old lady into a singer. Her enervating talking slowly transforms into a lyrical recitation in which she sings about

her village. We see the land basking in the sun; we hear the calls, the voices of women . . .

The Beloved Voice

Even the mother's voice on the telephone marks a reverse movement by which a central complex of sentimental pathos is dissolved. The motif is explicitly introduced in *La ley del deseo*. Paolo, the successful film director, stages Jean Cocteau's *La voix humaine* (1930) in the theater. In his staging, he connects the logic of seduction with the longing for the absent mother and the silence of the suffering woman.

A girl is being pulled on a wagon along the front edge of the stage. It is as if she were miming the curtain that opens and closes the play. Her gestures underscore Jacques Brel's chanson "Ne me quitte pas" like a rough lip-synching. Upstage we see Carmen Maura, who as the transsexual Tina plays a woman who is waiting for her lover's telephone call. With demonstratively dilettantish gestures, she is wrecking the furniture. Every strike is accompanied by the choppy battle cry that she had already practiced as the cleaning lady Gloria in the Asian marital arts school—the stylized gesture of a speechless rage. Tina, the director's sister, who was his brother before her transition, is, like Gloria, excluded from the erotic play of men; for the other women characters she functions as a kind of placeholder who stands in for the beloved others that they are all lacking. She cleans for and takes care of Pablo, her brother, who has no wife like Gloria; she becomes lovers with Antonio (Antonio Banderas), who merely uses her to get to her brother. And for the child at her side, who is acting with her in the theater, she replaces the mother.

The telephone rings, Tina lunges at the receiver. In the spectator's perception, Jacques Brel's chanson represents the voice of the absent beloved that Tina falls for. Both, the seduction of the voice on the telephone and the sentiment of the song, are connected with the separation from the mother. For while Cocteau's play progresses on stage, we see the girl, after her first appearance, in the dressing room. Suddenly her real mother turns up. The child's joy turns to rage when she learns of her mother's future plans. For they cater to the wishes of men, not to those of the daughter. When the girl is pulled across the stage again, this time in the opposite direction, the end

of the performance being signified by the same lip-synching number, Brel's song sings of the separation from the mother, who the child has turned away from, sullenly hurt. Suddenly the girl stops acting and instead begins to cry.

In Almodóvar's next film, *Mujeres al borde de un ataque de nervios*, the "beloved voice" becomes the central theme. The film develops this motif as the fundamental principle of seduction. Iván (Fernando Guillén), a variation on Don Juan with a Russian-sounding name, does not possess the beguiling power of singing that his model, Mozart's Don Giovanni, does, but he does know how to set up the soft, sensitive timbre of his spoken sentences like traps to catch women through endlessly connected telephones, answering machines, and microphones. He is the dubbed voice, talking to the silent woman on the screen.

Iván and Pepa are both employed as voice actors in a dubbing studio (the dubbed voice was already introduced in *La ley del deseo*). They are working on a Western with a quite untypical gunslinger as the central character: Johnny Guitar, the title character from Nicholas Ray's film of the same name (1954), played by Sterling Hayden, who seeks to beguile with his singing rather than his weapon. Pepa has overslept and arrived late to work, so Iván speaks his part of the dialogue alone: the man who talks to the woman in order to move her to assert her faithfulness and devotion. We see the screen image of the mute Joan Crawford, as if she were writhing under the man's pressing words. When Pepa speaks the woman's answers, she stands alone before the microphone. Her words fall into a void that Iván, her lover, who is pulling away from her without completely separating from her, has prepared for her with his alluring voice.

For Pepa, Iván's voice, whether in the dubbing studio or on the answering machine, is always a moment of his just fading presence, a trace of his presentness in the very moment that it is slipping into the past—the echo of a departing body that she always misses by just minutes, even seconds. Until Pepa finally understands that her madness in love is nothing more than a delusion that Iván produces with his strategic game of *fort-da*.

In the theatrical scene in *La ley del deseo* this art of seduction, the motif of the beloved voice, is tied to the ability to capture the place from which the voice of the absent mother is speaking. This is also the theme in *Tacones lejanos*: Letal (Miguel Bosé) is trying to seduce Rebeca by turning himself into the body of the beloved voice in the mimetic mirroring game of the

drag show. His costumes, the exalted gestures of the pop singer from long forgotten days, and the playback voice transform his body into a fetish that replaces the mother's body itself. It's her friend, explains Rebeca to her mother Becky, when she does not recognize herself in the drag queen on the poster announcing Letal's drag show. She fled to his show, says Rebeca, a child—who shows herself the return of the mother in order to overcome the fear of abandonment.

In the character of Becky, the singer, in *Tacones lejanos*, the voice of the absent mother becomes the main topic in a similar way to how the voice of the seducer had in *Mujeres al borde de un ataque de nervios*. While in that film the Don Juan surrounds Pepa with his electronically diffused whisperings, here it is a love song, sung by the mother, that imagines the love object as the absent body in a doubled sense: as the you to whom the song is addressed and as the singer's body, the voice's body, the exalted theatrical gestures that imagine an embrace that never takes place. In the same moment that Becky sings on stage of endlessly sacrificing love, Rebeca breaks down in prison, as if this song, which she is listening to on the radio, had become torture for her.

At the end of the film, Rebeca creeps into bed with the dead mother, a present body lacking voice, lacking breath. For her, the daughter, Becky, the mother, is the beloved object that continually withdraws from her desires. The beloved voice is the mother whose absence has been transformed into an insistent longing.

In *La flor de mi secreto* this motif is fundamentally shifted. The beloved voice no longer signifies the drawing power of the absent, beloved body, as it had in earlier films. The mother's irritating talking on the answering machine is instead a first, if also always weak and unspectacular, coming-into-relation with the outside world. Her voice has switched sides, as it were, now forming the opposite to the seductive arts of the Don Juan, here represented by Paco. When Leo joins in with the lacemaker's singing in the courtyard of her mother's house, this singing becomes the expression of the power that restores the character to a renewed life. What is formed in *La flor de mi secreto* as a lyrical intermezzo—the figuration of a motherly order of love in the image of the women's village—becomes a fundamental theme in *Todo sobre mi madre* and *Volver*. Viewed from these two films, it would seem that a movement is becoming identifiable from film to film,

joining all of them, from the first to the last. As if the films crossed, layer for layer, the appearances of a destroyed sociality, looking for an image of motherly happiness. And this image is closely associated with the motif of the voice. The divisions, ramifications, and transformations of this motif form the Ariadne's thread in the labyrinths of sentimental consciousness: the scream that begins *Pepi, Luci, Bom y otras chicas del montón* and the scream that comes from the television in *La flor de mi secreto*, Leo's singing and that of Raimunda, singing after many years of silence, Becky's voice on the radio and the mother's scream that is heard in the first few minutes of *Todo sobre mi madre*.

Everything, Really Everything . . . : *Todo sobre mi madre*

At the end of *¿Qué he hecho yo para merecer esto!!* Gloria is standing alone next to the bus that is taking the grandmother and grandchild back to the country. The musical motif, the saxophone, links Carmen Maura's Gloria to the Gloria that Gena Rowlands plays in John Cassavetes's film of the same name (1980). And, in fact, even the last sentences spoken by her son Miguel, who tells her he'll stay with her since the house needs a man, resonate with the cocky attitude of the boy, as cheeky as he is vulnerable, that Gena Rowlands leads through all the perils of the mafia world. And so the triumphant sound of the saxophone seems to promise a new, adventurous life to Almodóvar's Gloria, as well, as she starts off with the hustler into a new existence for her character. Seventeen years later, this mother-son couple will return to Almodóvar's world in a film that finally wants to say *everything* about the mother.

At the beginning of *Todo sobre mi madre* we see Manuela preparing food in the kitchen, while the son Esteban (Eloy Azorín) is waiting in front of the television. He rushes her—the film is beginning: *All About Eve* (1960) with Bette Davis. For only a few minutes, in harmonic spatial and color arrangements, *Todo sobre mi madre* shows us an image of the relationship that Sigmund Freud claimed was the most complete form of love that we are capable of. Then Esteban is dead, run over by a car, while he was chasing after his idol, the actress Huma Rojo (Marisa Paredes), who was a passenger in another car ahead.

We, the spectators, have just seen her on stage; we saw her face posted on the wall: a star, an idol, an icon. We see the oversized portrait with which Huma's face becomes a poster taking up the entire facade of the theater. This in turn transforms the facade into a face that looks at us; we, however, see Esteban, who is—shot, countershot, shot—watching his mother: Manuela lost and looking small in front of this oversized face. Our attention is not captured by the glamorous artificiality of the star but by the strangely unbroken psychological-realistic acting of Cecilia Roth. In the next moment it is this actress, whose artfully staged scream captivates us much like the star Huma does the fan Esteban, waiting in the rain for an autograph, chasing after her to get her attention for a moment and losing his life in the process.

Like all of Almodóvar's films, *Todo sobre mi madre* spins a dense web of references and reminiscences that attributes an almost factual life to the characters, a genuine origin, a real lineage, a youth, a maturity, an old age in other, earlier films, plays, songs. When, for instance, the actress Marisa Paredes, with her appearance and her acting style, plays the character of the female stage star as a variation of the role that Gena Rowlands plays in *Opening Night* (1977), another of John Cassavetes's films, or when, on the other hand, this character is explicitly devoted to another Hollywood star, choosing her name—Huma—for the way Bette Davis smokes cigarettes, taking her as the model for her self-presentation, then this is much more than an homage to two Hollywood actresses. Rather, the character herself, the stage star Huma, is presented from two overlapping perspectives: the one from the perspective of *All About Eve* with Bette Davis, the other from the perspective of *Opening Night* with Gena Rowlands. This perspectival doubling of the character is in turn mirrored in the two theatrical roles that Huma plays within the film. These are Blanche from Tennessee Williams's play *A Streetcar Named Desire* (1947) and the mother in García Lorca's *Bodas de sangre* (*Blood Wedding*, 1933) who is lamenting the death of her son: on the one hand, the woman who was never a mother and, on the other, a woman who is no longer a mother.

Two plays, two films, two Hollywood stars—this mirroring forms the fundamental structure of the film, from which are derived a wide array of similar entanglements. An image from multiple perspectives therefore arises in which, in the end, all the films' characters merge as dissolves

between various perspectives: various perspectives of a cinematographic image that gathers together all the possible views of Eva—*All About Eve*—and seeks to show all sides of the mother—*Todo sobre mi madre*.

When mother and son go to the theater, we see a scene from *A Streetcar Named Desire*, which will return in slight variations throughout the film. The rear area of the stage is bathed in a cold blue light; it is separated from the front of the stage by wire netting, a transparent wall. Behind this wall sit three men drinking beer and playing cards: Stanley Kowalski and his friends. In the foreground, in another room, are the women: Blanche, Stella, doctors from the psychiatric ward. As in scenes already described from *Pepi, Luci, Bom y otras chicas del montón*, *¿Qué he hecho yo para merecer esto!!*, *Tacones lejanos*, *La flor de mi secreto*, and *Volver*, a stark, untraversable separation is staged between the men and the women. Only Stanley's barking orders, his attempts to affect the women, connect the one area with the other. We see the play's final scene twice. But, unlike in Tennessee Williams's play or in Elia Kazan's filming of it (1951) with Vivian Leigh (Blanche) and Marlon Brando (Kowalski), Stella leaves the house. She walks downstage, past the men's area. Holding her baby in her arms, she repeats the words of farewell: "I'll never come back—never."

Once Again, the Motif of Repetition

We will follow Manuela, the mother, as she follows her son's transplanted heart; we will go along with her on a journey into her past: to Barcelona, where seventeen years ago she had left Lola (Toni Cantó), Esteban's father, who is working as a transvestite prostitute. The film stages this return as a dream sequence, as time travel in the space of consciousness.

Manuela has just returned to her apartment; she has seen the man who is living with her son's heart; a tentative wailing trumpet and arching strings come together with her interior monologue: Esteban's voice, his diary entries, how they might reverberate in Manuela's thoughts. A friend rings the doorbell; they have a short conversation without ever understanding each other; Manuela's tired, haggard face—she revolts angrily against her friend's good advice. A new trumpet theme rises distinctly out of the evenly extending dark tonal space; a new rhythm begins to form very tentatively, joining up with the sounds inside a driving train.

We see Manuela's face in close-up against the blue-black of the train seat. Once again we hear her thoughts, an interior monologue, now spoken with her voice—she is remembering how she had already taken this same trip, but in the other direction, when she was pregnant with her son seventeen years before. Manuela's voice and the sound of the driving train join up with the now clearly pronounced rhythm of the score. The sound of the saxophone gives way to a guitar motif that insistently pushes a small, monotonously repetitive theme into the foreground until it quite fills up the tonal space. The musical miniature is answered by a visual impression that analogously imagines a tunnel trip in a minimalist-abstract vein. The walls, lit up by headlights, rush past the edges of the visual field as if the camera's gaze itself were crashing into the deep black that fills the middle of the image. The meditatively repetitive guitar motif transforms into a bolero; the ingratiating sound of a harmonica leads away from the crash into the depths toward a swaying gaze that soars up over the sea of lights of the Barcelona night. The singing now introduced leads the camera's gaze into the city of Barcelona, as if the city had given up all its other purposes and was there only for this view. We see the blurred contours of Gaudí's Sagrada Familia mirrored in the windowpane of a taxi. The window is rolled down; we see Manuela's face, she is looking attentively, checking as if she were not sure if the city really existed. The camera remains with her searching, skeptical look; Manuela has to drive her to the relevant part of town; she is looking for Lola, Esteban's father.

Abruptly, the taxi is shown in the outskirts of the city, between highways, underpasses, and wasteland. The taxi driver skeptically asks if Manuela really wants him to drive on. Before the spectators' eyes, a world is revealed that for a short moment appears to be a fairy-tale world. Provocatively dressed women walk hand in hand, as if on a boulevard, squat at the edge of the road, and play clapping games like schoolgirls. Cars, headlights, motorcycles form a densely crowded parade that slowly revolves like a carousel; and among the cars move magical female beings in the light of headlights and fires. The nocturnal dance quickly turns out to be a transvestite prostitution scene. At the edge of the road, one of these fairy-tale figures is being brutally beaten. Manuela has the taxi stop; she gets out; the music ends. She finds her friend Agrado, who falls into her arms, battered and bruised. Thanks to this chance meeting, she gets away with only her face smashed up.

The whole sequence is composed from start to finish as an integral piece in which the visual and musical themes link together the most brusque oppositions through barely noticeable transitions: the burned-out emptiness of the sadness and the returning memory of the happy days of youth, the crash into darkness and floating euphoria, an anthemlike celebration of the city of Barcelona and the most wretched scene of street prostitution, a nocturnal fairy-tale world of nymphs and sprites and the wasteland of a demimonde of prostitution, drugs, and violent crime. The sequence is like an aria, the monologue of a character who encompasses the entire spectrum of these oppositions in her own consciousness, in her memory, in her world of sensations. Manuela moves as decisively and self-assuredly through the city as someone who is very familiar with even these extraterritorial zones.

But it is not only Manuela who takes a trip back into her past. Through numerous reminiscences, the film itself moves along precisely such a backward time line, which Manuela specifically names, over and over: "Seventeen years ago I left the father, eighteen years ago he was in Paris and had breast implants, twenty years ago we were in a theater group together, playing *A Streetcar Named Desire*; I was Stella, he was Kowalski." The time line that she describes not only concerns the years before Manuela was a mother; it also concerns the time in which Pepi and Bom and all the other girls in Almodóvar's debut film *Pepi, Luci, Bom y otras chicas del montón* broke out from the world of the paternal family, and it even concerns the time in which the main actress Cecilia Roth was leading exactly that life as the character Sexilia in the labyrinths of passions of Almodóvar's second film, which then, eighteen, twenty years later, becomes her remembered life story as Manuela.

Perspectival Multiplications

Time and again on this journey, Manuela will pause, weep, and return to the collapse of consciousness that the film set up in the first ten minutes: the scream of a mother whose son is being run over before her eyes. A scream, a pain that becomes acute again every time Manuela speaks out what happened—by her own choice or because someone is asking her about it. This scream, her crying, her painfully plaintive face is the opposite of the portrait of the star plastered on the wall, the opposite of Pepi's

artfully stylized scream in *Pepi, Luci, Bom y otras chicas del montón* or the screams of the "funny screaming contest" from *La flor de mi secreto*. The expression of pain is based on a way of acting we might think we had never seen before in a film by Almodóvar. It seems as if the illusion of interiority were creeping back into Almodóvar's films with this actress. In fact, Cecilia Roth expresses the pain in a way that speaks precisely to the logic of psychological realism.

But Manuela is not a character that leads us back into the psychological universe of sentimental consciousness. *Todo sobre mi madre* in no way unfolds any interior perspective on the suffering subject. Indeed, the pain is always already a remembered pain, and the gesture of suffering is always already the simulation of a gesture, the scream always already a reverberation, infinitely separate from the suffering body.

The principle of this performance becomes clear if we look more carefully at the scene of the accident: the son's death, the mother's scream. In its expressive dimension, this scream is in no way borne by the actress's acting. It is—not unlike in *La flor de mi secreto*—detached from the body to which it is ascribed. Indeed, it is the son's perspective, his lunging, his falling, the moment of his dying, that the film captures, or rather suggests capturing, at this moment.

The image of the mother is a diffuse face behind thick sheaths of rain. Its spatial perspective literally founders in the dynamic of a spinning, turning, and lunging camera. As if the shock of the accident represented were continuing like a temporal fracture in the visual structure, the scream is shifted slightly away from the face; a disturbing asynchronicity that divides the image of the mother into a perceived voice and a diffusely perceived face.

This impression forms the opposition to the poster, the portrait of the star. Indeed, in this dynamic reversal of spatial coordinates, the face approximates a figuration of formless expressive intensity, while the poster fixes expression in the static-emblematic mask of the character. The scene

of the son's death depicts a literal split in the image of the mother, a division and multiplication of the perspectives that constitute her as an image, oscillating between the poles of the star portrait and the expressive impression.

But even this scene represents a repetition, an initial mirroring or division, that functions as a kind of multiplication factor. Namely, the film begins with the fact that Manuela, a nurse, finds out about a patient's death and passes the news on to a transplantation center. Only then do we see mother and son at home in front of the television. A little later we see Manuela in a medical training seminar, playing a wife and mother learning of the death of her husband. And while Manuela as a film character is as impressive as the actual actress in performing a woman in mourning, the doctors attempt to use the role-play to practice conversational techniques for the worst-case scenario. Among the seminar participants, who are following the scene by video monitor, is Esteban, watching the death of the father portrayed for him by his own mother. In fact, Manuela had long ago invented this death for her son in order to avoid any questions about his father.

Even the role-play between Manuela and the doctors is nothing more than a sober variation of a melodramatic primal scene;[9] Manuela plays—like countless melodramatic heroines before her—a woman in the moment of her greatest abandonment, the fall from the illusion of love, the shock of the awareness of mortality. And she plays it for her son.

Esteban watches his mother playing the very suffering that he has suspected to be the earlier life of his parents. In so doing, he behaves more like a director with his actress than a writer to his character. Granted, he is introduced as such: an obsessive writer who wants to write everything about his mother. The son's observant gaze is represented as a projection that literally consolidates the woman perceived and the imago of the mother within a single image: the face of the stage star, the facade of the theater, and, smaller in the foreground, the mother.

Consequentially it is his death that causes this unity to break down, only to continue dividing, repeating, and overturning. It is his gaze that, by writing and notating, designs, films, and stages the image of the mother as the mirroring between Huma and Manuela, Stella and Blanche, Bette Davis and Gena Rowlands. The dead son is the gaze of the author and director, literally forced open in the accident scene into a permanently multiplying

play of perspectives, where the positions of speaking and presenting continually view each other (here Tennessee Williams, there García Lorca, here John Cassavetes, there Joseph Mankiewicz).

In the first ten minutes of the film, then, an image of the mother is created from a multiple division and a doubling of perspective: the repetition of the death scene—once as the character's role-play, once as the acting of the film actress Cecilia Roth; the doubling of the image of the mother in the character of Manuela and the image of the stage star; the mirroring of this double figure in the two Hollywood stars and their characters: Gena Rowlands in *Opening Night* and Bette Davis in *All About Eve*. Finally the mirroring of the film's entire constellation of characters within the perspective of the two plays.

Two plays about the suffering of women, two films about the actresses that play these figures of suffering, and two Hollywood stars who unite both within themselves. These are the vertices of a system of mirroring reversal, division, doubling of perspective. What they all have in common is the idea of performing the suffering woman, an imago of female pain, the pathos formula of being woman. When Huma rehearses the mother from

García Lorca's *Blood Wedding* in the last part of the film, all the threads seem to come together in her image. She gives the mother the definitive form, a pietà, in which even the dead son is just an image to further the suffering of women. She kneels on the ground in the rehearsal room in front of a small tub and mimes washing clothes. In the background a young man comes toward her, a director who could be her son. He bends down over her, forms her gestures, speaks suggestively to her. The film arranges its perspective in view of the position of such sons. What would I see of the mother if I could see how she was before I was there, and how will she be after I am no longer there?

A Different Kind of Sensitivity Gets to Speak

"My son is dead." Like the stroke of a clock, this sentence, the gesture of pain is inserted into the course of events that always pushes onward. And yet the only thing that repeats is what Manuela remembers by counting backward: seventeen years ago, eighteen years ago, twenty years ago. The film once again shows—in the new story—the same play with a different cast: the story of the woman who becomes a mother and of the woman who is simply getting older—who wants to be heard, beyond motherhood, as a voice that articulates a body, a desire, a sensuality . . . It shows it as a process through which the character finds its way to the scream that she was not capable of in the beginning. It shows it as a matter of becoming heard, of finding the words to speak.

When the doctors, in a variation on the role-playing exercise, give Manuela the news of her son's death, she resists the news briefly and then falls silent. Like all melodramatic heroines, she becomes a silent image of suffering, one that cannot say what torments her. Until she is standing onstage as an actress, finally playing Stella once again: the character who escapes from the play as a mother and who leaves her sister behind as an aging matron and hysteric. Manuela's appearance culminates in a wailing scream that never wants to end.

If the pain has been silent to this point, from now on Manuela will speak out what torments her: first, still quite cautiously, an invisible voice from the room next door, when Rosa discovers Esteban's photo and notebook; then deeply moved, when she confesses to Huma and Nina (Candela Peña)

that she, like Eve Harrington (Anne Baxter)—the title character from Joseph Mankiewicz's film—had crept into the star's dressing room; finally Manuela is shaken by a crying fit, when she has to answer Rosa's mother's question, whether she also has children. Time and again the disclosure becomes more articulate, the language clearer. In the last section of the film, starting with the cemetery at Rosa's funeral, all the words of grievance and denunciation become available to her. She tells everything to Lola, the man, the Kowalski of the play, who appears to her in the form of a female figure from a *danse macabre*: their son, her loss, her suffering. Manuela will cry and scream: he is an epidemic, he is death itself. In her accomplished acting style, she will mark exactly the place that Pepi and Bom, with their cry of indignation on the punk stage, could easily still occupy.

Even Cecilia Roth's acting style is only a reference, an aspiration, albeit a weighty one, to this net of reminiscences. She mimes the psychological authenticity of the American acting style from the fifties, which in part became the norm through the filming of Tennessee Williams's plays, the most famous of which is *A Streetcar Named Desire*. She plays the acting style of Vivian Leigh and that of Gena Rowlands, she plays the idea of acting the suffering woman, the pathos of the melodramatic heroine.

Through her acting style, the character of Manuela forms the center of the film from which the remaining characters find themselves being looked at, recognized, and understood in their self-representation. No matter who she comes across, she turns into their motherly sister, in relation to which everyone becomes a child. She is a character of compassion, a secular form of Maria, who knows how to help foolish women out of their difficulties in love, unconditionally and wondrously: Agrado, whom she saves from the rapist she had so carelessly surrendered to; Huma, to whom she, in her desperate infatuation, provides knowledge of the drug world; and finally Rosa, the nun, who fails in the role that Manuela knows perfectly well how to play. Rosa, in her attempt to be a rescuing, helping, compassionate sister, becomes a child herself, completely in need of help—pregnant, ill—in the end terminally ill—she lets herself be mothered by Manuela.

Rosa is the girl that is literally erased when she becomes a mother. Beyond her being a girl, this character has no existence. She is a character that, in every way and much like Becky/Rebeca in *Tacones lejanos*, embodies the longing to be a child. As the girl who finally wants to be a child, Rosa

joins Manuela as a kind of double character; they are intimately bound together by the new Esteban, her son, who now, in her place, takes over the position of Manuela's child.

Manuela forms a kind of viewpoint, a way of looking at all the other characters, that is constantly being adjusted and shifted in order finally to be positioned as an object at the level of the image. The way that Manuela is once again turned into a mother by Rosa, once again flees from Barcelona, and once again returns there, brings the motif of time travel to a ludicrous end. And in the end this journey is a repetition in which Manuela's life appears to be corrected and adjusted, like a newly staged, newly performed play, in which everything can be arranged quite differently this time. The journey, just as it returns to the time of girlhood, before motherhood, just as it describes a memory, a repetition, becomes a mirror in which the positions are made visible that restrict a woman's life to the stations where she exists socially: her role as the child, as a marriageable girl, as a mother, as a matron, as an elderly woman.

In the characters, however, that are mirrored in Manuela's motherliness, a sensitivity can be expressed that likewise strives to speak, in *All About Eve* and *Gloria*, in *A Streetcar Named Desire* and *Bodas de sangre*, but without ever getting to it. It is the sensuality of Pepi and Bom's music and the triumphant saxophone that Gloria hears at the bus station; it is the dance that Blanca would dance if her son would leave her the stage; it is the novel that Leo would write if she could give up trying to allot a male ego to her writing.

It is the desire that the title of *A Streetcar Named Desire* already alludes to and that defines the character of Blanche: Agrado will take the opportunity when she, the dressing room attendant, conquers the stage like Eve Harrington and Manuela, because both the lead actress cannot go on. Her speech, to the audience in the theater and in the cinema, in which she details the costs of the cosmetic efforts necessary to become a beautiful woman—if you used to be a truck driver—announces the triumph of the principle of artful self-presentation that is embodied by Blanche. The play—in which, performance after performance, Blanche is reviled as a deceptive seductress and a hysterical matron, is raped and locked up—is canceled.

At the end of the film, two years later, Manuela visits Huma and Agrado in the dressing room of a Barcelona theater. No matter what play is being

performed, Huma has youthfully wavy hair, half girl, half mature woman. She is still being cared for by Agrado, her hair cut short, half protective father and half loving mother, or indeed a tomboyish girl. Nina, the actress who played Stella, is no longer there. When Manuela asks about her, it is reported with great shock that she has married. Nina, like Luci in Almodóvar's debut film, has gone back to the family home.

When, in the end credits, the film is dedicated to all the actresses who play mothers and all the mothers who act, the homage precisely formulates what the film as a whole has attempted to develop: an image that seeks to show everything about the mother by replacing the singular interior perspective with a play of permanent alternation in perspective—a kind of cinematographic cubism that shows the girl and the aging woman in the image of the mother and, at the same time, that woman who is never mother, matron, old woman. At the end of the film, they are all Blanche . . . Lola, Rosa's mother, Manuela, Agrado, and Huma—women in their best years.

NOTES

Preface

1. Rorty, *Contingency, Irony, and Solidarity*, 198.
2. Rancière, Thesis 1.
3. Rorty, *Contingency, Irony, and Solidarity*, 69.
4. Rancière, "L'historicité du cinéma," 45f.
5. Rorty, *Contingency, Irony, and Solidarity*, 179.
6. Ibid., 182.
7. Rancière, *Aesthetics and Its Discontents*, 19.
8. Cf. Tan, *Emotion and the Structure of Narrative Film*.

1. Poetics and Politics

1. Frohne, "'That's the only now I get,'" 220.
2. Cf. Agamben et al., *Demokratie?* Cf. Streiter, "Die Frage der Gemeinschaft."
3. Cf. Streiter, "Die Frage der Gemeinschaft."
4. *Documenta X, Politics-Poetics.*
5. Cf. Stemmrich, *Kunst, Kino—48.*
6. Rancière, *Le spectateur emancipé.* Translator's note: All citations from this book here are taken from its third chapter, "Les paradoxes de l'art politique," which does not appear in the English version. A significantly different version of this text was published as one chapter of Jacques Rancière, *Dissensus: On Politics and Aesthetics* (London: Continuum, 2010). In order to maintain the integrity of the present text, however, the citations have been translated from the version that appears in French (and German).
7. Rancière, *Aesthetics and Its Discontents*, 7.
8. Rancière, "L'historicité du cinéma," 45f. Cf. also Jacques Rancière, *La Fable cinématographique.*

9. Rancière, "L'historicité du cinéma," 54f.
10. Rancière, *Aesthetics and Its Discontents*, 7.
11. Rancière, *Le spectateur emancipé*.
12. Rancière, *Le Partage du sensible*; English version, *The Politics of Aesthetics*.
13. Cf. Rancière, "L'historicité du cinéma," 55.
14. Ibid.
15. Ibid., 56.
16. Ibid.
17. Rancière, *Film Fables*.
18. Rancière, "L'historicité du cinéma," 56.
19. I myself have developed the Deleuzean concept of cinema further in some of my own works with regard to a concrete analysis of audiovisual images and their historical positioning; cf. Kappelhoff, *Matrix der Gefühle*; Kappelhoff and Müller, "Embodied Meaning Construction."
20. Rancière, "L'historicité du cinéma," 56.
21. Sorlin, "Der italienische Neorealismus," 97f.
22. Cf. Kluge and Negt, *Öffentlichkeit und Erfahrung*.
23. Rorty, *Achieving Our Country*, 101.
24. Cf. Rorty, "Solidarity or Objectivity?" and *Achieving Our Country*.
25. Rorty, "The Priority of Democracy to Philosophy."
26. Ibid, 189.
27. Rorty, *Contingency, Irony, and Solidarity*, 307.
28. The English expression *common sense* only covers one of the senses of the term as it is defined in Kant. This is why Rorty uses two terms: *common sense* and *sense of commonality*.
29. Rorty, *Contingency, Irony, and Solidarity*, xvi.
30. Cf. Vogl, "Einleitung."
31. Dewey, *Art as Experience*.
32. Rorty, *Contingency, Irony, and Solidarity*, 65.
33. Ibid., xvi.
34. Cf. Rorty, "Solidarity or Objectivity?"
35. Rancière, *Le spectateur emancipé*.
36. Ibid.
37. Ibid.
38. Ibid.
39. "The 'distribution of the sensible' is therefore a system or 'regime' of norms or habits that implicitly defines the perception of the common world, perception here meaning a topology that, independently of the places that individuals assume in space and time, assigns them to speak certain social functions, forms of activity, and ways of being." Muhle, "Einleitung," S. 10.
40. Rancière, *Le spectateur emancipé*.
41. Rancière, *Aesthetics and Its Discontents*.

42. Cf. Rancière, *The Politics of Aesthetics.*
43. Foucault, "Omnes et Singulatim."
44. Cf. Rancière, *Le spectateur emancipé.*
45. Rancière, *Aesthetics and Its Discontents.*
46. Rancière, *The Politics of Aesthetics.*
47. Rancière, *Le spectateur emancipé.*
48. Ibid.
49. Cf. ibid. and *Aesthetics and Its Discontents.*
50. Rancière, *Le spectateur emancipé.*
51. Rancière, *Aesthetics and Its Discontents* and *Le spectateur emancipé.*
52. Lück, "Poetiken der Demokratie?" www.rabbiteye.de/2012/4/lueck_poetiken.pdf.
53. Cf. Cavell, *The World Viewed,* 72.

2. Before the War

1. Cf. for instance Joyce, "The Soviet Montage Cinema of the 1920s," 422–24 and 433–36.
2. Cf. Kappelhoff, *Der möblierte Mensch.* Cf. also Schnell, *Medienästhetik;* McCullough, "Eisenstein's Regenerative Aesthetics; Engell, *Bewegen beschreiben* and *Bilder des Wandels.*
3. Rancière, "L'historicité du cinéma," 56.
4. This concept is highly instructive, particularly in view of the current discussion around the relation between movement, emotion, and media. Indeed, the majority of the essays currently under discussion remain at the level of narrative structures, the characters and plots that they represent. While many essays in contemporary film theory trace the affective dimension of the spectator's activity back to the individual, psychological reaction models of everyday behavior, Eisenstein, precisely in contra-distinction to psychology, proposes the cinematic movement image as an energetic model of social processes of exchange.
5. Eisenstein, "The Montage of Film Attractions," 35.
6. Cf. Cavell, *The World Viewed,* 72.
7. Eisenstein, "The Fourth Dimension in Cinema," 120.
8. Panofsky, "Style and Medium in the Motion Pictures," 96.
9. Eisenstein, "The Fourth Dimension in Cinema," 116.
10. Eisenstein, "The Montage of Film Attractions," 35.
11. Eisenstein, "The Fourth Dimension in Cinema," 113.
12. Eisenstein, "The Montage of Film Attractions," 35.
13. In "The Montage of Attractions" Eisenstein speaks of elements that summarize "the general projected emotional effect" (41) and in the "Fourth Dimension" of a "psychological sum total of the resonance of the shot as a whole, as a complex unity of all its component stimulants . . . taken to be the general sign of the shot" (113).

14. "This is the particular 'feeling' of the shot that the shot as a whole produces." Eisenstein, "The Fourth Dimension in Cinema," 113.

15. "By expressive movement I understand movement that discloses the realisation of a particular realisable motor intention in the process of being realised, i.e. the appropriate arrangement of the body and the extremities at any particular moment for the motor execution of the appropriate element necessary for the purpose of movement." Eisenstein, "The Montage of Film Attractions," 46. "Out of the affective impulse to movement and the deliberate hesitation to movement, a purely physiological system of expressive effects for actors can be formed, tailored to the individuality of their own bodies." Ibid., 44 and 49.

 These physiological systems are "the result of the processes of distribution of power loads for shocks, and the intensity of muscular responses; the neutralization of the inertias of preceding elements of the movements, the conditions that arise in connection with the general position of the body in space, etc., in the process of realising the expressive object. Thus, a precise organic rhythmic schema is taking shape that corresponds to the intensity of the course of the process and itself changes in changing conditions and in the common character of the precise resolution of the objective." Ibid., 49.

 "The arrangement assembled in this way involves the audience to the maximum degree in imitation and, through the emotional effect of this, in the corresponding ideological treatment. In addition as a whole it produces . . . the visual effect of the emotion apparently experienced." Ibid., 51.

16. Ibid., 36.

17. Ibid., 35.

18. Cf. Eisenstein, "The Fourth Dimension in Cinema," 114f. and 120–23.

19. In the current discussion, the neophenomenological school comes very close to this concept when cinematic perception is conceptualized as an experience of a way of experiencing. Cf. Sobchack, "Phenomenology and the Film Experience."

20. "In some places in *The General Line* I managed to achieve conflicting combinations of the tonal and overtonal lines. Sometimes they also collide with the metric and rhythmic lines. For example, individual junctions in the religious procession: 'diving' beneath the icons, the melting candles and the panting sheep at the moment of ecstasy, etc." Eisenstein, "The Fourth Dimension in Cinema," 121. Cf. also Eisenstein, "Organic Unity and Pathos in the Composition of Potemkin," 1–9.

21. Kracauer, *From Caligari to Hitler,* 165–80.

22. Balázs, *Early Film Theory,* 160.

23. Cf. Sloterdijk, *Critique of Cynical Reason,* 384ff. Cf. also Lethen, *Cool Conduct;* Lindner, *Leben in der Krise.*

24. Kracauer, *From Caligari to Hitler,* 175.

25. Cf. Denkler, "Sache und Stil," 167f. Cf. also Lethen, *Neue Sachlichkeit 1924–1932;* Prümm, *Die Literatur des soldatischen Nationalismus.*

26. Brinckmann has demonstrated the significance of Worringer's pair of terms, *abstraction* and *empathy*, for the contemporary understanding of art and film art. Brinckmann, "'Abstraktion' und 'Einfühlung' im frühen deutschen Avantgardefilm."

27. Hartlaub, "Zum Geleit."

28. Cf. Hülsewig-Johnen, "Wie im richtigen Leben?" 23.

29. Hartlaub, "Reply to a Questionnaire," 247–49.

30. Hartlaub, "Zum Geleit."

31. Cf. Golinski, "Der Rückblick nach vorn."

32. Roh, *Nachexpressionismus*.

33. Ibid., foreword, unpaginated. Cf. also Golinski, "Der Rückblick nach vorn."

34. Neumeyer, "Zur Raumpsychologie der Neuen Sachlichkeit," 66f.

35. Ibid., 69.

36. Cf. Denkler, "Sache und Stil," 177. Denkler presents the full spectrum of this program in his essay.

37. Staticness as a principle of the visual world of New Objectivity takes the semblance of its active "capacity for action" from the representation of human beings, a semblance that delivers moments of expression, visually capable of characterizing the individual, to the traditional portrait. The staticness of the visual world is therefore equated with a depersonalized conception of human beings. It proposes an ancillary world to which the person is classified, showing a juxtaposition of people and things in which isolation dominates and the person has lost his capacity to effect the world of things. It is hardly possible to understand this idea of the world according to the often-used formula of interpretation, as the expression of a new bourgeois consciousness, acclaiming technology, strengthened, illustrating his comprehensive aptitude. What is expressed here is not new "self"-confidence, but its loss. Cf. Hülsewig-Johnen, "Wie im richtigen Leben?" 23.

38. Neumeyer, "Zur Raumpsychologie der Neuen Sachlichkeit," 72.

39. Raphael, *Raumgestaltungen*, 63.

40. In relation to Ernst Jünger, Harro Segeberg emphasizes the correspondence between the realism of the New Objectivity, initiated by media technologies, and the "heroic realism" of the protagonists of the political right. Segeberg, "Faschistische Medienästhetik?"

41. Kracauer takes this term from Paul Rotha. Kracauer, *From Caligari to Hitler*, 76.

42. Ibid., 165.

43. Kracauer: "Photography."

44. Ibid., 61.

45. Kracauer, *From Caligari to Hitler*, 176.

46. Cf. Kappelhoff, *Der möblierte Mensch*.

47. Neumeyer, "Zur Raumpsychologie der Neuen Sachlichkeit," 72.

48. Sloterdijk thematizes the "aesthetic positivism" in dada. He places dadasim "in a broader spectrum of semantic cynicisms with which the demythologization of the

world and of metaphysical consciousness reaches a radical final stage. Dadaism and logical positivism are parts of a process that pulls the ground out from under all faith in universal concepts, formulas for the world, and totalizations." Sloterdijk, *Critique of Cynical Reason,* 397. Admittedly, in the end "subjective positivism" concerns the aesthetic subject and not the epistemological one.

49. Hausmann, "Rückkehr zur Gegenständlichkeit in der Kunst," 102–5.
50. Cf. Hartlaub, "Reply to a Questionnaire."
51. Hausmann, "Synthetisches Cino der Malerei," 30–31.
52. Herzfelde, "Introduction to the First International Dada Fair."
53. Döblin, "Der Geist des naturalistischen Zeitalters," 64.
54. Döblin, "An Romanautoren und ihre Kritiker," 17–18.
55. Ibid., 22.
56. Döblin, "Der Geist des naturalistischen Zeitalters," 74.
57. Ibid., 66.
58. Ibid., 80.
59. Cf. Sloterdijk, *Critique of Cynical Reason.*
60. Döblin, "Der Geist des naturalistischen Zeitalters," 83.
61. Ibid., 66.
62. Ihering, "Brecht-Uraufführung in Darmstadt," 257.
63. Cf. Prümm, "Die Stadt der Reporter und Kinogänger bei Roth, Brentano und Kracauer."
64. Ihering, "Dickicht – Deutsches Theater," 172.
65. Ibid., 174.
66. Ihering, "Der Schauspieler im Film," 378.
67. Ibid., 378f.
68. Balázs, *Early Film Theory,* 9.

3. After the War

1. Didi-Huberman, "Das Öffnen der Lager und das Schließen der Augen."
2. Cf. Ebert, "Kracauers Abbildtheorie"; Bazin, "The Evolution of the Western."
3. Cf. Ebert, "Kracauers Abbildtheorie."
4. This conception can be found in Bazin and Kracauer as well as in the theorist of Italian neorealism, Cesare Zavattini.
5. "When the image is no longer used up in the accomplishment of an action or conflict, it becomes an 'emptied space' in which both the function and the potential signification of the image change. The image becomes a space for reading: seeing and hearing as decipherment rather than following an action; a legible image or lectosign to be read, rather than an action-image to be absorbed or reacted to." Rodowick, *Gilles Deleuze's Time Machine,* 75. Cf. Olkowski, *Gilles Deleuze and the Ruin of Representation;* and Flaxman, *The Brain Is the Screen.*

6. Deleuze, *Das Zeit-Bild,* 2.

7. Ibid., 4.

8. Ibid.

9. In this respect, Kracauer's book on Weimar is a no less prominent example of a Nietzschean conception of history as his *Theory of Film.* Cf. Schlüpmann, *Ein Detektiv des Kinos.*

10. Cf. Witte, "Nachwort des Herausgebers," 605.

11. Cited by Witte, ibid., 606f.

12. Kracauer, *From Caligari to Hitler,* 7.

13. Ibid.

14. Horace M. Kallen, cited in Kracauer, *From Caligari to Hitler,* 7.

15. Koch, *Kracauer zur Einführung,* 107.

16. Cf. ibid. See also Hansen, "Introduction."

17. Kracauer, *Der verbotene Blick,* 31f.

18. Kracauer, *From Caligari to Hitler,* 240f.

19. Kracauer, *History,* 3f.

20. Cf. Kracauer, "Die Photographie" (1927).

21. Kracauer, *History,* 192.

22. Benjamin, "Dream Kitsch," 5.

23. On the terminology of the grounding in nature, cf. Rolf-Michael Bäumer's dissertation, "Rationalitätskritik als Kulturkritik." Cf. also Schlüpmann, *Ein Detektiv des Kinos,* 46.

24. Schlüpmann, *Ein Detektiv des Kinos,* 48f.

25. Ibid.

26. Ibid., 50.

27. Benjamin, "Surrealism"; cf. also Kappelhoff, "Empfindungsbilder."

28. Benjamin, "Surrealism."

29. Ibid., 216f.

30. Cf. Kappelhoff, *Der Lesende im Kino.*

31. Kracauer, *History,* 55.

32. Cf. Bacon, *Visconti.*

33. Visconti, "Da Verga a Gramsci."

34. Ibid.

35. Ibid.

36. "The crystal-image may well have many distinct elements, but its irreducibility consists in the indivisible unity of an actual image and 'its' virtual one." Deleuze, *Das Zeit-Bild,* 78. Cf. Rodowick, *Gilles Deleuze's Time Machine,* 90–92.

37. Doniol-Valcroze and Domarchi, "Luchino Visconti Interviewed," 145.

38. Henze, "Versuch über Visconti," 60.

39. Ibid., 61.

40. Teresa de Lauretis, "Visconti's *Senso,*" 450 and 454.

41. Ibid., 452.

42. Cf. Visconti, "Anthropomorphic Cinema."
43. Henze, "Versuch über Visconti," 62.
44. Ibid.
45. I am taking this term from Deleuze's writings on Bergson and the crystal-image. Deleuze, *Das Zeit-Bild*, 44ff.
46. Henze, "Versuch über Visconti," 63f.
47. Visconti, "Anthropomorphic Cinema," 84.

4. After '68

1. Cf. for instance Michel, "Die sprachlose Intelligenz II" and "Ein Kranz für die Literatur"; Enzensberger, "Gemeinplätze, die neueste Literatur betreffend"; Boehlich, "Autodafé." All were published in *Kursbuch* 15 (1968).
2. Cf. Kluge and Negt, *Öffentlichkeit und Erfahrung*.
3. Roth, "Annotated Filmography," 191.
4. I would like to limit myself here to this allusion, since I have investigated this problem in other contexts. Cf. Kappelhoff, "Bühne der Emotionen" and *Matrix der Gefühle*.
5. Cf. Kappelhoff, *Matrix der Gefühle*, 156–72, 191–98, 199–209, and 210–26.
6. Brecht, "Neue Technik der Schauspielkunst," 753.
7. Cf. Keller, "Der Gestus als neues ästhetisches Zeichen," 505.
8. Ibid.
9. Cf. Barthes, "Diderot, Brecht, Eisenstein."
10. In this way as well the texts refer to the dramatic writing style in which Diderot proposed his theory of acting.
11. Brecht, "Über den Beruf des Schauspielers," 409.
12. On all of this, cf. Kappelhoff, *Matrix der Gefühle*, especially 82f.
13. Cf., for instance, Sternagel, *Methodische Schauspielkunst und Amerikanisches Kino*.
14. Brecht, "Appendices to the 'Short Organum,'" 277.
15. Brecht, "Short Organum for the Theatre," 193f.
16. Brecht, "Über den Beruf des Schauspielers," 408.
17. Ibid., 409.
18. Cf. Keller, "Der Gestus als neues ästhetisches Zeichen," 505.
19. Here the decisive transfer of the gesture's meaning is completed. Indeed, it means neither an expressive externalization of subjective sensations nor the secondary underscoring of speech by means of bodily movement. Instead, the physiognomic reading of psychological empathy, the interrogation of facial expression and bodily appearance concerning its inner movement of sensation, becomes a model of a kind of looking that is directed at the act of everyday communication. It is as if it assigns this to a second-tier reading, thereby introducing a play of differentiation, which I have already addressed, into all social relationships and actions. I mean the difference that the performer has emphasized in the action, by letting exactly those elements

that the concrete action sets apart from pure completion become the object of the mimetic repetition.

20. In the "Short Organum" Brecht writes about this distinction: "The realm of attitudes adopted by the characters towards one another is what we call the realm of gest. Physical attitude, tone of voice and facial expression are all determined by a social gest." Brecht, "Short Organum for the Theatre," 198.

21. Cf. Deleuze, *Das Zeit-Bild*, 185ff.

22. Cf. Plessner, "Lachen und Weinen," 249ff; cf. also his "Zur Hermeneutik des nicht-sprachlichen Ausdrucks," 459–78.

23. Cf. Brenez, "Die Anti-Körper."

24. Cf. Brenez, *De la figure en général*, 244–52.

25. Roth, "Annotated Filmography," 114f.

26. The film's title in full is as follows: *Fontane—Effi Briest Oder: Viele, die eine Ahnung haben von ihren Möglichkeiten und Bedürfnissen und dennoch das herrschende System In ihrem Kopf akzeptieren durch ihre Taten und es somit festigen und durchaus bestätigen* (Fontane: Effi Briest; or, Many People Who Have Some Idea About Their Possibilities and Needs and Nonetheless Accept the Dominant System Through Their Acts and in Doing So Stabilize It and Completely Endorse It).

27. "I don't make films about gangsters, but about people who have seen a lot of gangster films." Fassbinder, cited by Thomas Elsaesser, *Fassbinder's Germany: History Identity Subject* (Amsterdam: Amsterdam University Press, 1996), 49.

28. The motif of a postoedipal form of socialization also turns up frequently in Fassbinder's later films: In *Mutter Küsters' Fahrt Zum Himmel* (1975) it is a conglomeration of the remains of fatherless families and a political group, in *Satansbraten* (1976) the grotesque farce of a group that collects around the sadistic chimera of a father, in *Die Dritte Generation* (1979) a terrorist cell, and, finally, in *Lili Marleen* (1981) a murderous party with a marked sense for how to mobilize by using popular culture, countered by the intact patriarchal order of the moneyed and educated middle-class and Jewish families.

29. Roth, "Annotated Filmography," 133f.

30. Ibid., 134.

31. Cf. Steadman Watson, *Understanding Rainer Werner Fassbinder*, 94f. Steadman Watson sees *Warnung Vor Einer Heiligen Nutte* as a reflection on the "self-destructive experience" that the shooting of *Whity* had represented.

32. Elsaesser, *Fassbinder's Germany*, 63f.

33. This has often been noted in Fassbinder, although mostly denounced as "chic identification theater" (Wendt) or as the "melodramatic revocation of the modern." Brüggemann, "Berlin Alexanderplatz," 51.

34. It is in this sense that Gilles Deleuze takes Brecht's social gesture as the starting point for his reflections on the category of the body. Cf. Deleuze, *Das Zeit-Bild*, 189f. Cf. also Rodowick, *Gilles Deleuze's Time Machine*, 154: "The cinema of the body is not a picturing of the literal body. Rather, its goal is to give an expression to forces of becoming

that are immanent in body, as well as the body's receptivity to external forces through which it can transform itself. Deleuze follows Spinoza in defining the body not as static mass (this would be equivalent to reasserting the model of identity), but as a potentiality defined by relations and forces or he power to affect and be affected." Cf. also Pisters, *The Matrix of Visual Culture*.

5. Beyond Classical Hollywood Cinema

1. Cavell, *The World Viewed*, 169f.
2. Eisenstein, "The Montage of Film Attractions," 35.
3. Ibid.
4. Wilder, "Billy in Conversation with Hellmuth Karasek," at the *Berliner Lektionen 1987*, conversational forum of the Berliner Festspiele, held since 1987.
5. Cf. Schaeffer, "Gaugin a Revolution," 374f.
6. Cf. Gelder, "Introduction to Part Nine."
7. Köhne, Kuschke, and Meteling, *Splatter Movies*, 11.
8. Ibid.
9. Cf. Wood, *Hollywood from Vietnam to Reagan*, 70–94.
10. Hoberman and Rosenbaum, *Midnight Movies*, 40. As examples of this we could mention the films of Kenneth Anger and John Waters.
11. For instance, when Divine, the star of *Pink Flamingos*, caps off his appearance by eating a piece of dog feces in an unedited shot.
12. Seeßlen and Jung, *Stanley Kubrick und seine Filme*, 188.
13. Mörchen, "Des Pudels Kern," 11.
14. Kermode, *The Exorcist*, 45.
15. Haubner, "Der Exorzist," 214.
16. It is the films of the New Hollywood that develop a sound design resulting, shortly thereafter, in a fundamental renewal of the technology of audiovisual presentations.

6. A New Sensitivity

1. Eisenstein, "Montage of Film Attractions," 35.
2. Cf., for example, Smith, *Desire Unlimited*; Huven, *Gendering Images*; Isabel Maurer Queipo, *Die Ästhetik des Zwitters im filmischen Werk von Pedro Almodóvar*.
3. Cf. Chappuzeau, *Transgression und Trauma bei Pedro Almodóvar und Rainer Werner Fassbinder*.
4. Cf. Forgione, *Spiando Pedro Almodóvar*; Rodríguez, *Almodóvar y el melodrama de Hollywood*.
5. Cavell, *The World Viewed*, 32.

6. Cf. Kappelhoff, *Matrix der Gefühle*, 174–94.

7. I mean by this the scene of the suffering woman, designed according to the Ariadne myth by the first melodramas in the eighteenth century, which can be understood in many ways as the primal scene of modern psychological thought. Cf. Kappelhoff, ibid., 174–85.

8. Cf. Allinson, *A Spanish Labyrinth*, 199–200.

9. At the same time, it represents another repetition. Such a role-playing scene has already been encountered in *La flor de mi secreto*, a side note at the beginning, which mirrors the scene of suffering that pulls Leo in.

BIBLIOGRAPHY

Agamben, Giorgio, Alain Badiou, Daniel Bensaïd, Wendy Brown, Jean-Luc Nancy, Jacques Rancière, Kristin Ross, and Slavoj Žižek. *Demokratie? Eine Debatte.* Frankfurt: Suhrkamp, 2012.

——. *Mittel ohne Zweck, Noten zur Politik.* Freiburg: diaphanes, 2001.

Allinson, Mark. *A Spanish Labyrinth: The Films of Pedro Almodóvar.* London: I. B. Tauris, 2001.

Bacon, Henry. *Visconti, Explorations of Beauty and Decay.* Cambridge: Cambridge University Press, 1998.

Balázs, Béla. *Early Film Theory: Visible Man and the Spirit of Film.* Ed. Erica Carter and Rodney Livingstone. Oxford: Berghahn, 2010.

——. *Der Geist des Films,* In *Schriften zum Film.* Vol. 2. Ed. H. H. Diederichs and W. Gersch. Munich: Carl Hanser, 1984 [1930].

——. *Der sichtbare Mensch.* In *Schriften zum Film,* 1:52. Ed. H. H. Diederichs and W. Gersch. Berlin: Henschelverlag Kunst und Gesellschaft, 1982.

Barthes, Roland. "Diderot, Brecht, Eisenstein." *Screen* 15, no 2 (1974): 33–40.

Bäumer, Rolf-Michael. "Rationalitätskritik als Kulturkritik. Zum Voraussetzungssystem in Siegfried Kracauers Schriften bis 1933." Ph.D. diss., University of Siegen, 1992.

Bazin, André. "The Evolution of the Western." In *What Is Cinema?* 2:149–57. Berkeley: University of California Press, 1971.

Benjamin, Walter. "Dream Kitsch." In *Selected Writings,* vol. 2: *1927–1934.* Cambridge: Harvard University Press, 1999.

——. "Surrealism." In *Selected Writings,* vol. 2: *1927–1934,* 207–24. Cambridge: Harvard University Press, 1999.

——. *Der Surrealismus.* In *Gesammelte Schriften* 1–4, no. 2.1, 295–310. Ed. Rolf Tiedemann and Hermann Schweppenhäuser. Frankfurt: Suhrkamp, 1980.

Boehlich, Walter. "Autodafé." In *Kursbuch 15,* 1968.

Brecht, Bertolt. "Appendices to the 'Short Organum.'" In *Brecht on Theatre,* 277. New York: Hill & Wang, 1964.

———. "Kleines Organon für das Theater." In *Gesammelte Werke*, vol. 16. Frankfurt: Suhrkamp, 1967.

———. "Neue Technik der Schauspielkunst." In *Gesammelte Werke*, vol. 16. Frankfurt: Suhrkamp, 1967.

———. "Short Organum for the Theatre." In *Brecht on Theatre*. New York: Hill & Wang, 1964.

———. "Über den Beruf des Schauspielers." In *Gesammelte Werke*, 15:389–436. Frankfurt: Suhrkamp, 1967.

Brenez, Nicole. "Die Anti-Körper. Abenteuer des klassischen Körpers bei Genet, Fassbinder und Van Sant." In *Unter die Haut. Signaturen des Selbst im Kino der Körper*, 73–92. Ed. Jürgen Felix. St. Augustin: Gardez, 1998.

———. *De la figure en général et du cors en particulier. L'invention figurative au cinéma*, 244–52. Brussels: De Boeck Université, 1998.

Brinckmann, Christine N. "'Abstraktion' und 'Einfühlung' im frühen deutschen Avantgardefilm." In *Mediengeschichte des Films III*. Ed. Harro Segeberg. Munich: Wilhelm Fink, 2000.

Brüggemann, Heinz. "'Berlin Alexanderplatz' oder Franz, Mieze, Reinhold, Tod & Teufel?" *Text + Kritik*, no. 103 (1989): 51–65.

Cavell, Stanley. *Nach der Philosophie*. Vienna: Verlag des Verbandes der Wissenschaftlichen Gesesellschaft Österreichs, 1987.

———. *The World Viewed: Reflections on the Ontology of Film*. Enlarged ed. Cambridge: Harvard University Press, 1979.

Chappuzeau, Bernhard. *Transgression und Trauma bei Pedro Almodóvar und Rainer Werner Fassbinder. Gender – Memoria – Visum*. Tübingen: Stauffenburg Medien, 2005.

Deleuze, Gilles. *Cinema 2: The Time-Image*. Minneapolis: Minnesota, 2001.

———. *Das Zeit-Bild*. Frankfurt: Suhrkamp, 1991.

Denkler, Horst. "Sache und Stil. Die Theorie der 'Neuen Sachlichkeit' und ihre Auswirkung auf Kunst und Dichtung." In *Wirkendes Wort*, 18:67–85. Düsseldorf: Pädagogischer Verlag Schwann, 1968.

Dewey, John. *Art as Experience*. New York: Minton, Balch, 1934.

Didi-Huberman, Georges. "Das Öffnen der Lager und das Schließen der Augen." In *Auszug aus dem Lager. Zur Überwindung des modernen Raumparadigmas in der politischen Philosophie*, 11–45. Ed. Ludger Schwarte. Berlin: Transcript, 2007.

Döblin, Alfred. "Der Geist des naturalistischen Zeitalters." In *Aufsätze zur Literatur*, 64. Ed Walter Muschg. Breisgau: Walter, 1963 [1924].

———. "An Romanautoren und ihre Kritiker." In *Aufsätze zur Literatur*, 17–18. Ed. Walter Muschg. Breisgau: Walter, 1963 [1913].

Documenta X, Politics-Poetics. Ed. documenta and Museum Fridericianum. Ostfildern: Hatje Cantz, 1997.

Doniol-Valcroze, Jacques and Jean Domarchi. "Entretien avec Luchino Visconti." *Cahiers du Cinéma*, no. 93 (March 1958): 1–10.

———. "Gespräch mit Luchino Visconti." In *Der Film. Manifeste – Gespräche – Dokumente*, vol. 2: *1945 bis heute*, 61. Ed. Theodor Kotulla. Munich: R. Piper, 1964.

———. "Luchino Visconti Interviewed." *Sight and Sound* 3, no. 4 (1959): 144–48.

Ebert, Jürgen. "Kracauers Abbildtheorie." *Filmkritik* 21, no. 4 (1977): 196–217.

Eisenstein, Sergei. "The Fourth Dimension in Cinema." In *The Eisenstein Reader*, 111–23. Ed. Richard Taylor. London: British Film Institute, 1998.

———. "Montage der Filmattraktionen." In *Das dynamische Quadrat. Schriften zum Film*, 17–44. Ed. Oksana Bulgakova. Leipzig: Reclam, 1988.

———. "The Montage of Film Attractions." In *The Eisenstein Reader*, 35–52. Ed. Richard Taylor. London: British Film Institute, 1998.

———. "Organic Unity and Pathos in the Composition of Potemkin." In *Problems of Film Direction*, 1–9. Honolulu: University Press of the Pacific, 2004.

———. "Das Organische und das Pathos." In *Schriften 2: Panzerkreuzer Potemkin*. 150–86. Ed. Hans Joachim Schlegel. Munich: Hanser, 1973.

———. "Die vierte Dimension im Film." In *Das dynamische Quadrat. Schriften zum Film*, 90–108. Ed. Oksana Bulgakova. Leipzig: Reclam, 1988.

Elsaesser, Thomas. *Fassbinder's Germany: History Identity Subject*. Amsterdam: Amsterdam University Press, 1996.

———. *Rainer Werner Fassbinder*. Berlin: Bertz + Fischer, 2001.

Engell, Lorenz. *Bewegen beschreiben. Theorie zur Filmgeschichte*. Weimar: VDG, 1995.

———. *Bilder des Wandels*. Weimar: VDG, 2003.

Enzensberger, Hans Magnus. "Gemeinplätze, die neueste Literatur betreffend." *Kursbuch* 15, 187–97. Frankfurt: Suhrkamp, 1968.

Flaxman, Gregory. *The Brain Is the Screen: Deleuze and the Philosophy of Cinema*. Minneapolis: University of Minnesota Press, 2000.

Forgione, Anna Pasqualina. *Spiando Pedro Almodóvar. Il regista della distorsione*. Naples: Giannini, 2003.

Foucault, Michel. "Omnes et Singulatim: Towards a Criticism of Political Reason." In *The Tanner Lectures on Human Values*, 225–54. Ed. Sterling M. McMurrin. Salt Lake City: University of Utah Press, 1981.

Frohne, Ursula. "'That's the only now I get': Immersion und Partizipation in Video-Installationen." In *Kunstino*, 217–38. Ed. Gregor Stemmrich. Berlin: Verlag der Buchhandlung König, 2001.

Gelder, Ken. "Introduction to Part Nine." In *The Horror Reader*, 273–75. London: Routledge Chapman & Hall, 2000.

Golinski, Hans Günther. "Der Rückblick nach vorn. Die Kunst der Neuen Sachlichkeit zwischen romantischer Tradition und expressionistischer Zeitgenossenschaft." In *Neue Sachlichkeit. Magischer Realismus*, 53–63. Ed. Kunsthalle Bielefeld. Bielefeld: Kunsthalle Bielefeld, 1990.

Hansen, Miriam. "Introduction." In *Siegfried Kracauer: Theory of Film, the Redemption of Physical Reality*. Princeton: Princeton University Press, 1997.

Hartlaub, Gustav Friedrich. "Ein neuer Naturalismus? Eine Rundfrage des Kunstblattes." Ed. Paul Westheim. *Kunstblatt* 6, no. 9 (1922): 369–414.

————. "Reply to a Questionnaire." In *Art in Theory 1900–2000: An Anthology of Changing Ideas*, 247–50. Ed. Charles Harrison and Paul Wood. Oxford: Blackwell, 2003.

————. "Zum Geleit." In *Ausstellung "Neue Sachlichkeit" – Deutsche Malerei seit dem Expressionismus*. Ed. G. F. Hartlaub. Cologne: Verlag der Buchhandlung Walther König, 1988 [1925].

Haubner, Steffen. "Der Exorzist." In *Filme der 70er*, 214–17. Ed. Jürgen Müller. Cologne: Taschen, 2003.

Hausmann, Raoul. "Rückkehr zur Gegenständlichkeit in der Kunst." In *Dada Berlin. Texte, Manifeste, Aktionen*, 102–5. Ed. Hanne Bergius and Karl Riha. Stuttgart: Reclam, 1977 [1920].

————. "Synthetisches Cino der Malerei." In *Dada Berlin. Texte, Manifeste, Aktionen*, 30–31. Ed. Hanne Bergius and Karl Riha. Stuttgart: Reclam, 1977 [1918].

Henze, Hans Werner. *Schriften und Gespräche*. Berlin: Henschelverlag, 1981.

————. "Versuch über Visconti." *Merkur*, no. 10 (1958).

Herzfelde, Wieland. "Introduction to the First International Dada Fair." Trans. Brigid Doherty. *October*, no. 105 (2003): 93–104.

Hoberman, James and Jonathan Rosenbaum. *Midnight Movies*. New York: Da Capo, 1991.

Hülsewig-Johnen, Jutta. "Wie im richtigen Leben? Überlegungen zum Porträt der Neuen Sachlichkeit." In *Neue Sachlichkeit. Magischer Realismus*. Ed. Kunsthalle Bielefeld. Bielefeld: Kunsthalle Bielefeld, 1990.

Huven, Kerstin. *Gendering Images. Geschlechterinszenierung in den Filmen Pedro Almodóvars*. Frankfurt: Peter Lang, 2002.

Ihering, Herbert. "Brecht-Uraufführung in Darmstadt. 'Mann ist Mann.'" In *Theater in Aktion. Kritiken aus drei Jahrzehnten 1913–1933*. Ed. E. Krull and H. Fetting. Berlin: Henschel, 1986 [1926].

————. "Dickicht – Deutsches Theater." In *Theater in Aktion. Kritiken aus drei Jahrzehnten 1913–1933*. Ed. E. Krull and H. Fetting. Berlin: Henschel, 1986 [1924].

————. "Der Schauspieler im Film." In *Von Reinhardt bis Brecht*, vol. 1. Berlin: Aufbau, 1958 [1920/21].

Joyce, Mark. "The Soviet Montage Cinema of the 1920s." In *An Introduction to Film Studies*, 422–24, 433–36. Ed. Jill Nelmes. London: Routledge, 1996.

Kappelhoff, Hermann. "Bühne der Emotionen, Leinwand der Empfindung—Das bürgerliche Gesicht." In *Blick Macht Gesicht*, 9–41. Ed. Helga Gläser, Bernhard. Groß, and Hermann Kappelhoff. Berlin: Vorwerk 8, 2001.

————. "Empfindungsbilder—Subjektivierte Zeit im melodramatischen Film." In *Zeitlichkeiten—Zur Realität der Künste. Theater, Film, Photographie, Malerei, Literatur*, 93–119. Ed. Theresia Birkenhauer and Annette Storr. Berlin: Vorwerk 8, 1998.

————. "Der Lesende im Kino. Allegorie, Fotografie und Film bei Walter Benjamin." In *Die Spur durch den Spiegel. Der Film in der Kultur der Moderne*, 330–40. Ed. Malte Hagener, Johann N. Schmidt, and Michael Wedel. Berlin: Bertz + Fischer, 2004.

————. *Matrix der Gefühle. Das Kino, das Melodrama und das Theater der Empfindsamkeit*. Berlin: Vorwerk 8, 2004.

——. *Der möblierte Mensch. G. W. Pabst und die Utopie der Sachlichkeit. Ein poetologischer Versuch zum Weimarer Kino.* Berlin: Vorwerk 8, 1994.

Kappelhoff, Hermann and Cornelia Müller. "Embodied Meaning Construction: Multimodal Metaphor and Expressive Movement in Speech, Gesture, and Feature Film." *Metaphor and the Social World* 1, no. 2 (2011): 121–53.

Keller, Otto. "Der Gestus als neues ästhetisches Zeichen." In *Zeichen und Realität.* Ed. Klaus Oehler. Hamburg: Stauffenburg, 1981.

Kermode, Mark. *The Exorcist.* London: British Film Institute, 1997.

Kluge, Alexander. *Bestandsaufnahme, Utopie Film.* Frankfurt: Zweitausendeins, 1983.

Kluge, Alexander and Oskar Negt. *Öffentlichkeit und Erfahrung. Zur Organisationsanalyse von bürgerlicher und proletarischer Öffentlichkeit.* Frankfurt: Suhrkamp, 1972.

Koch, Gertrud. *Kracauer zur Einführung.* Hamburg: Junius, 1996.

Köhne, Julia, Ralph Kuschke, and Arno Meteling, eds. *Splatter Movies: Essays zum modernen Horrorfilm.* Berlin: Bertz + Fischer, 2005.

Kracauer, Siegfried. *From Caligari to Hitler: A Psychological History of the German Film.* Princeton: Princeton University Press, 1947.

——. "Geschichte – Vor den letzten Dingen." In *Schriften 4.* Frankfurt: Suhrkamp, 1971.

——. *History: The Last Things Before the Last.* Princeton: Markus Wiener, 1995.

——. "Die Photographie." In *Das Ornament der Masse.* Frankfurt: Suhrkamp, 1977 [1927].

——. "Photography." In *The Mass Ornament.* Cambridge: Harvard University Press, 1995.

——. *Der verbotene Blick: Beobachtungen, Analysen und Kritiken.* Ed. Johanna Rosenberg. Leipzig: Reclam, 1992.

Lauretis, Teresa de. "Visconti's *Senso:* Cinema and Opera." In *The Italian Metamorphosis, 1943–1968,* 450–57. Catalogue of the exhibition organized by Germano Celant at the Guggenheim Museum. New York: Solomon R. Guggenheim Foundation and Rome: Progetti Museali, 1994.

Lethen, Helmut. *Cool Conduct: The Culture of Distance in Weimar Germany.* Berkeley: University of California Press, 2002.

——. *Neue Sachlichkeit 1924–1932. Studien zur Literatur des "Weißen Sozialismus."* Stuttgart: Metzler, 1970.

——. *Verhaltenslehren der Kälte. Lebensversuche zwischen den Kriegen.* Frankfurt: Suhrkamp,1994.

Lindner, Martin. *Leben in der Krise. Zeitromane der Sachlichkeit und die intellektuelle Mentalität der klassischen Moderne.* Stuttgart: Metzler-Studienausgabe, 1994.

Lück, Michael. "Poetiken der Demokratie?" *Rabbit Eye–Zeitschrift für Filmforschung,* no. 4 (2012): 35–47.

Lyotard, Jean-François. "Der Zahn, die Hand." In *Essays zu einer affirmativen Ästhetik,* 11–23. Ed. Jean-François Lyotard. Berlin: Merve, 1982.

Maurer Queipo, Isabel. *Die Ästhetik des Zwitters im filmischen Werk von Pedro Almodóvar.* Frankfurt: Vervuert, 2005.

McCullough, Arthur. "Eisenstein's Regenerative Aesthetics: From Montage to Mimesis." In *The Montage Principle: Eisenstein in New Cultural and Critical Contexts*, 45–65. Ed. Jean Antoine-Dunne and Paula Quigley. New York: Rodopi, 2004.

Michel, Karl Markus. "Ein Kranz für die Literatur." *Kursbuch 15*, 1968.

——. "Die sprachlose Intelligenz II." *Kursbuch 4*, 1966.

Mörchen, Roland. "Des Pudels Kern. Der Teufel tobt und trollt sich im Kino." *Film-Dienst* 54, no. 4 (2001): 10–13.

Negt, Oskar and Alexander Kluge. *Öffentlichkeit und Erfahrung. Zur Organisationsanalyse von bürgerlicher und proletarischer Öffentlichkeit.* Frankfurt: Suhrkamp, 1972.

Neumeyer, Alfred. "Zur Raumpsychologie der Neuen Sachlichkeit." *Zeitschrift für bildende Kunst*, no. 61 (1927/28): 66–72.

Olkowski, Dorothea. *Gilles Deleuze and the Ruin of Representation.* Berkeley: University of California Press, 1999.

Panofsky, Erwin: *Die ideologischen Vorläufer des Rolls-Roys-Kühlers & Stil und Medium im Film.* Frankfurt: Campus, 1993.

Panofsky, Erwin. "Style and Medium in the Motion Pictures." In *Three Essays on Style.* Edited by Irving Lavin, 91–168. Cambridge: MIT Press, 1997.

Pisters, Patricia. *The Matrix of Visual Culture: Working with Deleuze in Film Theory.* Stanford: Stanford University Press, 2003.

Plessner, Helmuth. "Lachen und Weinen." In *Gesammelte Schriften VII.* Frankfurt: Suhrkamp, 1982.

——. "Zur Hermeneutik des nichtsprachlichen Ausdrucks." In *Gesammelte Schriften VII.* Frankfurt: Suhrkamp, 1982.

Prümm, Karl. *Die Literatur des soldatischen Nationalismus der 20er Jahre (1918–1933).* Kronberg: Scriptor, 1974.

——. "Die Stadt der Reporter und Kinogänger bei Roth, Brentano und Kracauer. Das Berlin der zwanziger Jahre im Feuilleton der 'Frankfurter Zeitung.'" In *Die Unwirklichkeit der Städte*, 80–105. Ed. K. Scherpe. Hamburg: 1988.

Rancière, Jacques. *Aesthetics and Its Discontents.* Cambridge: Polity, 2009.

——. *Die Aufteilung des Sinnlichen. Die Politik der Kunst und ihre Paradoxien.* Ed. Maria Muhle. Berlin: b_books, 2006.

——. "Einleitung." In *Die Aufteilung des Sinnlichen. Die Politik der Kunst und ihre Paradoxien*, 7–19. Ed. Maria Muhle. Berlin: b_books, 2006.

——. *La Fable cinématographique.* Paris: Seuil, 2001.

——. *Film Fables.* Trans. by Emiliano Battista. Oxford: Berg, 2006.

——. "Die Geschichtlichkeit des Films." In *Die Gegenwart der Vergangenheit. Dokumentarfilm, Fernsehen und Geschichte*, 230–46. Ed. Eva Hohenberger and Judith Keilbach. Berlin: Vorwerk, 2003.

——. "L'historicité du cinéma." In *De l'histoire au cinéma*, 45–60. Ed. Antoine de Baecque and Christian Delage. Brussels: Complexes, 1998.

——. *Le Partage du sensible: Esthétique et politique.* Paris: Fabrique, 2000.

———. *The Politics of Aesthetics: The Distribution of the Sensible*. London: Continuum, 2004.

———. *Le spectateur emancipé*. Paris: Fabrique, 2008.

———. Thesis 1. In "Ten Theses on Politics." *Theory and Event* 5, no. 3 (2001).

———. *Das Unvernehmen*. Frankfurt: Suhrkamp, 2002.

Raphael, Max. *Raumgestaltungen. Der Beginn der modernen Kunst im Kubismus und im Werk von Georges Braque*. New York: Campus, 1986.

Rodríguez, Jesús. *Almodóvar y el melodrama de Hollywood: Historia de una pasión*. Valladolid: Maxtor, 2004.

Rodowick, David Norman. *Gilles Deleuze's Time Machine*. Durham: Duke University Press, 1997.

Roh, Franz. *Nachexpressionismus. Magischer Realismus. Probleme der neuesten europäischen Malerei*. Leipzig: Klinkhardt & Biermann, 1925.

———. "Vorwort." In *Magischer Realismus. Probleme der neusten europäischen Malerei*. Leipzig: Klinkhardt & Biermann, 1925.

Roth, Wilhelm. "Annotated Filmography." In *Fassbinder*. New York: Tanam, 1981.

———. "Kommentierte Filmographie." In *Rainer Werner Fassbinder*, Reihe Film, vol. 2. Ed. Peter W. Jansen and Wolfram Schütte. Munich: Carl Hanser, 1985.

Rorty, Richard. *Achieving Our Country*. Cambridge: Cambridge University Press, 1989.

———. *Contingency, Irony, and Solidarity*. Cambridge: Cambridge University Press, 1989.

———. "The Priority of Democracy to Philosophy." In *Objectivity, Relativism, and Truth: Philosophical Papers*. Cambridge: Cambridge University Press, 1990.

———. "Solidarity or Objectivity?" In *Objectivity, Relativism, and Truth: Philosophical Papers*. Cambridge: Cambridge University Press, 1991.

Schaeffer, Eric. "Gaugin a Revolution: 16mm Film and the Rise of the Pornographic Feature." In *Porn Studies*. Ed. Linda Williams. Durham: Duke University Press, 2004.

Schiller, Friedrich. *Schillers Werke. Nationalausgabe*. vol. 2,1: *Gedichte in der Reihenfolge ihres Erscheinens 1799–1805*, 185–87. Ed. Norbert Oellers. Weimar: Hermann Böhlaus, 1983.

Schlüpmann, Heide. *Ein Detektiv des Kinos. Studien zu Siegfried Kracauers Filmtheorie*. Frankfurt: Stroemfeld, 1998.

Schnell, Ralf. *Medienästhetik. Zu Geschichte und Theorie audiovisueller Wahrnehmungsformen*. Stuttgart: Metzler, 2000.

Seeßlen, Georg and Fernand Jung. *Stanley Kubrick und seine Filme*. Marburg: Schüren, 1999.

Segeberg, Harro. "Faschistische Medienästhetik? Ernst Jüngers 'Der Arbeiter' und Leni Riefenstahls *Triumph Des Willens* im Vergleich." In *Autorität der/in Sprache, Literatur, Neuen Medien. Dokumentation des Germanistentages 1998 in Bonn*. Ed. Jürgen Fohrmann. Berlin: Akademie, 1999.

Sloterdijk, Peter. *Critique of Cynical Reason*. Minneapolis: University of Minnesota Press, 1988.

Smith, Paul Julian. *Desire Unlimited: The Cinema of Pedro Almodóvar*. London: Verso, 2000.

Sobchack, Vivian. "Phenomenology and the Film Experience." In *Vewing Positions: Ways of Seeing Film*, 36–58. Ed. Linda Williams. New Brunswick, NJ: Rutgers University Press, 1995.

Sorlin, Pierre. "Der italienische Neorealismus als Versuch eines *cinema corale*." In *Die Frage der Gemeinschaft. Das westeuropäische Kino nach 1945*, 95–108. Ed. Hermann Kappelhoff and Anja Streiter. Berlin: Vorwerk 8, 2012.

Steadman Watson, Wallace. *Understanding Rainer Werner Fassbinder: Film as Private and Public Art*. Columbia: University of South Carolina Press, 1996.

Stemmrich, Gregor. *Kunst, Kino—48. Jahresring*. Ed. Kulturkreis des Bundes der Deutschen Industrie and Gregor Stemmrich. Cologne: Oktagon, 2001.

Sternagel, Jörg. *Methodische Schauspielkunst und Amerikanisches Kino*. Berlin: Wissenschaftlicher Verlag Berlin, 2005.

Streiter, Anja. "Die Frage der Gemeinschaft und die 'Theorie des Politischen.'" In *Die Frage der Gemeinschaft. Das westeuropäische Kino nach 1945*, 21–37. Ed. Hermann Kappelhoff and Anja Streiter. Berlin: Vorwerk 8, 2012.

Tan, Ed. *Emotion and the Structure of Narrative Film: Film as an Emotion Machine*. Mahwah, NJ: Lawrence Erlbaum, 1996.

Visconti, Luchino. "Anthropomorphic Cinema." In *Springtime in Italy: A Reader on Neo-Realism*, 83–85. Ed. David Overbey. London: Talisman, 1978.

——. "Il cinema antropomorphico." *Cinema* (1943): 173–74.

——. "Da Verga a Gramsci." In *Visconti: il Cinema*. Modena: Ufficio cinema del Comune di Modena, 1977.

——. "Von Verga zu Gramsci." In *Der Film. Manifeste – Gespräche – Dokumente*, vol. 2: *1945 bis heute*. Ed. Theodor Kotulla. Munich: Piper, 1964.

Vogl, Joseph. "Einleitung." In *Gemeinschaften. Positionen zu einer Philosophie des Politischen*, 7–27. Ed. Joseph Vogl. Frankfurt: Suhrkamp, 1994.

Wilder, Billy. "Billy in Conversation with Hellmuth Karasek." In the *Berliner Lektionen 1987*.

Witte, Karsten. "Nachwort des Herausgebers." In *Siegfried Kracauer: Von Caligari zu Hitler*. Frankfurt: Suhrkamp, 1979.

Wood, Robin. *Hollywood from Vietnam to Reagan*. New York: Columbia University Press, 1986.

INDEX

COLUMBIA THEMES IN PHILOSOPHY, SOCIAL CRITICISM, AND THE ARTS
LYDIA GOEHR AND GREGG M. HOROWITZ, EDITORS

Lydia Goehr and Daniel Herwitz, eds., *The Don Giovanni Moment: Essays on the Legacy of an Opera*

Robert Hullot-Kentor, *Things Beyond Resemblance: Collected Essays on Theodor W. Adorno*

Gianni Vattimo, *Art's Claim to Truth*, edited by Santiago Zabala, translated by Luca D'Isanto

John T. Hamilton, *Music, Madness, and the Unworking of Language*

Stefan Jonsson, *A Brief History of the Masses: Three Revolutions*

Richard Eldridge, *Life, Literature, and Modernity*

Janet Wolff, *The Aesthetics of Uncertainty*

Lydia Goehr, *Elective Affinities: Musical Essays on the History of Aesthetic Theory*

Christoph Menke, *Tragic Play: Irony and Theater from Sophocles to Beckett*, translated by James Phillips

György Lukács, *Soul and Form*, translated by Anna Bostock and edited by John T. Sanders and Katie Terezakis with an introduction by Judith Butler

Joseph Margolis, *The Cultural Space of the Arts and the Infelicities of Reductionism*

Herbert Molderings, *Art as Experiment: Duchamp and the Aesthetics of Chance, Creativity, and Convention*

Whitney Davis, *Queer Beauty: Sexuality and Aesthetics from Winckelmann to Freud and Beyond*

Gail Day, *Dialectical Passions: Negation in Postwar Art Theory*

Ewa Płonowska Ziarek, *Feminist Aesthetics and the Politics of Modernism*

Gerhard Richter, *Afterness: Figures of Following in Modern Thought and Aesthetics*

Boris Groys, *Under Suspicion: A Phenomenology of the Media*, translated by Carsten Strathausen

Michael Kelly, *A Hunger for Aesthetics: Enacting the Demands of Art*

Stefan Jonsson, *Crowds and Democracy: The Idea and Image of the Masses from Revolution to Fascism*

Elaine P. Miller, *Head Cases: Julia Kristeva on Philosophy and Art in Depressed Times*

Lutz Koepnick, *On Slowness: Toward an Aesthetic of Radical Contemporaneity*

John Roberts, *Photography and Its Violations*